The Art of Conservation

— 2010 —

An International Exhibit of Nature in Art

"The Art of Conservation" exhibit recognizes artists for their commitment to artistic excellence and conservation, raises awareness of environmental issues, and directly supports conservation organizations through the sale of artwork.

The Art of Conservation
—— 2010 ——
An International Exhibit of Nature in Art

Artists for Conservation™
Supporting Nature through Art

www.ArtistsForConservation.org

Published by Artists for Conservation Foundation, Inc. by arrangement with
The Heliconia Press, Inc.

Artists for Conservation Foundation, Inc.
P.O. Box 200, G.D.
Clayton, Ontario, Canada
K0A 1P0
Tel: 613-256-7300
www.artistsforconservation.org

Co-published by arrangement with:
The Heliconia Press, Inc.
1576 Beachburg Road
Beachburg, Ontario, Canada
K0J 1C0
www.helipress.com

Library and Archives Canada Cataloguing in Publication

The art of conservation 2010 : an international exhibit of nature in art /
edited by Jeffrey Whiting.

Accompanies a virtual exhibition opening in October, 2010.

ISBN 978-1-896980-47-8

1. Nature in art–Exhibitions. 2. Wildlife art–Exhibitions. 3. Art, modern-
-21st century–Exhibitions. 4. Nature conservation. I. Whiting, Jeffrey,
1972- II. Artists for Conservation Foundation

N7650.A78 2010 704.9'43074 C2010-903308-6

Printed and bound in Korea.

First Edition

A portion of the proceeds from each exhibit artwork sold during The Art of
Conservation 2010 exhibit will be donated to a conservation organization of
the artist's designation.

This book has been printed on 150gsm Korean Matt Art paper stock, from an
FSC-certified source, using sustainable forestry practices.

Mixed Sources
Product group from well-managed
forests and other controlled sources
www.fsc.org Cert no. CU-COC-812078
© 1996 Forest Stewardship Council

Book design and concept by Jeffrey Whiting
Front Cover: "Shadows of Panama" by Jason Kamin
Back Cover: "Devotion" by Val Warner

Artists for
Conservation™
Supporting Nature through Art

"The Art of Conservation" is the annual exhibit of Artists for Conservation—the world's leading artist group supporting the environment.

Published by the Artists for Conservation Foundation, Inc.
in association with the Heliconia Press, Inc., Beachburg, Ontario

Introduction by:
Jeffrey Whiting

This book has been published as a companion to The Art of Conservation 2010 exhibit, produced by the Artists for Conservation Foundation.

The AFC would like to express its gratitude to the following sponsors who have provided support for this exhibition and the publication of this book.

Wildscape is a UK-based magazine focused on the interests of animal artists. Wildscape covers as wide a variety of subjects and media as possible, with quality, in-depth and informative articles by some of the leading exponents of the genre. For more information, please visit www.wildscapemag.co.uk.

ISCAPE Internet Consulting, a professional services firm based in Vancouver, BC, provides Internet solutions through the combined expertise of advisory, usability, design, technology, and online marketing strategies. For more information about ISCAPE, please visit their website at www.iscapeinternet.com.

The Heliconia Press is a leading publisher in the outdoor industry and has won numerous awards for its publications in both print and video. Heliconia's books and DVDs can be found throughout North America and are distributed worldwide. For more information, please visit www.helipress.com.

Table of Contents

Photo by Yasaman Whiting

Introduction
by Jeffrey Whiting,
President and Founder, Artists for Conservation

What a year to reflect upon. Earth rang in the Year of Biodiversity with a prolonged geological belch of ash and rock in Iceland. Eyjafjallajokull (I actually trained myself to pronounce this) – dormant volcano turned mountain-sized orifice – brought travel in Europe to a standstill and disrupted lives around the world.

But if an erupting Icelandic volcano was a belch, than surely, ensuing events in the Gulf of Mexico were tantamount to a human-induced vomit of planetary proportions. For 87 days, the world watched powerlessly with revulsion and despair as 4.9 million barrels of crude oil (or 205 million gallons) gushed into the crystalline waters of the Gulf of Mexico. We now know this to be the worst oil spill in history. As astronauts added another module to the International Space Station on shuttle Atlantis' final voyage, they shared with us how bad the spill looked from space. What will we learn from this?

We can't reflect on the year without mentioning earthquakes in Haiti and Chile that wrought enormous destruction. The resulting extended shutdown of the pulp industry in Chile had a major impact on the availability of paper worldwide. Options for producing a short-run book, such as this one, on environmentally friendly stock became severely limited. It caused costs to rise and slowed production. It is cause for thought that a single earthquake, could have a global impact on printing on sustainably forested paper.

On a more symbolic level, we face an immediate challenge in the survival of one of nature's most iconic species – tigers.

Although the fate of the world does not rest on the survival of one type of animal, symbolically, the loss of tigers is not an option. Simply put, if we cannot rally the global community to do what is needed to save as dramatic and charismatic an animal as the tiger, it does not bode well for the 99.9% of diversity of life on earth that isn't so photogenic.

On the up-side, loggers and environmental NGOs (and notably NOT government) struck a new deal this year to protect the boreal forest in Canada – a huge chunk of the world's largest forest ecosystem – and commit to setting new international standards in forest management. Environmental groups that were only last year calling for a boycott on Canadian pulp, are claiming total victory and heaping praise on their prior adversaries. Vision, appreciation and cooperation mixed with determination and a dash of pragmatism made this happen. The recipe works.

We arguably averted two doomsday scenarios, thanks in large part to intergovernmental cooperation and planning. A global pandemic of H1N1 influenza fizzled from the public's radar with far less human casualties than feared. And while we will never know for sure, we may have at least temporarily prevented a global economic depression -though we are far from perfect or complete solutions, we hope we have learned a big lesson: the fiscal saga underlines the interconnectedness of our global village. It underlines the consequences of our society as a whole not taking responsibility for its actions, acting unsustainably, and allowing irresponsible and unaccountable behavior to take place.

As for Artists for Conservation, the last year has been a year of renewal and growth. This fall, we are set to launch the AFC's next generation website, including a dedicated site for our Flag Expeditions program, and a truly groundbreaking virtual exhibit site for the AFC's annual exhibit — The Art of Conservation. All three new websites will be highly interactive, providing many ways for artists and visitors to engage through discussion, blogs, video, audio, contributed articles, and tight integration with social media such as Facebook, Twitter, LinkedIn and YouTube.

Last September, we had a wonderful opening weekend to our annual exhibit at the Hiram Blauvelt Art Museum in Oradell, New Jersey. The event again brought AFC members from around the world to participate. Among them was John Banovich, internationally renowned artist and prominent AFC member. John joined us to receive the AFC's top annual honour – the Simon Combes Conservation Award. We had the pleasure of learning more about John's conservation work and the Banovich Wildscapes Foundation. In particular, we learned of John's inspirational and important P.R.I.D.E lion initiative in Kenya and Khunta Mi project in support of the Amur Tiger in the Russian far east.

In February, I traveled to Houston to present this year's Simon Combes Conservation Award to joint recipients Rob Glen and Sue Stolberger. The two are an inspiration to anyone who has the privilege to meet them. Their story is a must-read and is summarized in a chapter near the end of this book. The world needs more people like John, Rob and Sue.

This year's exhibit brings a great deal of innovation through change. In addition to developing a virtual exhibit website, I am also proud to say that we developed a successful new system of jurying for the selection of work in this exhibit that is more fair, impartial, and inclusive than any I'm aware of. It was met with unanimous and enthusiastic approval by all six judges who participated.

Unlike previous years, where the host museum independently selected the jury panel, we decided to have actual AFC members represented on the jury. The process involved a grading system, with selected works determined on an average score of marks from each of the jurors. Signatures were obscured from each image seen by the jury, and any juror who entered work of their own, abstained from grading their own work. To add further level of fairness, scoring was anonymous and members of the jury were un-

known to one another until after the scores were determined.

We had a record number of entries this year – 410 artworks submitted in total from 188 members. Of these, 150 artworks from 101 artists have been selected for inclusion in our 2010 exhibit.

We have the pleasure of featuring three Flag Expeditions in this year's book, with members Ria Winters, Susan Fox and Kelly Dodge. Ria visited Mauritius in the Indian Ocean to study the myriad endangered and endemic species on the remote island. Susan brought us vicariously to Mongolia in search of the argali (mountain sheep), and Kelly Dodge visited the Galapagos archipelago.

Two very exciting new Flag Expeditions are scheduled for this fall with American plein-air artists Stephen Quinn and David Gallup. In partnership with the American Museum of Natural History and the Houston Zoo, AFC will be supporting Stephen's Flag Expedition to Rwanda and Congo in November. There, Steve will retrace the steps of iconic explorer and artist Carl Akeley, to observe Mountain Gorillas in the wild and to support the critical conservation work of the Mountain Gorilla Veterinarian Project. Also in the fall, David Gallup will be working alongside marine biologists off the coast of Northern California, tracking and cage diving with our greatest oceanic predator - the Great White Shark. Both promise to be exciting and informative adventures in conservation.

Finally, I'm excited to announce the launch of AFC's first annual environmental calendar, produced in partnership with the Wildlife Conservation Society. The calendar will raise the profile of our annual exhibit and hopefully raise much needed funds for both AFC and WCS. Filled with dramatic images from the exhibit and with key environmental dates and weeks highlighted, it will make a wonderful gift for anyone who appreciates nature.

I remain ever optimistic and excited about our future, and the role of artists in making our world richer, more diverse and sustainable. More exciting announcements are on the horizon. I invite you to visit us often on the AFC website to follow the new developments and to experience this year's exhibit in an exciting virtual presentation online at www.artistsforconservation.org/exhibit2010. I would also encourage you to consider supporting AFC and its programs by becoming an AFC friend or patron. We have important exciting work ahead and need your help.

Sincerely,

The Exhibit

The Art of Conservation exhibition celebrates artistic excellence in the depiction of nature, raises awareness of important conservation issues and directly supports organizations dedicated to addressing them.

2010 Judges

The AFC extends its sincere thanks to the following individuals who served as the jury panel for the selection of the artworks included in this show.

- James Coe (USA), AFC Signature Member (Painter)

- Susan Fisher (USA), Artist and Director at Arizona Sonora Desert Museum - Art Institute

- David Kitler (Canada), AFC Signature Member (Painter) and 1st AFC Flag Expedition fellowship recipient

- Stephen Quinn (USA), AFC Signature Member (Painter & Sculptor), AFC Flag Expedition fellowship recipient and Senior Exhibits Manager at American Museum of Natural History

- Rosetta (USA), AFC Signature Member (Sculptor)

- Ken Stroud (UK), AFC Signature Member (Painter) and Publisher of Wildscape Magazine

2009 Award Winners

Medal of Excellence

- Carel Brest Van Kempen for his painting, *"Creekside Conclave -Varied Harlequin Toads"*;

- Jim Coe for his painting, *"Snowy Fields"*;

- Guy Combes for his painting, *"The Creche"*;

- Andrea Rich for her woodblock print, *"Cranes in the Mist"*, and

- Mary Taylor for her lifesize metal sculpture, *"The Filly"*.

Wildscape Editor's Choice Award

- Patricia Pepin for her painting *"Takhi"*. Also recognized by the magazine for special recognition were Doug Aja (*"Final Warning"*), Sally Berner (*"Washed Up"*) and Linda Sutton (*"Imposing Prescents"*).

Hiram Blauvelt Museum Purchase Award

- Robert Glen for his sculpture, "Warthog Running"

2010 Award Winners

Environmental Statement Award

- Val Warner for her painting, *"Devotion"*.

Medals of Excellence

- Guy Coheleach for his painting, *"Seacoast Pelicans"*;

- Anni Crouter for her painting, *"Solitaire"*;

- Kelly Dodge for her painting, *"Where's Waldo?"*;

- David Kitler for his painting, *"Madagascar - Creatures of the Night I"*;

- Robert Parkin for his painting, *"I See You"*, and

- Val Warner for her painting, *"Devotion"*;

Honorable Mentions

- Michael Dumas for his painting, *"The Yearling"*;

- Martin Gates for his sculpture, *"Fish Hawk"*;

- Jason Kamin for his painting, *"Shadows of Panama"*;

- Alison Nicholls for her painting, *"Ensnared"*;

- Sandra Temple for her painting, *"Just Us Trees"*, and

- Rosetta for her sculpture, *"Cheetahs on the Run"*.

Wildscape Editor's Choice Award

- Winner: Anni Crouter for her painting, *"Solitaire"*. Also recognized by the magazine for special recognition were Ron Orlando ("The Dye Maker"), Christopher Walden ("Balance of Nature"), and Val Warner for her painting, "Devotion".

Environmental Statement Award

- Val Warner for her painting, *"Devotion"*.

Exhibiting Artists

Following is a list of all artists whose artwork is represented in The Art of Conservation 2010 exhibit. As with the list, the artworks featured on the pages that follow appear in alphabetical order of the artists' names.

Sue Adair (USA)
John Agnew (USA)
Al Agnew (USA)
Douglas Aja (USA)
Phillip Allder (UK)
Del-Bourree Bach (USA)
Sheila Ballantyne (Canada)
Cheryl Battistelli (Canada)
Linda Besse (USA)
Adam Binder (UK)
Peter Blackwell (Kenya)
Sandra Blair (USA)
Peta Boyce (Australia)
Carel Brest van Kempen (USA)
Diane Burns (USA)
Wayne Chunat (USA)
James Cow (USA)
Guy Coheleach (USA)
Guy Combes (USA)
Carrie Cook (USA)
Brent Cooke (Canada)
Anni Crouter (USA)
Andrew Denman (USA)
David Derrick Jr. (USA)
Kim Diment (USA)
Kelly Dodge (Canada)
Michael Dumas (Canada)
Lori Dunn (Canada)
Kathleen Dunn (USA)
Lyn Ellison (Australia)
Leslie Evans (USA)
Linda Feltner (USA)
Martin Gates (USA)
Sue Gombus (USA)

Bridget Grady (USA)
Gemma Gylling (USA)
Grant Hacking (USA)
Julia Hargreaves (Canada)
Guy Harvey (USA)
Kitty Harvill (Brazil)
Martin Hayward-Harris (UK)
Janet Heaton (USA)
Cindy House (USA)
Mike Hughes (UK)
Alan M. Hunt (UK)
Terry Isaac (Canada)
Clint Jammer (Canada)
Stephen Jesic (Australia)
Richard Jones (USA)
Jason Kamin (Canada)
Hans Kappel (Germany)
David Kitler (Canada)
John Kobald (USA)
Barbara Kopeschny (Canada)
Susan Labouri (USA)
Karen Laurence-Rowe (Kenya)
Esther Lidstrom (USA)
Bo Lundwall (Sweden)
Harro Maass (Germany)
Chris McClelland (Australia)
John Megahan (USA)
Billy-Jack Milligan (Canada)
Dianne Munkittrick (USA)
Sean Murtha (USA)
Ken Newman (USA)
Alison Nicholls (USA)
Carole Niclasse (USA)
Mary Louise O'Sullivan (USA)

Steve Oliver (USA)
Ron Orlando (USA)
Robert Parkin (UK)
Dr. Jeremy Paul (UK)
Cristina Penescu (USA)
Patricia Pepin (Canada)
Dag Peterson (Sweden)
Pollyanna Pickering (UK)
Stephen Quinn (USA)
David Rankin (USA)
Diana Reuter-Twining (USA)
Andrea Rich (USA)
Katerina Ring (Italy)
Rosetta (USA)
Linda Rossin (USA)
Sharon K. Schafer (USA)
John Seerey-Lester (USA)
Suzie Seerey-Lester (USA)
Morten Solberg (USA)
Eva Stanley (USA)
Mary Taylor (USA)
Sandra Temple (Australia)
Dahrl Thomson (USA)
France Tremblay (Canada)
Alex Underdown (UK)
Jerry Venditti (USA)
Lute Vink (South Africa)
Christopher Walden (USA)
Val Warner (USA)
Taylor White (USA)
Ellen Woodbury (USA)
Chris Woolley (USA)
Steve Worthington (USA)

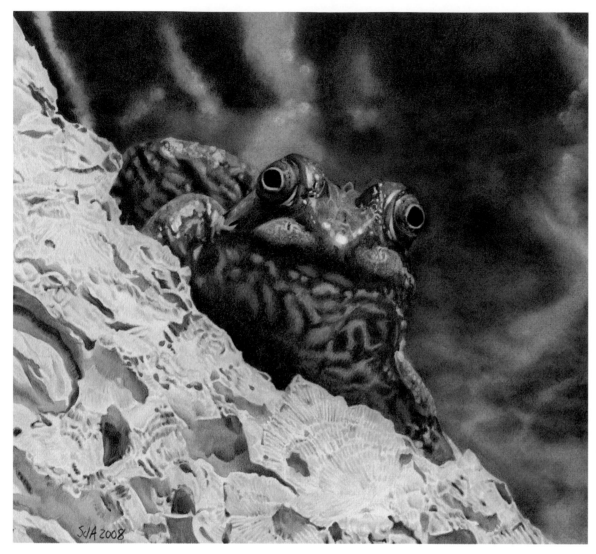

"I came upon this Green Frog while hiking along a stream at a preserve in southern Albany County in New York State. I took a number of photos of the frog and whenever I looked at them it made me think of the first creature to crawl out of the sea onto the land (well, either that or the creature from the black lagoon!). It was something about the dark water behind the animal, and the fact that it is an amphibian I guess. So I decided to call the painting Evolution and perch the frog on a rock full of fossils instead of the log it sat on in the field."

SUE ADAIR

Evolution
Watercolor and Colored Pencil
5.5" x 6"

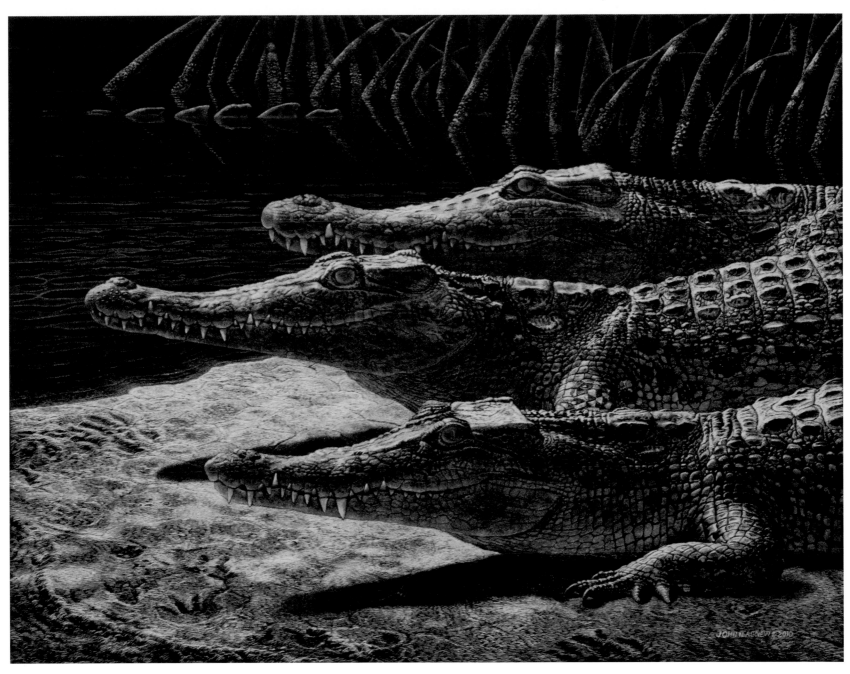

JOHN AGNEW

Three Young Salties
Scratchboard
11" x 14"

"Crocodiles make wonderful subjects for scratchboard drawings because of their amazing textures. Crocodilian textures make them irresistible subjects for scratchboard, although some may question my sanity."

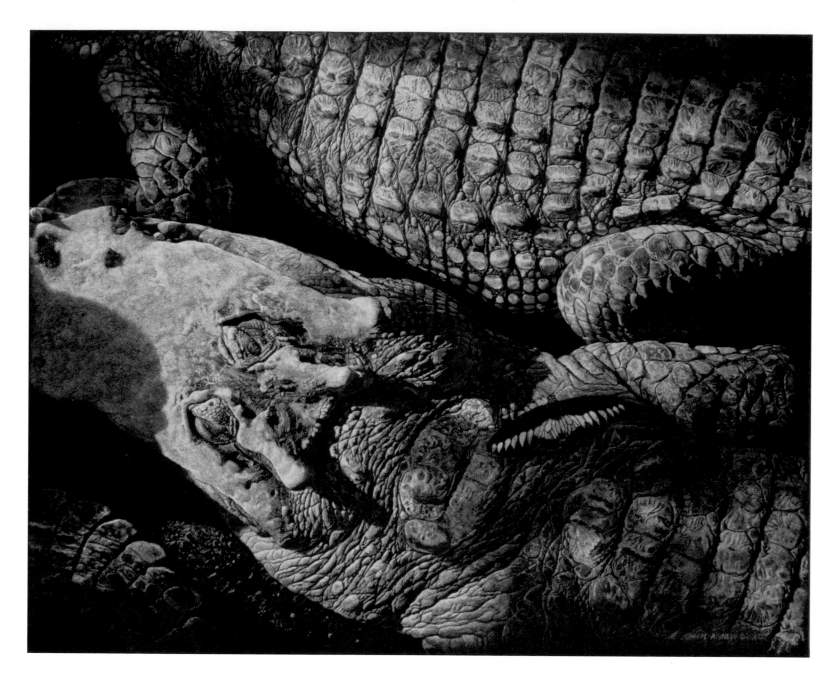

JOHN AGNEW

Crocodile Dreams
Scratchboard
11" x 14"

"What do crocodiles dream about? I have no idea, but seeing a butterfly land on a sleeping croc made me wonder..."

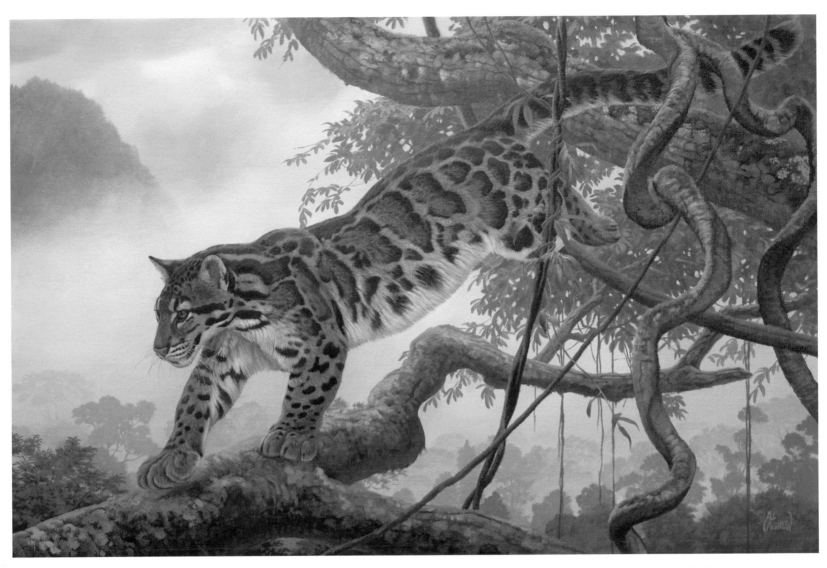

AL AGNEW

Cloud Spirit
Acrylic on panel
16" x 24"

"Clouded Leopards are one of the most endangered of the big cats. Native to the rainforests of Southeast Asia, their habitat has been greatly impacted by war and deforestation. An odd looking cat, they have comparatively short legs, long body and large muzzle which accommodates their canine teeth, the largest of any living cat."

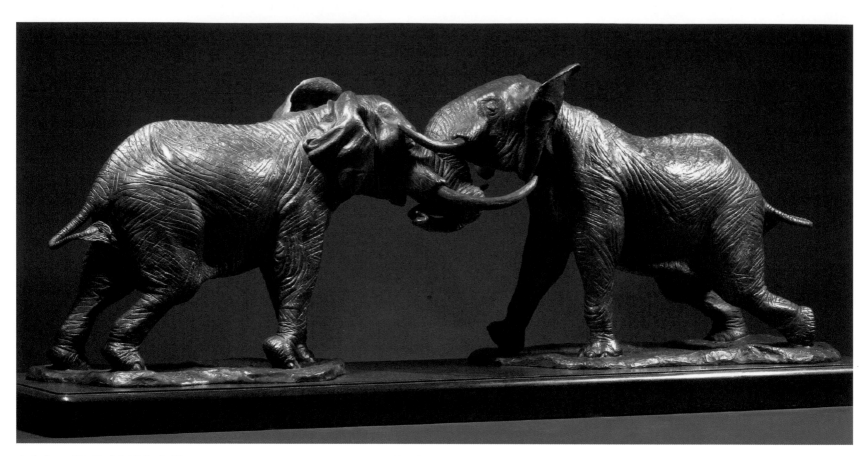

AJA, DOUGLAS

Locked in Battle
Bronze
15" x 40" x 10"

"'Locked in Battle' depicts a fight between two bulls in musth, Dionysus and Iain. At the time, Iain was Amboseli's highest ranking bull, Dionysus its third. During this dramatic battle, Iain was able to lift Dionysus off his feet. Knowing he was beaten, Dionysus wisely turned and fled with Iain chasing him across the plains for nearly an hour."

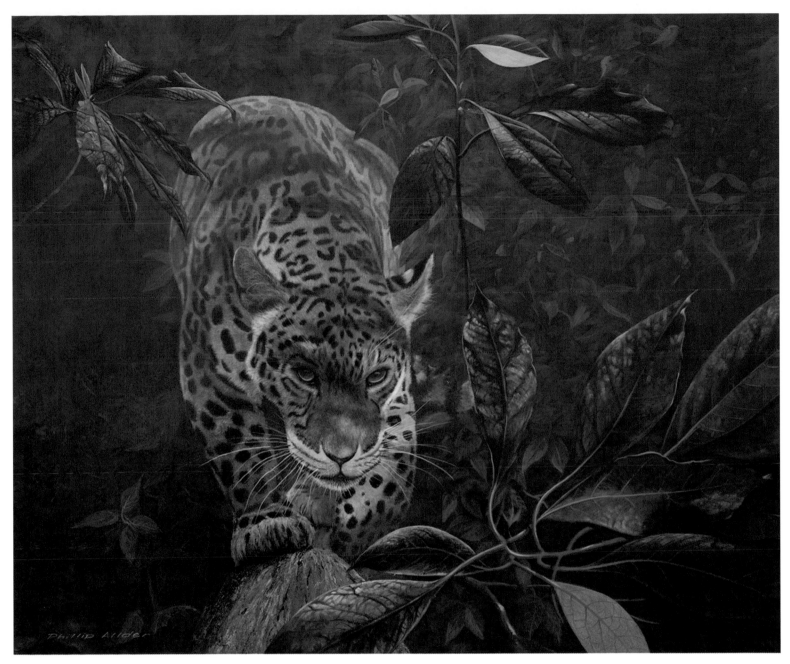

PHILLIP ALLDER

Creep
Oil on canvas
28" x 32"

"The beautiful Jaguar is the top predator in the Brazillian rainforest. If we loose the rainforest we lose so much more than just the Jaguar; scientists discover new species here on a regular basis. Many are unique to the area and many have important medical potential. We just don't know, and we may never find out."

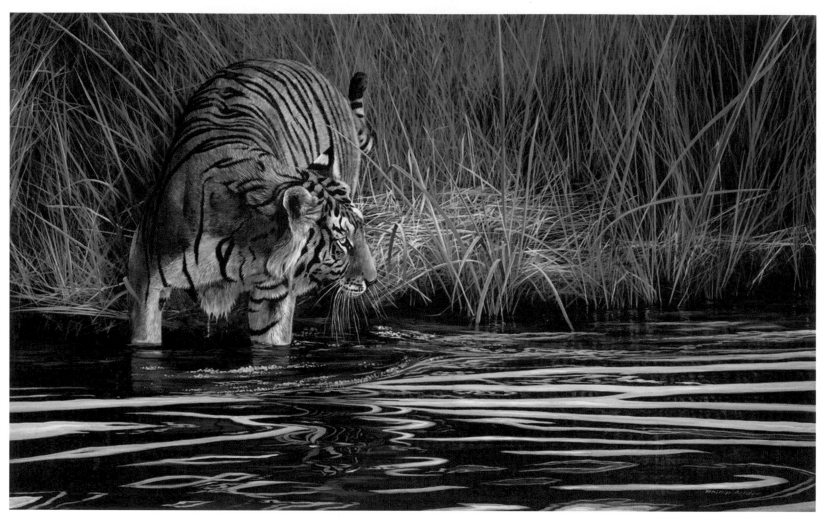

PHILLIP ALLDER

Breaking Cover
Oil on canvas
36" x 56"

"I like my paintings to tell a story. In this story the tiger pauses as she senses danger ahead, symbolic of the dangers that face all these magnificent creatures."

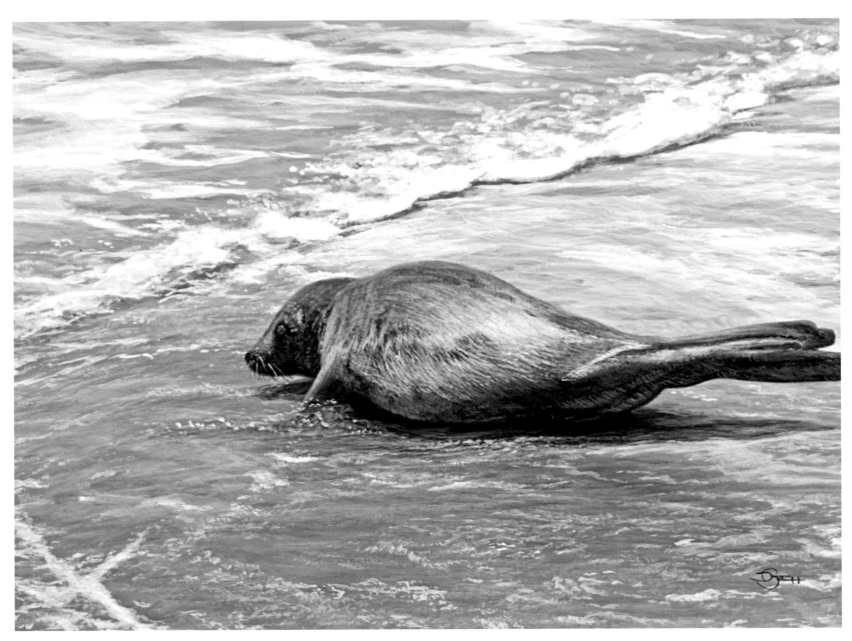

DEL-BOURREE BACH

Almost Home
Acrylic on panel
9" x 12"

"This little Harp Seal is on his way home after successful rehab in the Marine Mammal and Sea Turtle Rescue Clinic at Sea Research Foundation's Mystic Aquarium. I have the pleasure of attending releases and getting reference photos. It's a great feeling to see these animals return to the sea and I'm glad to be a part of the ongoing efforts of the Clinic."

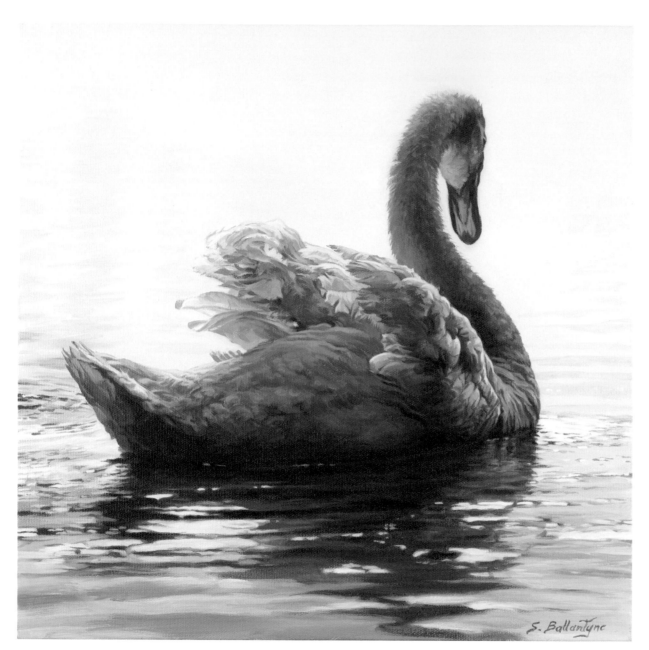

"The title of this piece truly represents my desire to capture the majestic beauty of the Mute Swan, hoping the viewer can become immersed in the feeling it evokes. I found myself in a surreal moment in time, having stumbled across this creature in the wild, a gift that will long be cherished. I was humbled in the presence of this magnificent bird."

SHEILA BALLANTYNE

Grace
Acrylic on canvas
14" x 14"

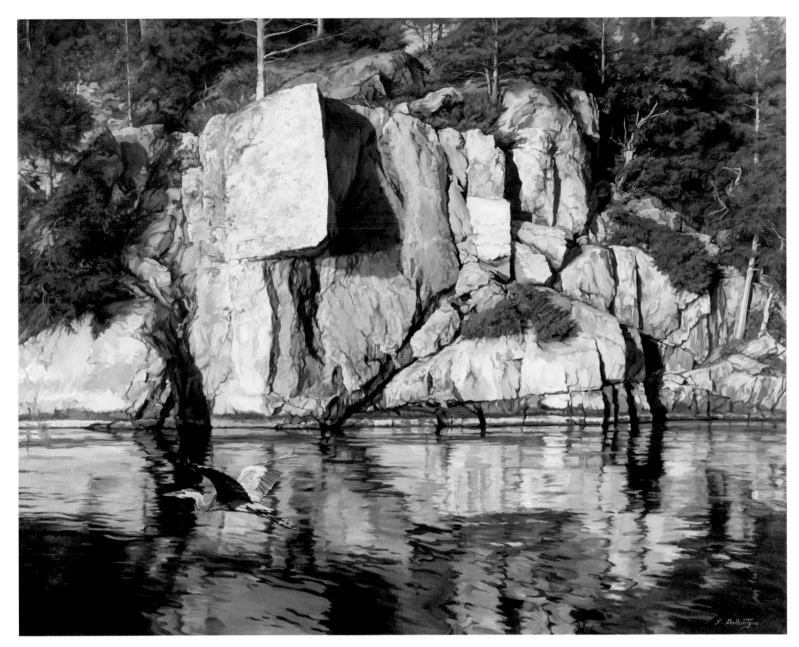

SHEILA BALLANTYNE

Tomahawk Rock
Acrylic on canvas
32" x 40"

"I believe everyone has a place that is a personal favourite, a place that they return to (if only in their mind) that brings a feeling of peace and tranquility. People need to go to these places to ground themselves, to get back to reality and to connect themselves to the creator of all things.

This painting portrays a small piece of our Canadian Shield, located on Charleston Lake, Ontario. We dubbed it 'Tomahawk Rock' for obvious reasons. It is a place near and dear to my heart, nature's cathedral, my personal sanctuary."

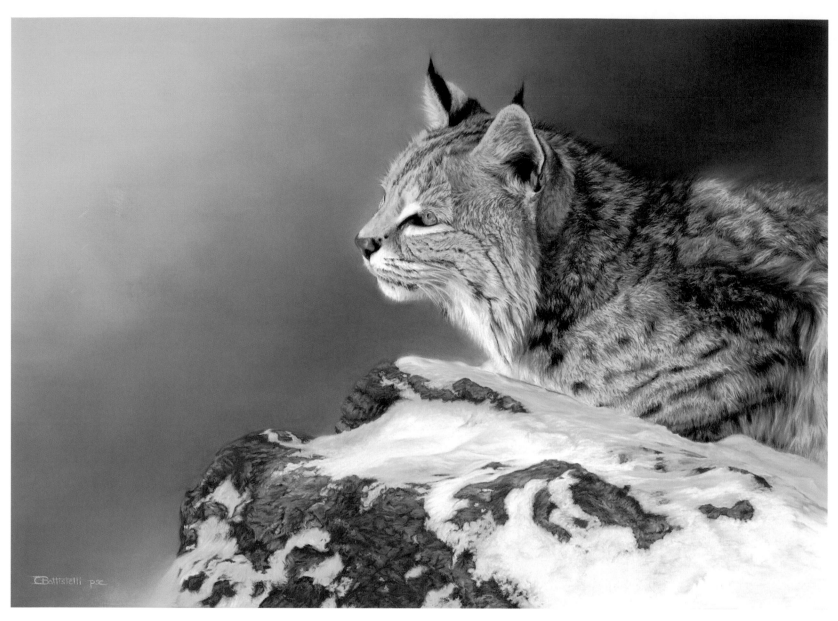

CHERYL BATTISTELLI

Winter Light
Pastel on archival sandpaper
14" x 23"

"Canadian winters, albeit often quite harsh, are very beautiful as well. In 'Winter Light', I have depicted a Bobcat relaxing on an outcropping of snowy Precambrian bedrock, taking a moment to soak in the warm rays of winter sunshine. Perhaps he can sense spring right around the corner...."

CHERYL BATTISTELLI

My Song
Pastel on archival sandpaper
11" x 10"

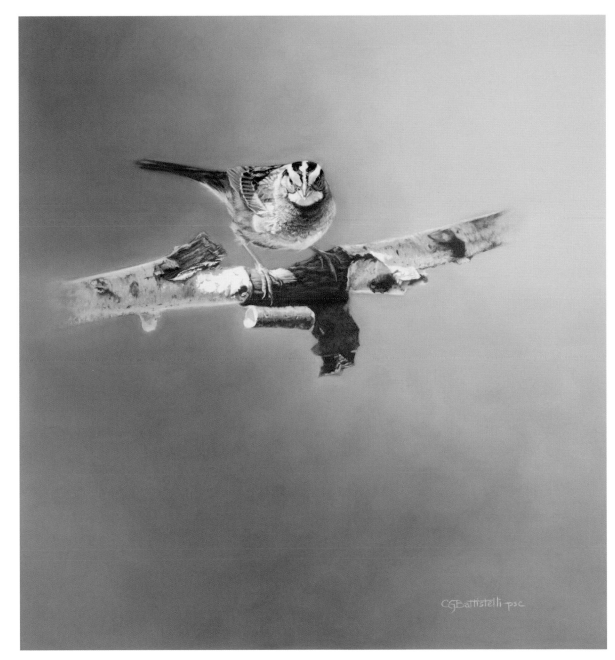

"The hauntingly beautiful song of the White-throated Sparrow never fails to evoke in me happy memories of peaceful childhood summer mornings spent at our family cottage in Northern Ontario - memories of a glassy lake, the humming of bees, the feel of sand under your bare feet, and the early morning sunshine warming your face.

These lovely little birds never seem to be still for long, and this is why I enjoy the attitude of the bird in the painting; you know that this sight represents a very brief moment in time, and he's gone..."

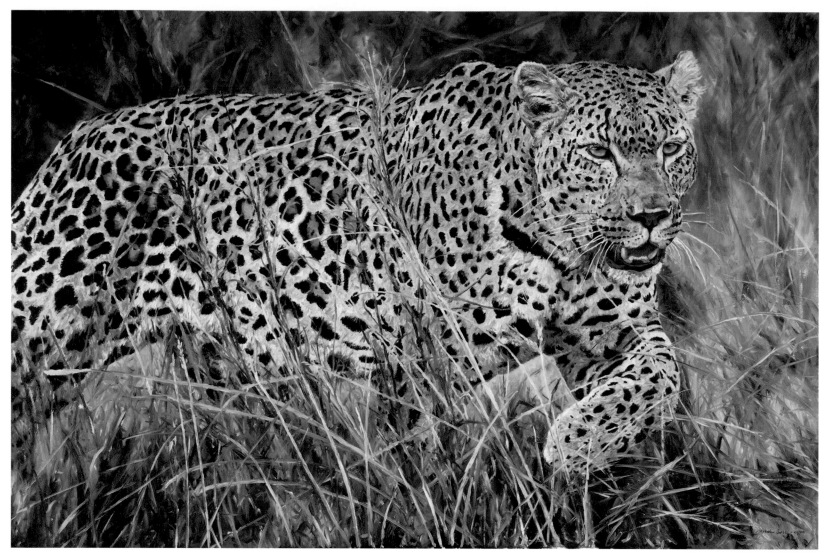

LINDA BESSE

Leopard!
Oil
30" x 45"

"The leopard has been called the most intelligent and feline of the big cats. Maybe he has been circling you for the last 15 minutes and you were unaware of his presence. Your first thought when you see him - 'Leopard!' - may well be your last thought."

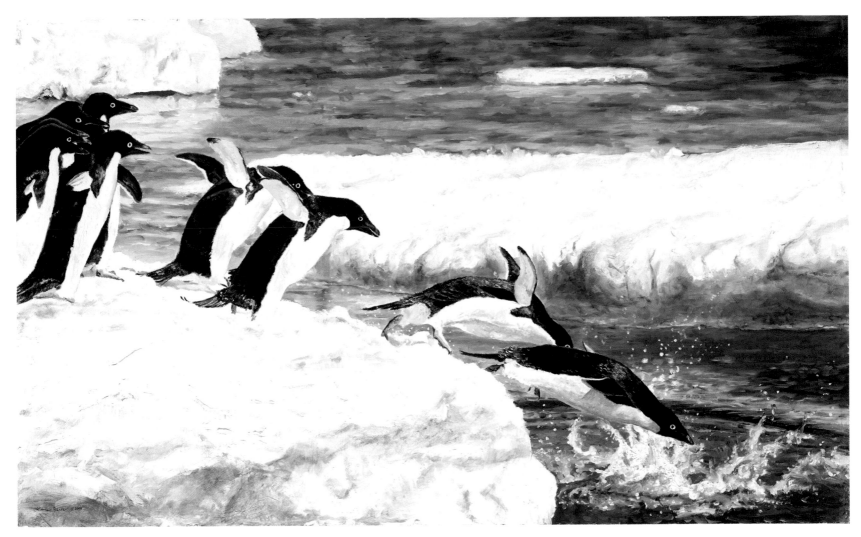

LINDA BESSE

Polar Plunge
Oil
14" x 23"

"On my trip to Antarctica, I had the good fortune to spend hours with Adele Penguins. This is one of the scenes I wanted to capture in a painting. Watching them 'stack up' before taking the plunge, I was reminded of my fellow shipmates and me as we waited, then boldly leapt into the frigid waters of the Antarctic. I think the penguins were better prepared for the water's temperature than we were covered only with bathing suits and a healthy dose of insanity."

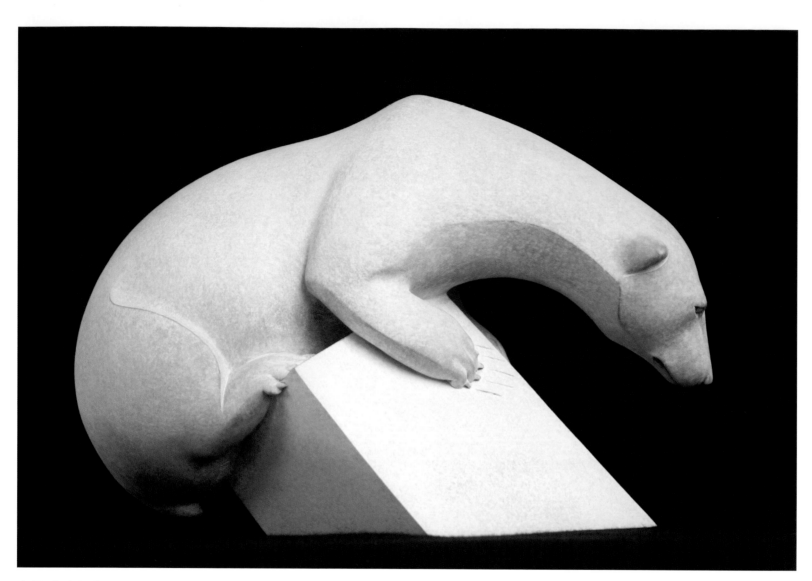

ADAM BINDER

Sinking Feeling
Bronze
9" x 13" x 6"

"We all know the devastating effect that global warming is having on our planet, but none more prevalent than the immediate crisis faced by our Polar Bears. 'Sinking Feeling' depicts nature's instinct, regardless of circumstance ,to hold on until the very last moment. I hope that through the work and support of conservation organisations around the globe time will never run out for the magnificent Polar Bear."

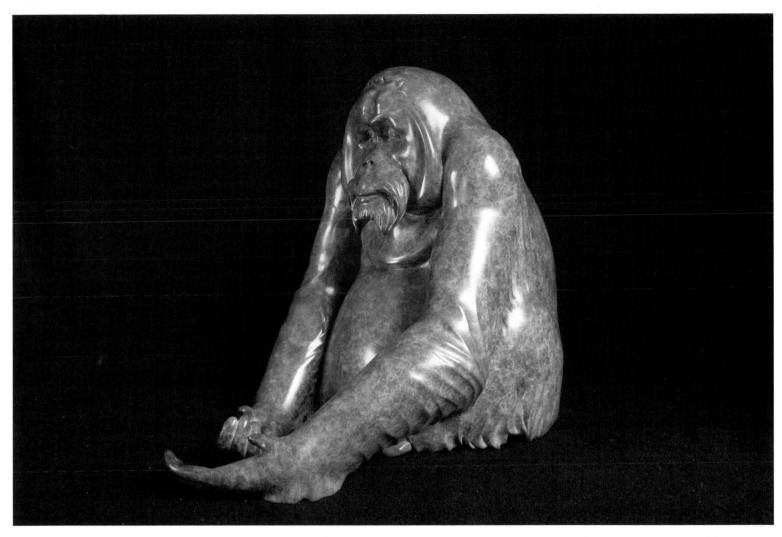

ADAM BINDER

Orang-utan
Bronze
13″ x 12″ x 10″

"This sculpture considers whether or not the Orang-utan is able to contemplate his own fate as he sits peacefully in the dappled light of the diminishing rainforest."

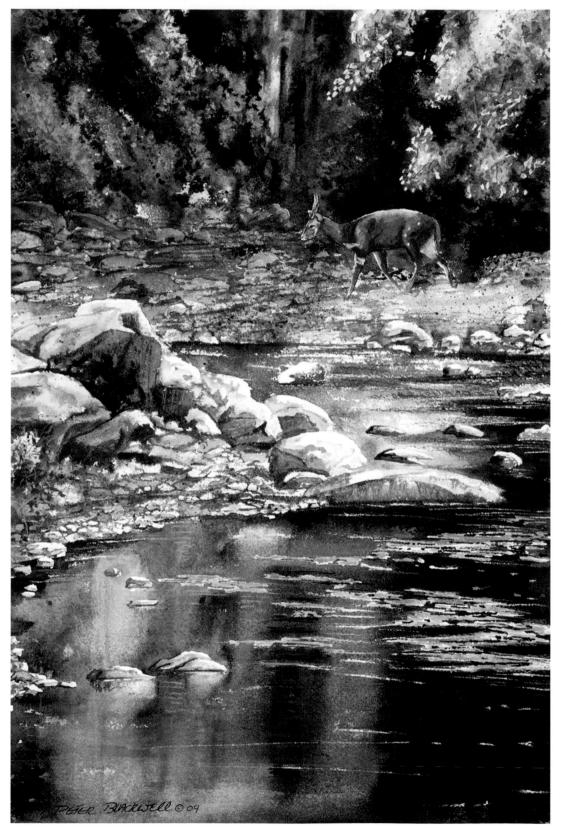

PETER BLACKWELL

Enchanted Corner
Watercolour
22" x 14"

"I have often just sat on a riverbank to soak in the atmosphere and tranquillity of the scene; invariably something wonderful presents itself.

A typical habitat for a bushbuck, this enchanting scene in the Aberdare Mountains of Kenya is the perfect setting for this extremely shy creature.

The Aberdare National Park is 716 square kilometres and has over the last several years been fenced due to the efforts of RhinoArk, a charity-based organisation. By enclosing the Aberdares it is hoped that this important water catchment area will be preserved and the spectacular, delicate, forest ecosystem which is home to bushbuck, bongo, elephant and rhino, to name a few, will be maintained."

SANDRA BLAIR

The Night Watch
Acrylic
8" x 10"

"My wildlife paintings provide an 'up-close and personal' view of each creature's unique beauty, power and grace. My hope is that the awareness of that beauty will remain with my audience, enticing them to slow down and observe their surroundings with fresh eyes. Until we truly see, we cannot fully understand the devastation that is occurring through loss of habitat and vanishing species. Seeing fosters thinking; thinking fosters action. A quote by Vincent van Gogh sums it up nicely:

'It is not the language of painters but the language of nature which one should listen to. The feeling for the things themselves, for reality, is more important than the feeling for pictures.'"

PETA BOYCE

Summer Visitors
Mixed Media
17" x 35"

"There is an area in the Pumicestone Passage in Queensland, Australia where hundreds of migratory waders congregate to rest and feed each summer. Although it is in a National Park, the area is small and heavily populated as it is also a popular waterway for fishermen and recreational boating. This all puts a lot of pressure on these birds. Many are exhausted from the long migration and it is important that they can feed and rest before heading north again. As a painter and conservationist I find the waders a particularly fascinating and quite beautiful group of birds and a joy to paint."

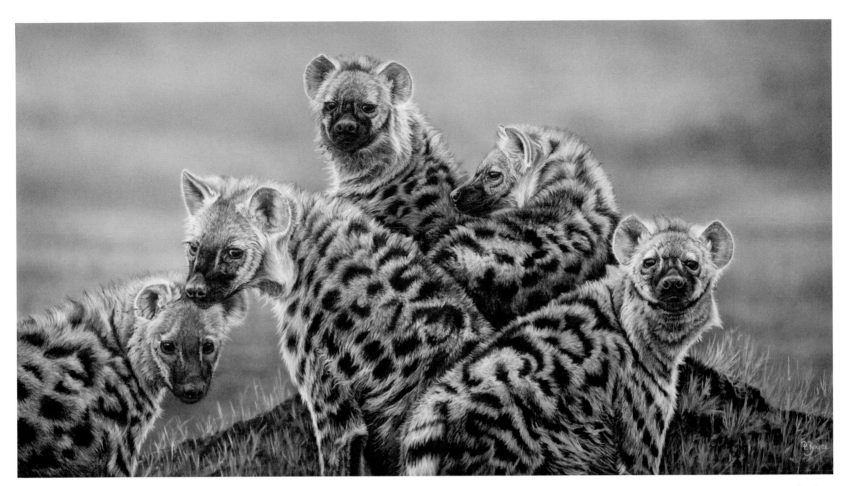

PETA BOYCE

Spotted Mischief
Mixed Media
20" x 36"

"I have a soft spot for hyenas. Much maligned, not always particularly attractive to look at, accused of cowardice and rarely seen to be much more than that, they do, however, have the most amazing and complex social structure and some quite interesting physical attributes too. These teenagers were quite appealing to look at and I have attempted to convey that in the painting. I placed the subjects in a huddle together, looking around shifty-eyed, the teenage gang out for a spot of mischief."

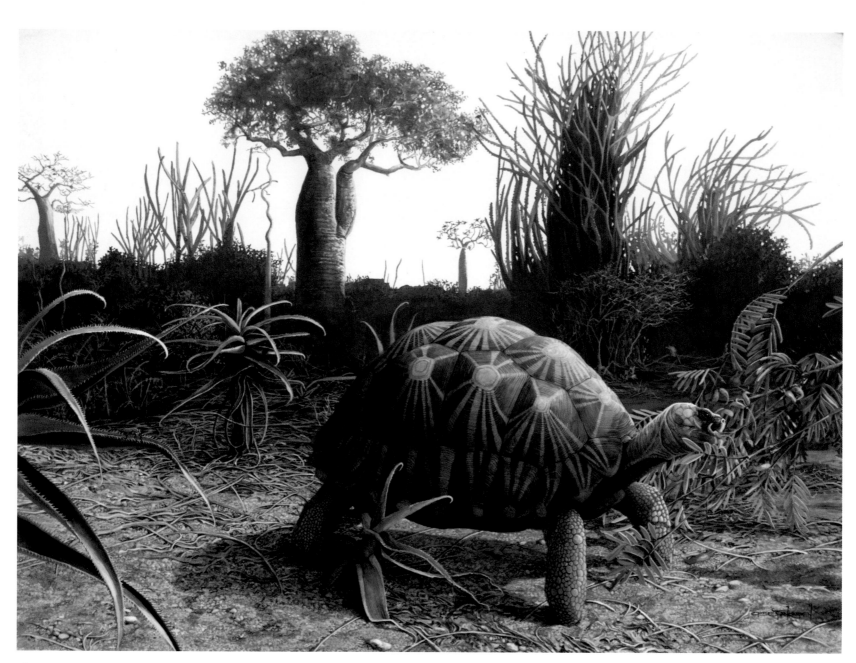

CAREL BREST VAN KEMPEN

Radiated Tortoise
Acrylic on illustration board
18" x 24"

"Once common in the spiny deserts of Madagascar's southwest, the critically endangered Radiated Tortoise (*Astrochelys radiata*) has undergone a dramatic population decrease over the past two decades. Nearly 80% of the species' habitat has been severely degraded and in recent years it has been subjected to substantial illegal harvesting for human consumption. Most population models predict extinction around 2050. The two ethnic groups that historically share A. radiata's range, the Mahafaly and the Antandroy, traditionally shun the turtles, but outsiders in increasing numbers have been collecting them in unprotected areas as well as in reserves. In this painting a Radiated Tortoise browses on *Chadsia grandifolia* flowers in typical spiny desert habitat."

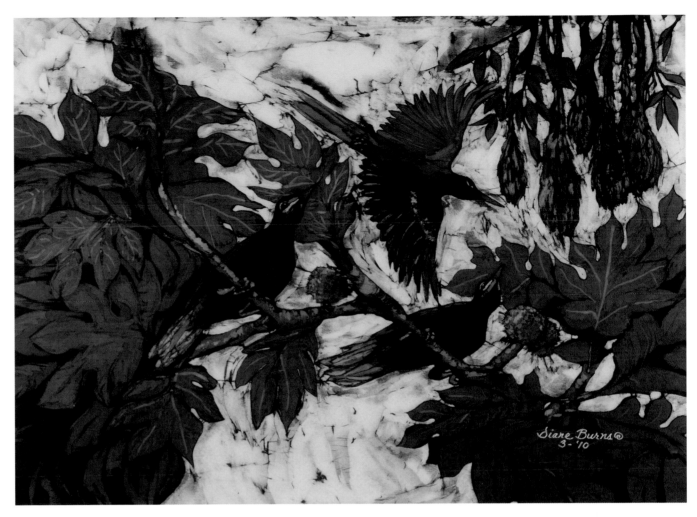

DIANE BURNS

Many a Splendid Nest
Batik on silk
22.5" x 27.5"

"The Montezuma Oropendola is a beautiful bird that weaves its long basket-like nest high in the trees. When they have finished getting it just right they begin to sing a birdsong every bit as beautiful as they are.

When visiting Tikal Park in Guatemala, I heard their song for the first time. I could hardly believe my ears. It is truly stunning."

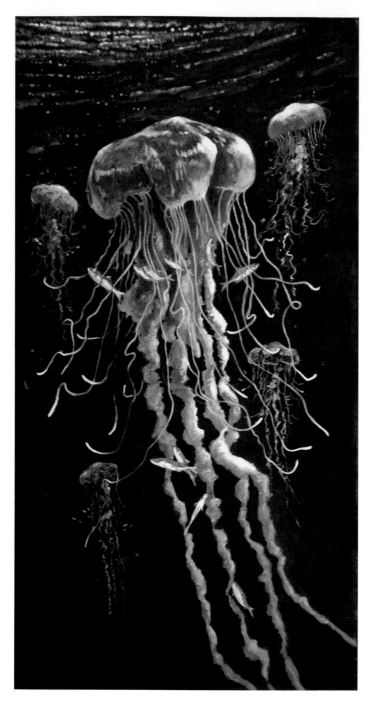

"It was mid-September during a family vacation with the grandchildren at Ocean City, MD, when early one morning we strolled to the beach to find not one but hundreds of jelly fish, all sizes and shapes, washed ashore and drying on the sand. It just amazed us all as we walked along the shore, the kids squealing in disgust but still fascinated by this unusual display.

We could only imagine what a raft of jellies would look like, floating free in the sea. When I got home I started my research and experimentation and with the memory of our family encounter on the beach that day, "Lion's Mane" came to be."

WAYNE CHUNAT

Lion's Mane
Acrylic
24" x 12"

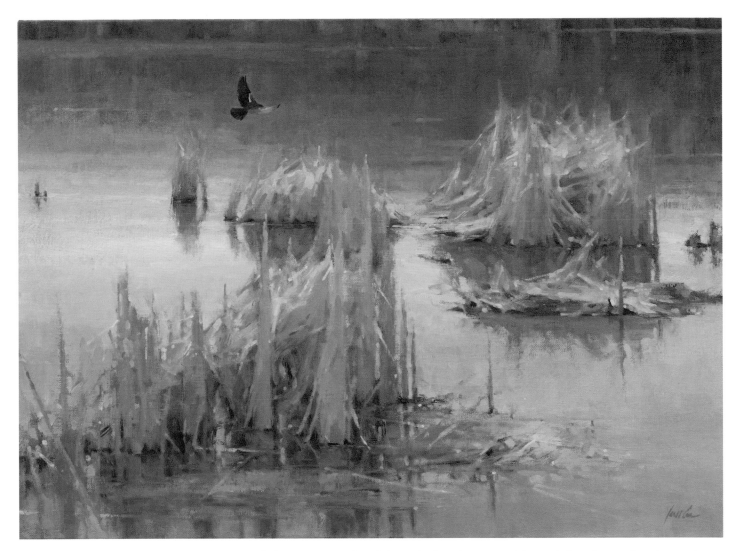

JAMES COE

Reflections of April
Oil on linen
16" x 22"

"The concept for this painting began with a plein-air study of weather-beaten cattails in a nearby marsh, painted on a dingy gray morning early last April. As I worked, a Red-winged Blackbird flew into the scene; I quickly sketched the bird into my painting. The success of that field study inspired me to refine the idea and repaint the scene on a larger canvas, and with the bird flying rather than perched atop the cattails. While this studio version lacks some of the immediacy of the field study, the evolution of the image allowed for a more carefully composed design and quieter, contemplative mood. Currently, I am working on yet another adaptation of this motif, on an even grander scale."

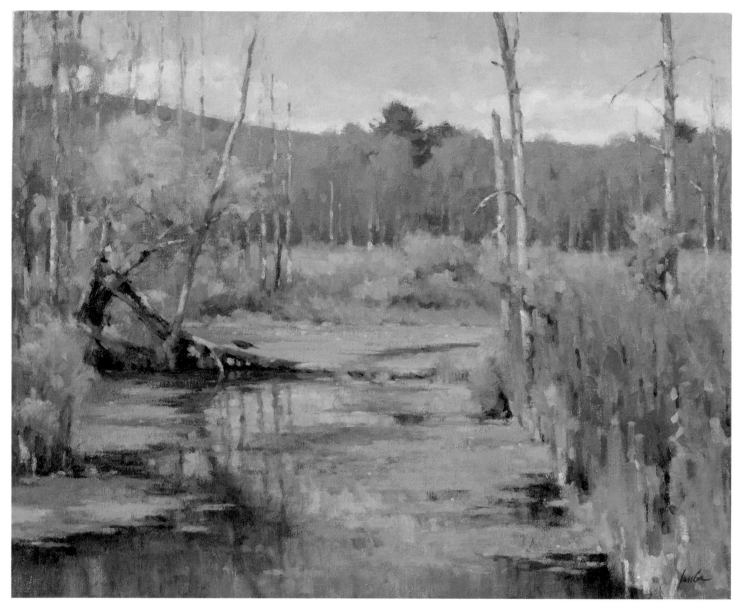

JAMES COE

West Wind, Black Creek
Oil on linen
18" x 22"

"For several years I spent summer mornings at Black Creek Marsh, painting and birdwatching while my children attended a nearby day camp. This extensive wetland, just southwest of Albany, has many nooks and inlets, but my favorite view into the marsh is this channel with the fallen willow. I painted this scene at least once during each of those summers; in fact, you can date the sequence of paintings by the angle of the limb, which gradually settled and eventually fell into the water. This particular canvas was, like the others, started as a plein-air study, but I ultimately resolved and refined the space and lighting back in the studio. The little Green Heron, spotted on nearly every visit to the marsh, perched on that very branch, was an essential component of the scene."

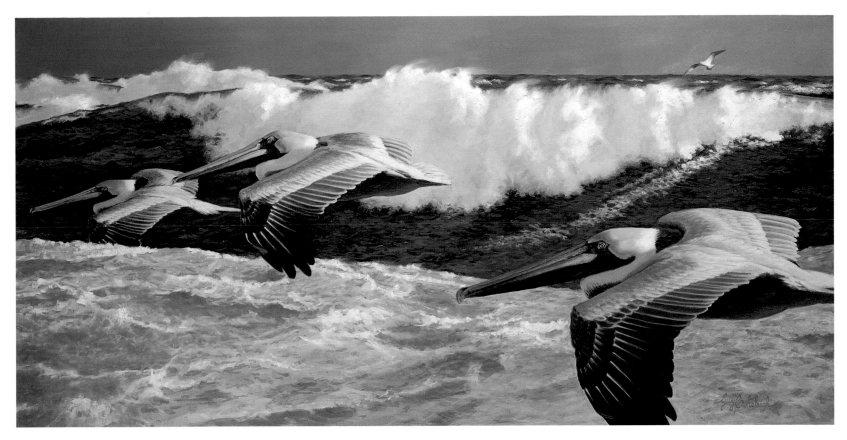

GUY COHELEACH

Seacoast Pelicans
Oil on canvas
36" x 72"

"Pelicans are wonderful creatures to paint. They have a character all their own. It is very pleasant for me when I see them gliding low over the water following the ups and downs of the waves and actually disappearing behind a wave it has just floated over.

I deliberately put one of these birds behind such a wave to enhance the illusion of the third dimension. I also find painting water a great challenge."

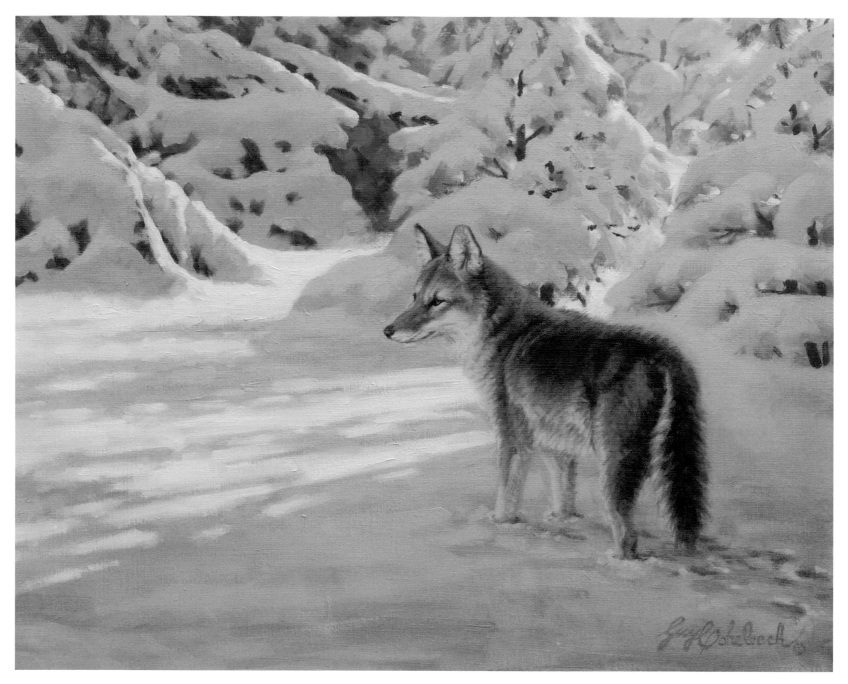

GUY COHELEACH

Dusk Patrol
Oil on canvas
16" x 20"

"Coyotes are becoming quite common in the northeastern United States. We had sixteen in our New Jersey backyard a few years back. They can be deadly to pets left outdoors and as every farmer in North America knows are far worse to all kinds of their livestock.

Here we see a lone coyote patrolling the edge of woodland looking for any feeding opportunity that may appear."

"Of the three giraffe species in Kenya (others are the Reticulated and the Maasai), the Rothschild is distinguishable by its size (the largest), markings and the fact that it is born with five 'ossicorns'. Its habitat is severely depleted and restricted now to Murchison Falls Nat. Park, Uganda, Nakuru National Park, Kenya, and Soysambu Conservancy, Kenya.

It is estimated that there are LESS THAN 700 in existence, and this number could be as low as 500. Compare this to the Polar Bear (approx. 20 - 25,000), the Orangutan (appx. 6500), the Black Rhino (appx. 3500), Cheetah (appx. 1000). The Rothschild Giraffe is not yet classified as an endangered species.

At Soysambu we have a population of 60 that are breeding very successfully.

The African Great White Pelican is widespread throughout the Rift Valley lakes but is only able to breed and produce young on one - Lake Elmenteita (part of Soysambu Conservancy). This is because it is the only lake with islands that are inaccessible to predators when the lake level is normal.

We MUST succeed in our mission to protect Soysambu and educate the community as to the importance of these creatures if they are to survive."

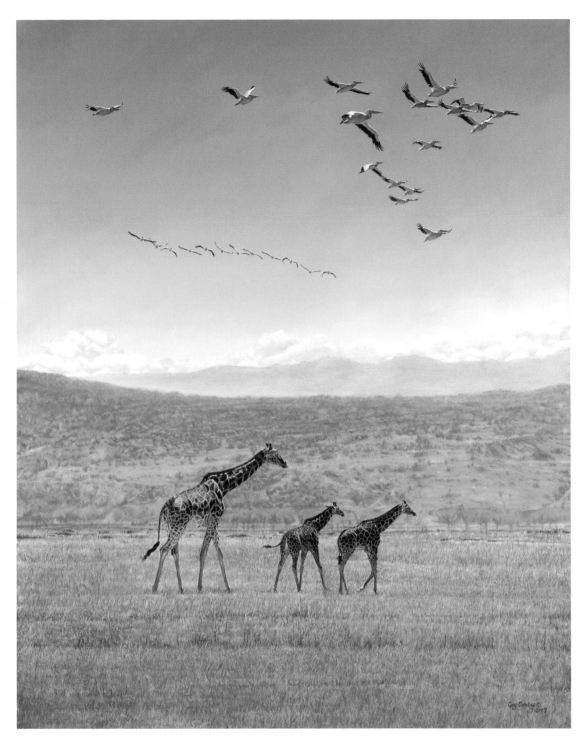

GUY COMBES

High Hopes
Oil on canvas
38" x 30"

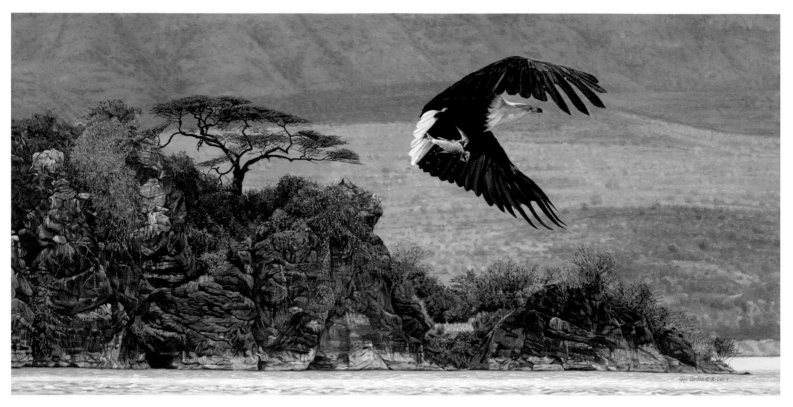

GUY COMBES

The Siren's Isle
Oil on canvas
15" x 30"

"The call of a Fish Eagle is one of the most recognisable sounds of Africa. Whenever you are close to water you will hear its distinctive sound. Lake Baringo is no exception. One of the most unspoilt freshwater lakes in the Great Rift Valley system, Baringo is as distinctive as the others in that its positively-charged ion water keeps silt in suspension at all times. This gives the lake the appearance of milky tea. The abundant bird life in Baringo, with many species unique to the area, makes it one of the top destinations for ornithologists in the world.

The island in the background of this painting is called Lesukut, or Devil's Island. The local Njemps people believe it is occupied by their dead ancestors. This and the staggering beauty of the area make Baringo one of the most mysterious and irresistable places I know."

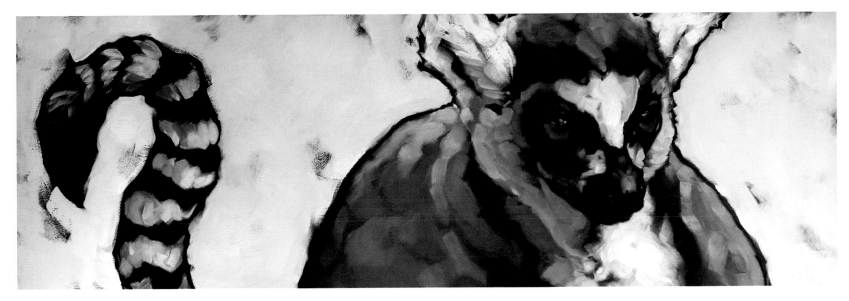

CARRIE COOK

Ring-tailed Lemur - Near Threatened
Oil on board
12″ x 36″

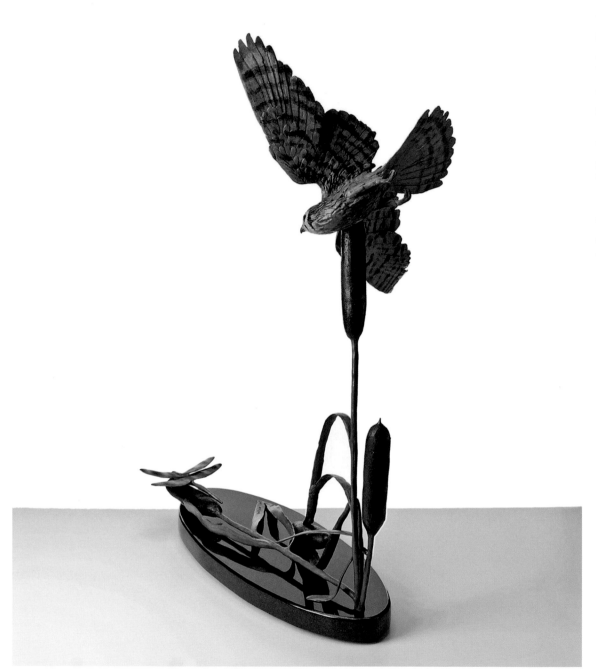

"When I first became involved in working with clay and bronze, I was delighted to find that I could really put a sense of movement in the pieces. This bronze medium allows me to create a real feeling of flow as the subjects become part of a larger story. Birds of prey for me, exemplify the top of the avian food chain. The story of a pursuit is immediately understood by viewers of all ages and does not require any explanation. I prefer to combine realism in the birds with abstract mounts to create the "flow" of the sculpture."

BRENT COOKE

Reed Raider
Bronze on a black granite base
24" x 8" x 22"

ANNI CROUTER

Hang Time
Acrylic
20" x 24"

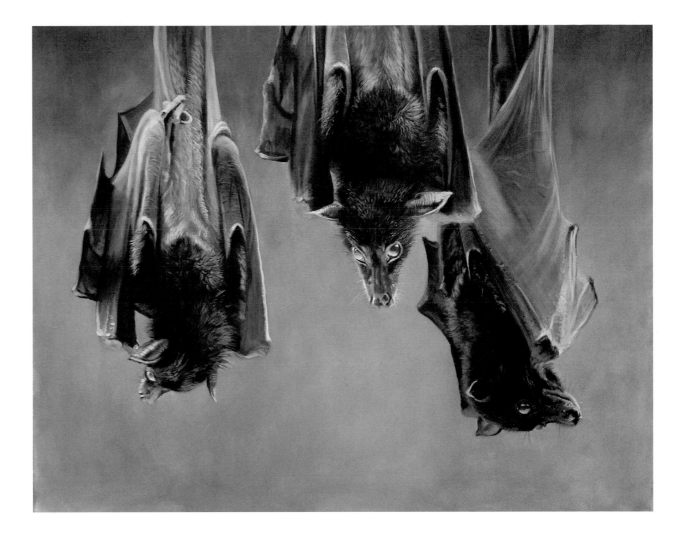

"I've always been interested in bats. Their conservation is crucial for many reasons, one of them being regeneration of the forests in tropical areas."

ANNI CROUTER

Solitaire
Acrylic
36" x 24"

"Hopefully mankind can turn around the environmental effects that are destroying the habitat of this remarkable creature. We cannot underestimate the importance of their survival."

ANDREW DENMAN

Out of the Cradle
Acrylic on board
24" x 48"

This painting was inspired by a trip to Moss Beach, CA, in 2005 where I observed this pod of Harbor Seals basking on an exposed reef while a Western Gull drifts by and Brown Pelicans fly low over the waves in the background. Part of the Fitzgerald Marine Reserve, Moss Beach is a beautiful and environmentally sensitive area known for its tide pools and rich marine life. Though much has been done to protect this three-mile stretch of shore since its official designation as a reserve in 1969, even today it remains in peril from thousands of visitors to the tide pools who can unintentionally disturb the delicate ecosystem. I remember quite vividly visiting Moss Beach as a child on a school field trip and hearing only a few years later that it had to be temporarily closed to recover from damage.

"My art is my own direct interpretation of the natural world. I do not seek to recreate what I see, instead I strive to push the gesture, attitude and pose to create a dynamic work of art all its own."

DAVID DERRICK JR.

Pensive
Bronze
18" x 8" x 15"

KIM DIMENT

Saddlebill Study
Acrylic
24" x 16"

"The African Saddlebill is a tall bird with an amazing combination of colors on its bill. Its name comes from the upper section of the bill which looks like the seat of a saddle.

Female saddlebills are distinguished from the male in that they have a bright yellow eye. The male on the other hand, has a dark brown eye. This stunning male was observed close to the Okavango Delta in Botswana.

Most of the cranes in Africa are of an endangered status. This is a pity for these beautiful birds, but more so for us. What will be lost to the eyes will also be lost to the ears. Cranes have haunting calls that are part of the amazing symphony of African animal sounds. I find it ironic that cranes in general are a symbol of long life and good luck in the Orient. If only this could apply to their future existence."

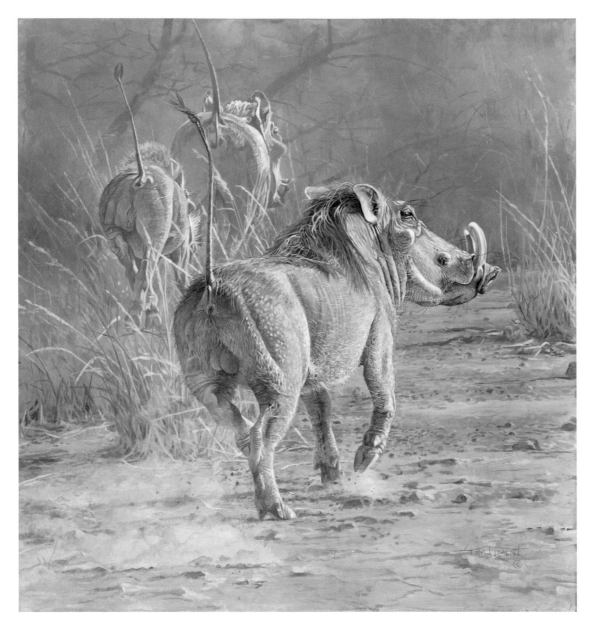

"Warthogs have inhabited almost every park I have visited in Africa. They all pick up their own individual look based on the terrain and their habitat. Some have much more bushy hair, while some appear almost hairless. Some are gray while others are red or brown. These colors are the result of the warthog's habitat. Warthogs are a mirror of their surroundings! If the soil is purple you can bet the area's warthogs will be purple too! Warthogs are a tasty meal for many predators so they must always be wary. They dig an elaborate burrow which they will back into so that any predator looking for a pork meal will first have to deal with a face full of tusk. This burrow if dug by a mother warthog will have a baby chamber. This chamber is curved upward off the main entrance so incoming rainwater will not drown the young.

Warthogs' tusks are not actually tusks. They are elongated incisors, the female's being thinner and much more curved than the male's. The male in general is a little more porky than the female and has an extra set of facial warts."

KIM DIMENT

High Tailing It
Acrylic
36" x 34"

KELLY DODGE

Where's Waldo?

Pastel on museum paper
19" x 29"

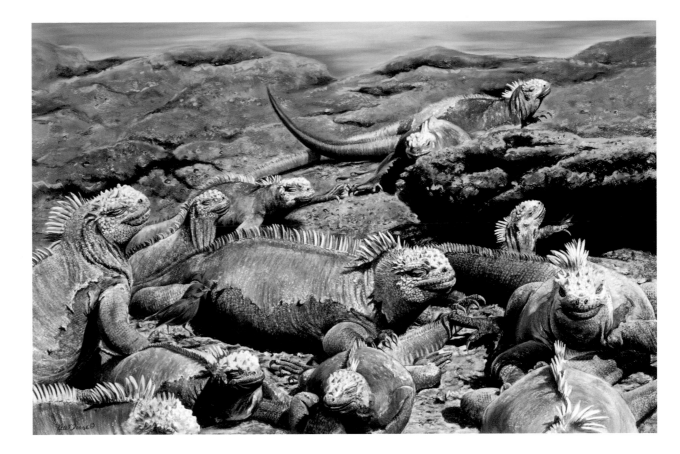

"Galapagos Marine Iguanas are the only sea-going lizard in the world. They feed almost entirely on algae, larger stronger males by diving once a day and smaller females and juveniles by feeding on exposed reefs close to shore. They are cold-blooded and must warm by basking in the sun on the black lava rocks, both before and after feeding trips. A pleasant pastime was observing the many dainty finches such as this one hopping about taking ticks and mites from the skin of the gruff Marine Iguanas. Of the 7 Marine Iguana populations, 6 are categorized as Vulnerable under the IUCN red list. One subspecies on San Cristobal and Santiago is classified as Endangered due to an oil spill in 2000 that caused extensive habitat contamination. All Galapagos Marine Iguana populations are susceptible to ongoing predation by introduced feral cats and dogs."

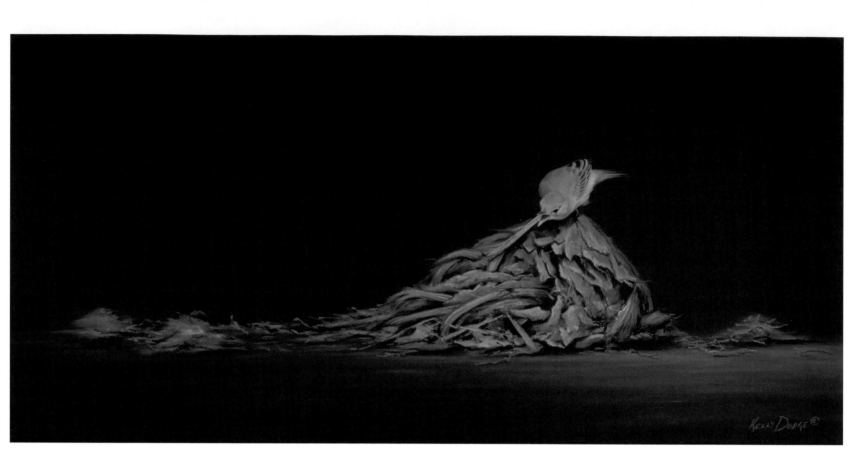

KELLY DODGE

Particularly Poignant
Pastel on museum paper
11.75" x 22.5"

"What's more poignant than pooh? The endemic giant tortoises of Galapagos are the only natural, land-based herbivores that move throughout the islands. By leaving their pooh behind they transport a great amount of semi-digested biomass from the highlands to the lowlands. They open gaps in the forests and the seeds from their intestinal tracts germinate at a faster rate than other seeds. Their pooh attracts insects which become a food source for warblers, finches, mockingbirds and lava lizards. It then decomposes quickly, generating soil and allowing plants to grow. As the designers and engineers of the ecosystem they keep the ecological connection between plants and animals linked thus making them the keystone species of Galapagos. Without giant tortoises biodiversity on any island where they are absent will suffer. The ultimate recyclers, other species rely on them because they support the ecosystem by leaving their poignant pooh behind!"

MICHAEL DUMAS

The Yearling
Oil
8.25" x 6.25"

"The tracks of this young moose wound their way across the gray muddy bottom of a dried-up beaver pond in Algonquin Park. Such dry conditions make an impact on the degree of fire hazard, and affect many species in their requirements for food and shelter. Visually though, the cool colour of the exposed earth made for a wonderful complement to the rich, warm tones of the moose. I suspect that the contrast of feelings these things generated in me could not help but find their way into the mood of the painting."

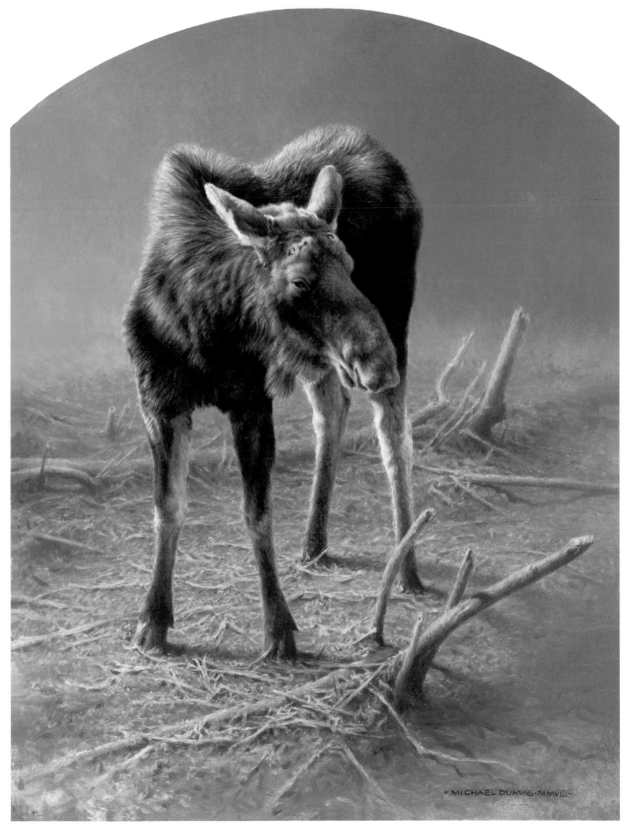

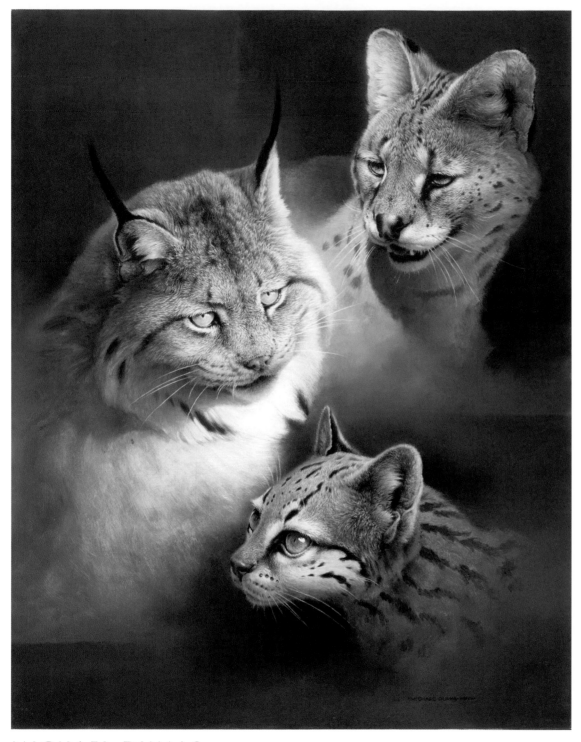

"Genetic Drift is a visual exploration of the evolutionary processess which, over time, produce variation within a population of animals, eventually resulting in sub-species, and entirely separate species. The painted glimpse of this principle presents three species that all clearly belong to the cat family, but with the readily apparent variations that indicate their independent evolvement."

MICHAEL DUMAS

Genetic Drift
Oil
18.5" x 14.5"

"The Grizzly Bear (*Ursus arctos horribilus*) has historically roamed over most of western North America as far south as Mexico. Today there are only 55,000 left - half of which reside in Canada. Factors influencing the decline of this species include habitat loss, habitat fragmentation, hunting, overfishing of salmon, and climate change.

The Grizzly Bear is considered a 'keystone' species – meaning that they have a major influence on the entire ecosystem they inhabit. Grizzlies contribute to nutrient cycling of the soil through foraging, help disperse seeds over large areas, and transfer oceanic nutrients to the forest.

'Out of the Shadows' represents the need to bring awareness to large predator conservation in Canada. As one of the few countries left in the world to have these animals in our midst, we have a great responsibility in guiding the decisions regarding the future of our keystone species."

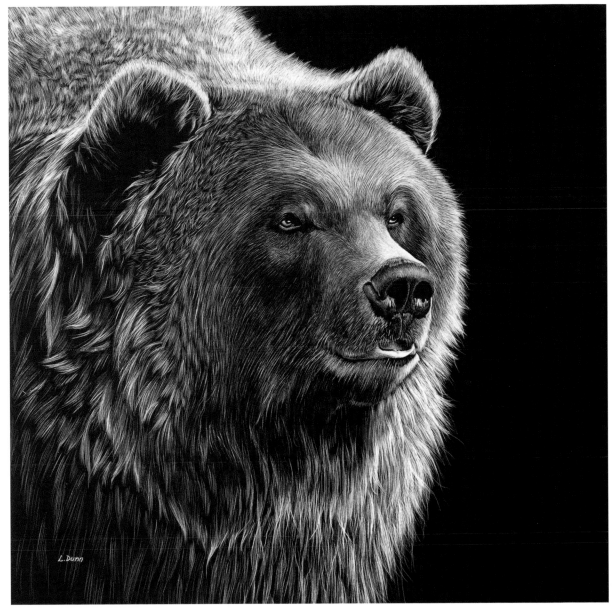

LORI DUNN

Out of the Shadows
Scratchboard
12" x 12"

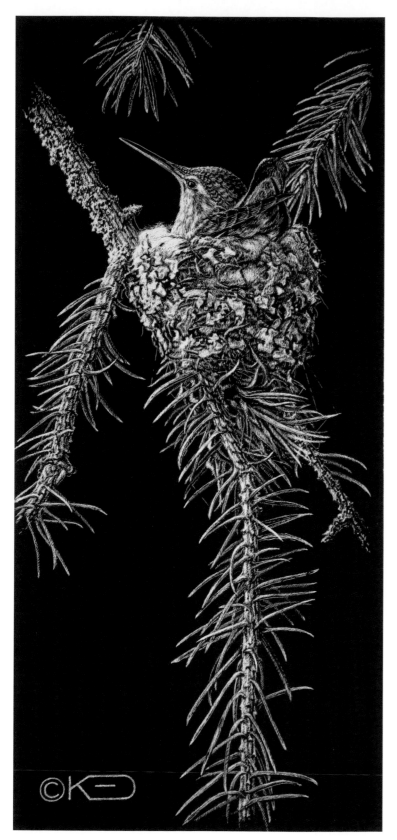

"This female Anna's Hummingbird built her lovely spiderweb and lichen nest right off our deck. She politely endured my picture taking as I watched her raise her two youngsters from eggs to fledglings. It was a gift I will always treasure."

KATHLEEN DUNN

Day 14
Scratchboard
9.5" x 4.25"

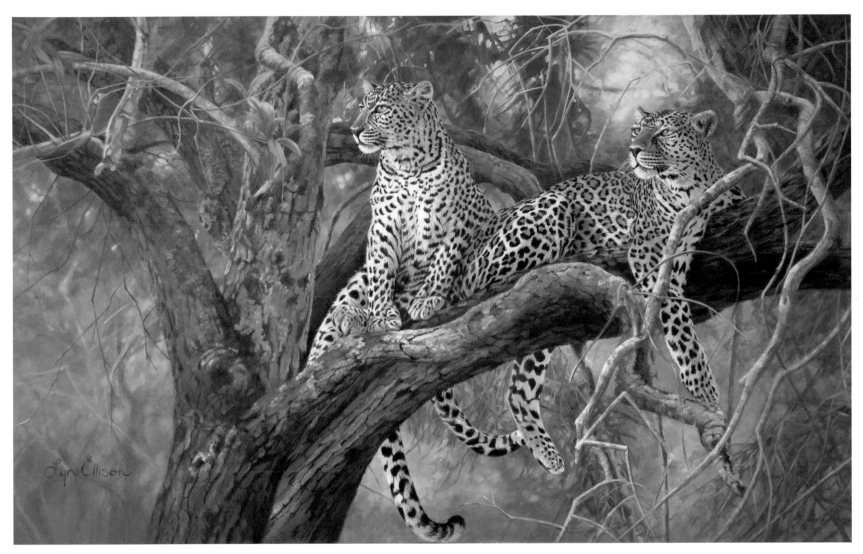

LYN ELLISON

Out of Reach
Oil
22" x 35"

"These two cubs were living a charmed life, though their mother may have had something to do with their lucky survival! With their home within the range of a very large lion pride it seemed amazing that they had managed to survive to reach near maturity. We had watched them play together with their mother on the grass below their favourite trees without a care in the world, seen them chased up the same trees by some very aggressive lionesses and followed their race for safety as they lost their kill to the hungry pride. Their mother must have taught them well as last I heard the two cubs were still alive and surviving well having gone their separate ways, relying on the skills learnt as growing cubs."

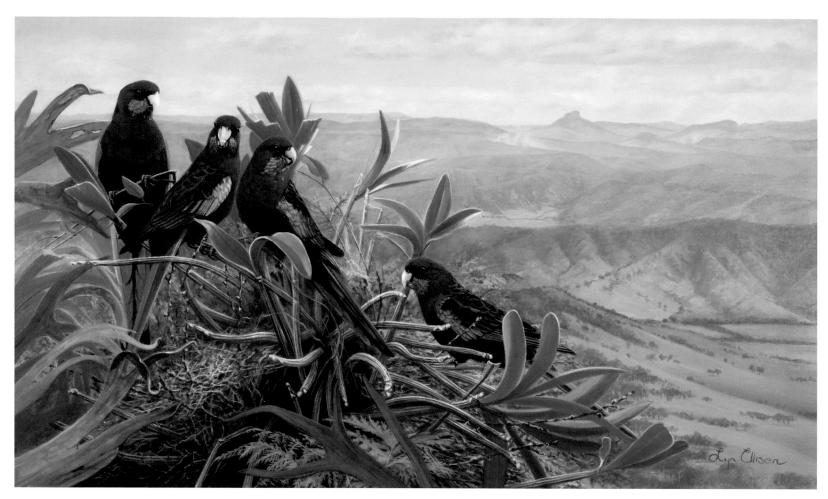

LYN ELLISON

A Perch with a View
Oil
20" x 34"

"Crimson Rosellas are such splashes of colour! To see them cut a path through the tall trees in the mountain forest just takes your breath away! Their flight is a series of flaps interspersed with swooping glides and their bell-like call is often the first thing that alerts you to their presence. They forage adeptly on the ground and in the foliage of trees and bushes looking for fruits and seeds and even eucalyptus blossom for nectar. Adults often gather in small groups of 5 or 6, while immatures are often found in groups as large as 30."

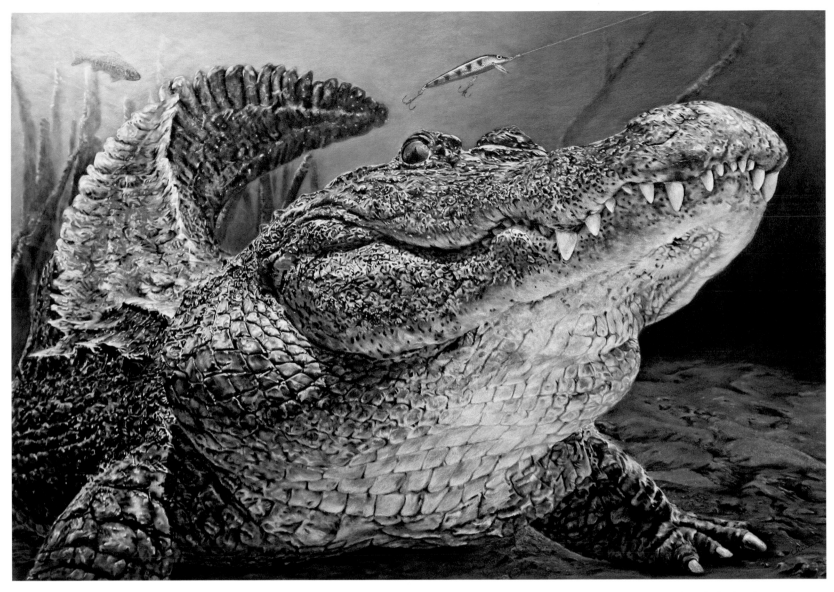

LESLIE EVANS

Breaking Up The Monotony
Colored Pencil
18" x 26"

"I photographed this big fella through a glass wall while he lay submerged at the bottom of a concrete pool exhibit. My subject wasn't doing much - big surprise - but the water was crystal clear and the sunlight was doing wonderful things with his skin texture. Rendering him in colored pencil was a piece of cake. The naturalistic background elements and a special added feature floating over his snout required a bit more inspiration."

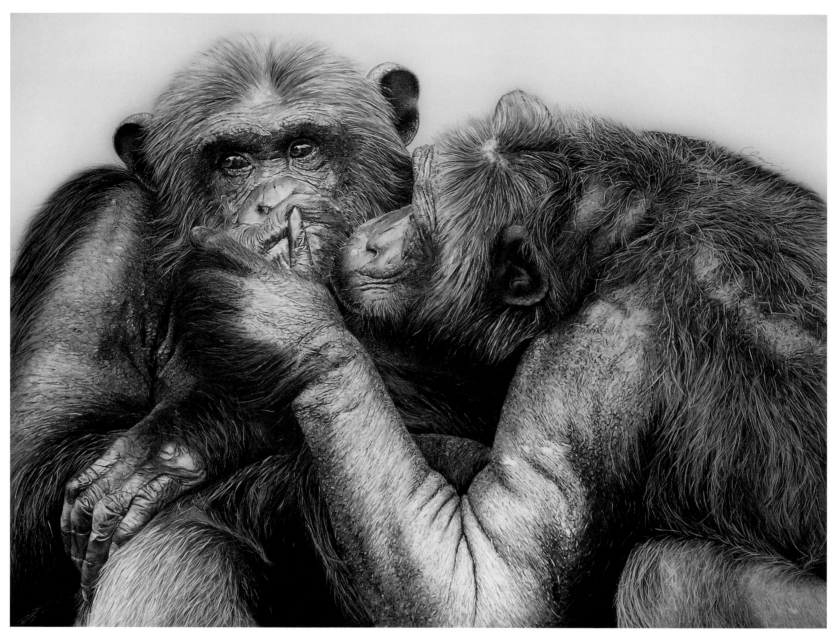

LESLIE EVANS

Hold Still
Colored Pencil
21.5" x 30"

"For the socially conscious chimpanzee, a visit to the local groomer goes way beyond the mere removal of bothersome parasites or unsightly skin blemishes. There's serious bonding to be had, or at least that's what the experts tell us. To me, however, that poor ape on the receiving end just looks bored silly..."

LINDA FELTNER

Elegant Pair
Transparent watercolor
15" x 16.5"

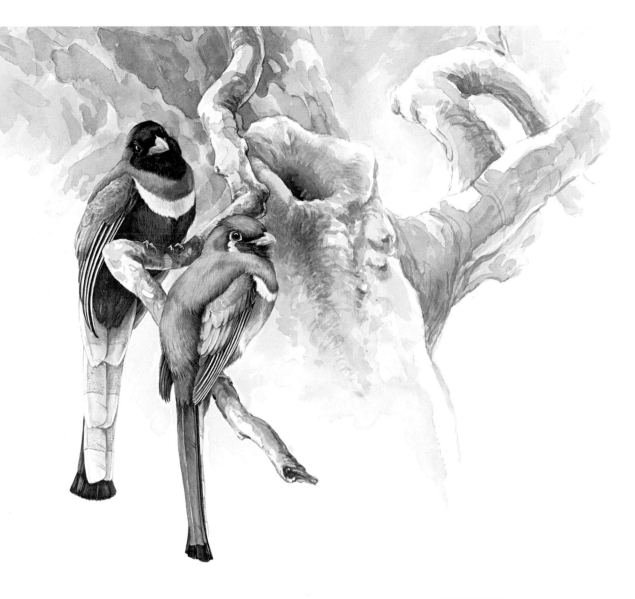

"Trogons are found around the world, most in forested areas that are diminishing. Since moving to southeast Arizona, I've begun a series about the plants and animals that live here in the Huachuca Mountains. In spring, Elegant Trogons (*Trogon elegans*) are found in the canyons along with Arizona Sycamores (*Plantanus wrightii*). In portraying the pair, I chose to place them in a tree that is both strikingly beautiful and frequently used for nest holes. Trogons calmly settle on a branch and slowly rotate their heads to look for berries. The subtle coloration of the female, as well as the rich plumage of the male, are perfect for watercolor. The sycamore's pale blended colors and smooth texture, along with the sculptural shapes of its limbs make this one of my favorite trees to paint. To show the relationship of the birds and tree, I located the pair near a nest hole and added a sinuous limb that depicts the properties of growth that produce such unusual nesting cavities."

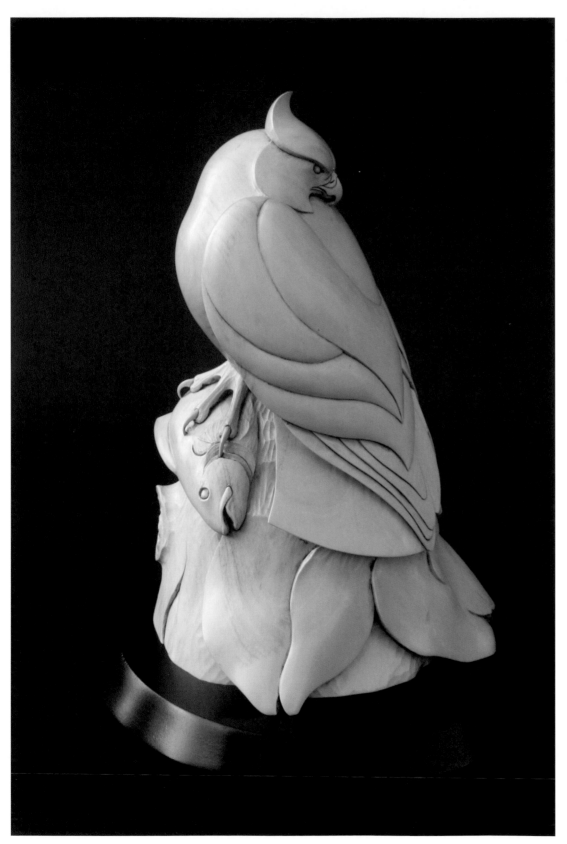

"Holly is one of my favorite woods. Its whiteness plays well with shapes and light. When finished its appearance is that of ivory or bone."

MARTIN GATES

Fish Hawk
Wood (Holly)
12" x 8" x 8"

"Symbolic reminder of the cycle of ruined civilizations."

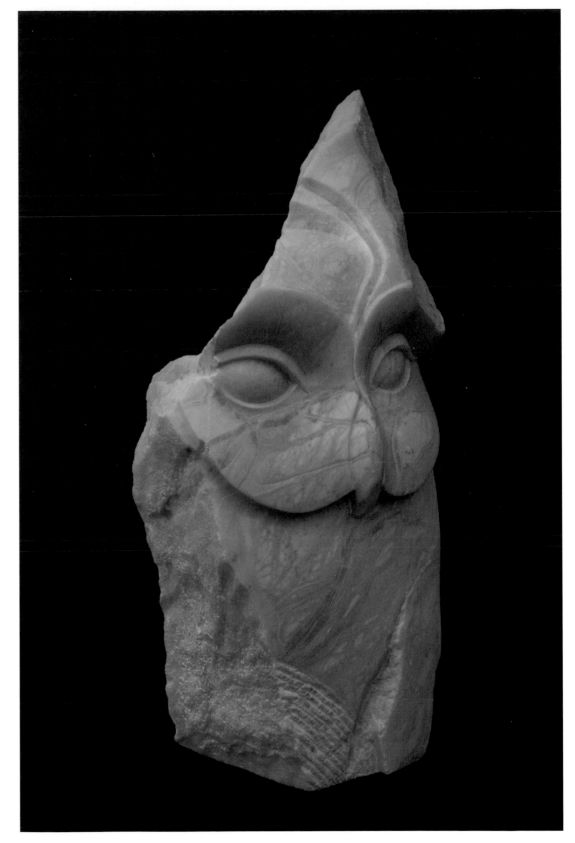

MARTIN GATES

Totemic Owl
Alabaster
26″ x 12″ x 6″

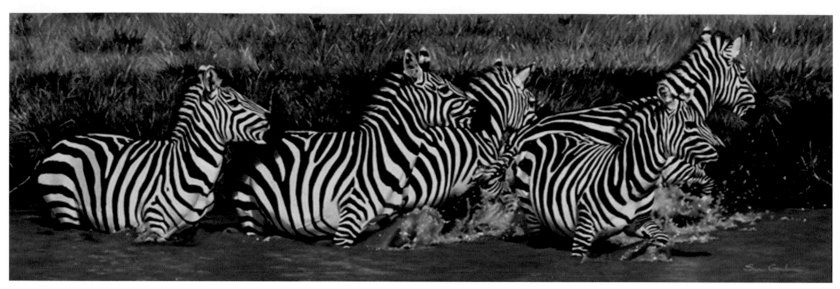

SUE GOMBUS

Splash
Pastel
13" x 39"

"'In the end we will conserve only what we love; we will love only what we understand; and we will understand only what we are taught.' (Baba Dioum, 1968)

My hope for my art and conservation work is to promote a global understanding of the wildlife and wild places that I love, so that in the end, future generations will love, understand, and care for the incredible diversity of wildlife that our planet has to offer."

SUE GOMBUS

Being Cheetah
Pastel
18" x 24"

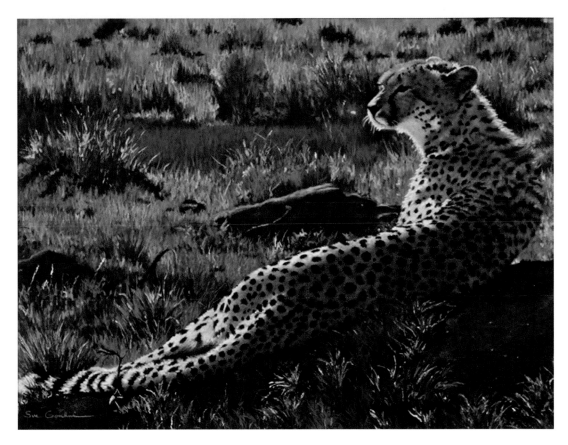

"My hope for my art and conservation work is to promote a global understanding of the wildlife and wildplaces that I love, so that in the end, future generations will work to understand and care for the immense diversity of life in our natural world."

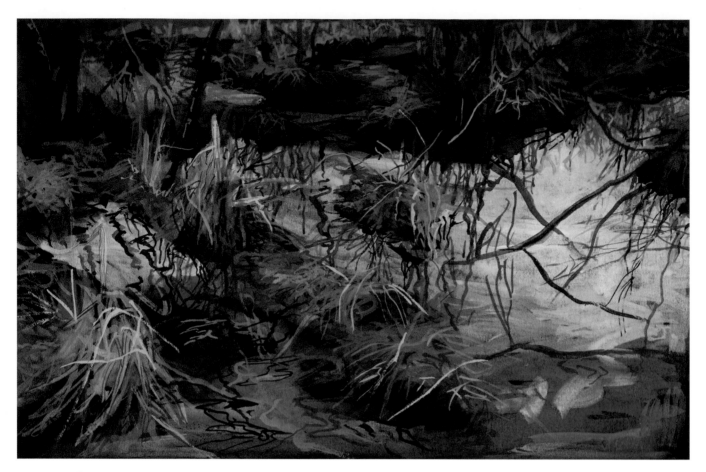

BRIDGET GRADY

December Whites Woods
Gouache on paper
6" x 8"

"This work is part of my continuing visual study of the place I call home."

GEMMA GYLLING

Reflections
Colored Pencil
24" x 10"

"I was so excited when I was able to capture the photograph of this magnificent animal. I photographed him while I was visiting Kalispell, Montana. I couldn't believe it when he started working his way down the log and into the water. It was so exciting! As soon as I saw what I was able to capture I knew I just had to paint him. This piece was done on suede mat board using Prismacolor and Derwent Colorsoft pencils."

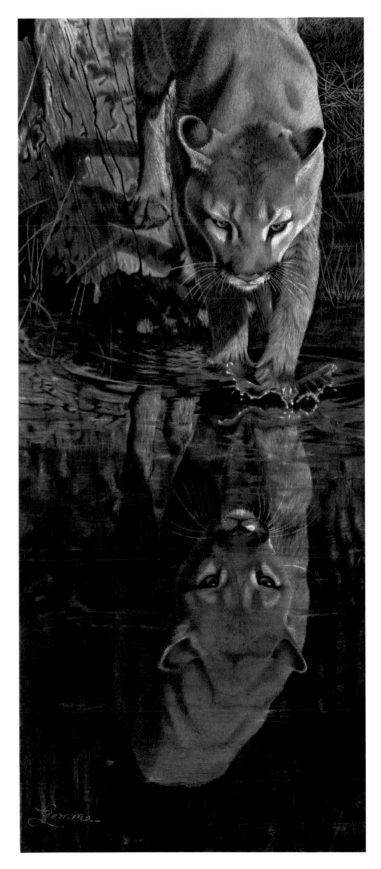

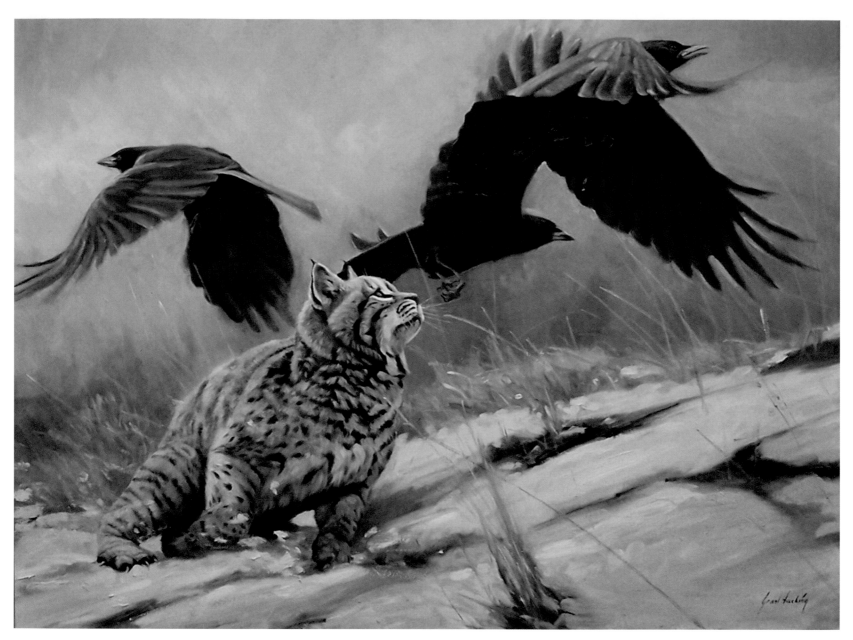

GRANT HACKING

Thrill Seeker
Oil on canvas
30" x 40"

"This is an important piece for me and it represents a huge change in my art career. Prior to 2006/2007 I had been painting predominantly African wildlife reflecting my place of birth. However, I felt I had now lived in the USA long enough to make a serious effort at painting the wildlife and scenery of my adopted home. During the year of 2006 (with the help of a life coach) I had also taken some serious steps to streamline my career.

In my painting 'Thrill Seeker', the Crows represent three major hurdles I needed to overcome in order to accomplish my goals. The Bobcat emerging strong and energetic is symbolic of the result."

"The composition of this painting is very simple with very little color and no background to complicate the painting. This allowed me to play with many different techniques in a single canvas. In the light areas I used a variety of brushstrokes from soft blending to thick, chunky bristle strokes. In the dark area I used very thin paint which I scraped and scratched for effect."

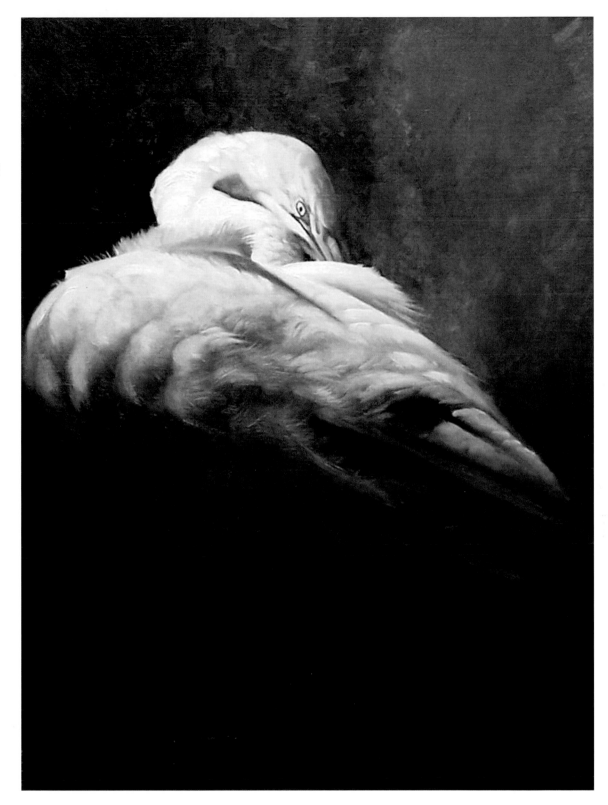

GRANT HACKING

Preening
Oil on linen
24" x 18"

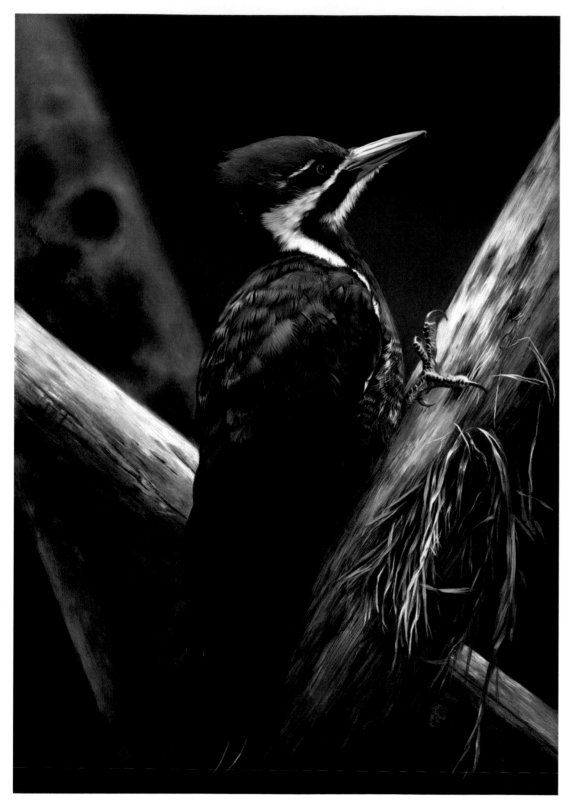

"I wanted to paint this female because she is more subtle than the male. I liked the soft lighting and the way the red stood out against the darker, complementary colour of the greenish background."

JULIA HARGREAVES
Lady in Red
Acrylic
20" x 14"

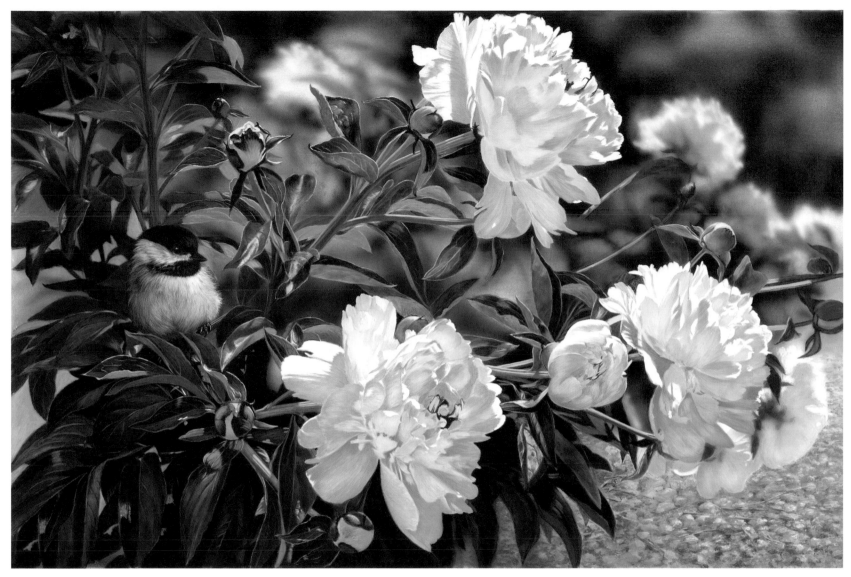

JULIA HARGREAVES

Peonies & Chickadee
Acrylic
16" x 24"

"These peonies grow in my yard. It was a challenge to capture the colours in the white petals. Peonies are sometimes heavily infested with ants which are attracted by the sugars given off by the flower buds and may be the reason why the chickadee is attracted to the plant."

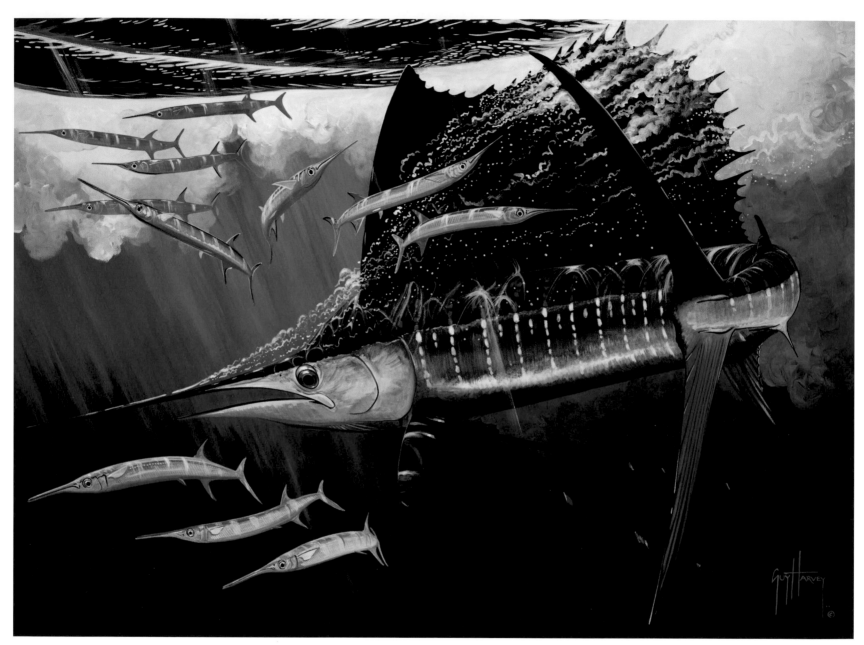

GUY HARVEY

Hound Dog
Acrylic on canvas
30" x 40"

"I spent some time off Isla Mujeres, Mexico, diving in groups of sailfish that were feeding on sardines, ballyhoo, and needlefish. One sailfish came right up to me while chasing needlefish that were trying to shelter near me. It spun around, sail flared, splashing at the fleeing baitfish, before disappearing into the blue."

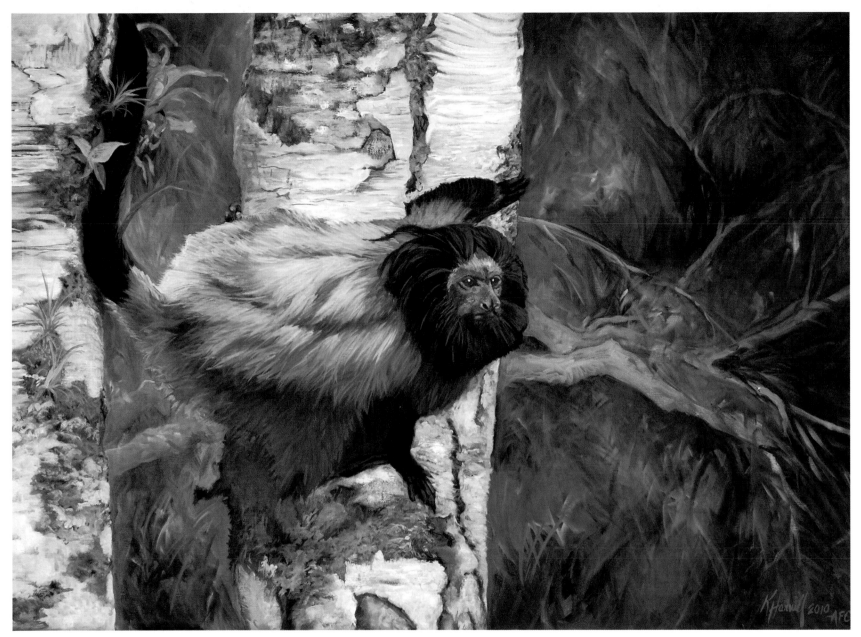

KITTY HARVILL

Mico Leão-de-cara-preta
Oil
20″ x 28″

"There are four species of lion tamarin existing today and all are critically endangered. This Black-faced Lion Tamarin is one of an estimated 300 remaining in the world. The National Park of Superagüi in the Guaraqueçaba Bay of Brazil is home to approximately 200 of the 300. I spent two days searching for this beautiful little animal before I was rewarded with the appearance of a family of seven. What personalities are contained within a creature smaller than a typical North American squirrel. It was a rare treat to be able to observe and photograph this family and a joy to paint."

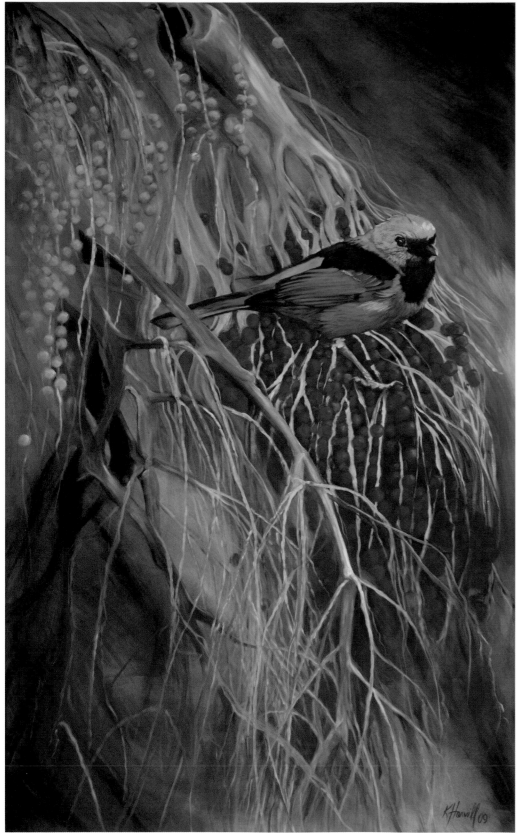

"The beautiful tanagers, especially the Green-headed Tanager, of Brazil's Atlantic Forest are a delight to observe and to paint. They are abundant there; unfortunately their habitat isn't. It is estimated that only 7% of the Atlantic Forest is remaining. I chose to paint this small bird on such a large scale to draw attention to him and the fragile ecosystem in which he lives."

KITTY HARVILL

Saíra-de-sete-cores sobre Frutas da Palmeira
Oil
5' x 3'

"*Falco subbeuteo* has been portrayed in ancient Egyptian art as the sky god, Horus, both in hieroglyphs and in bronze sculpture. It migrates to Europe from central Africa and was to the Egyptians the bird that represented Royal status and gave many powers. There are examples of embalmed falcons inside bronze effigies. I can only describe this most exquisite of falcons as the most mercurial of all birds."

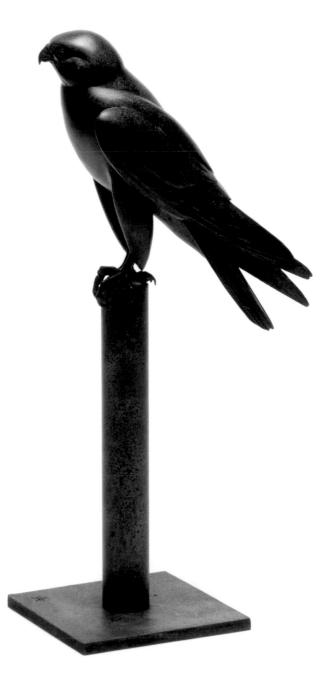

MARTIN HAYWARD-HARRIS

Horus - Lord of the Skies [Falco subbeuteo]
Limited Edition Bronze
177" x 110" x 55"

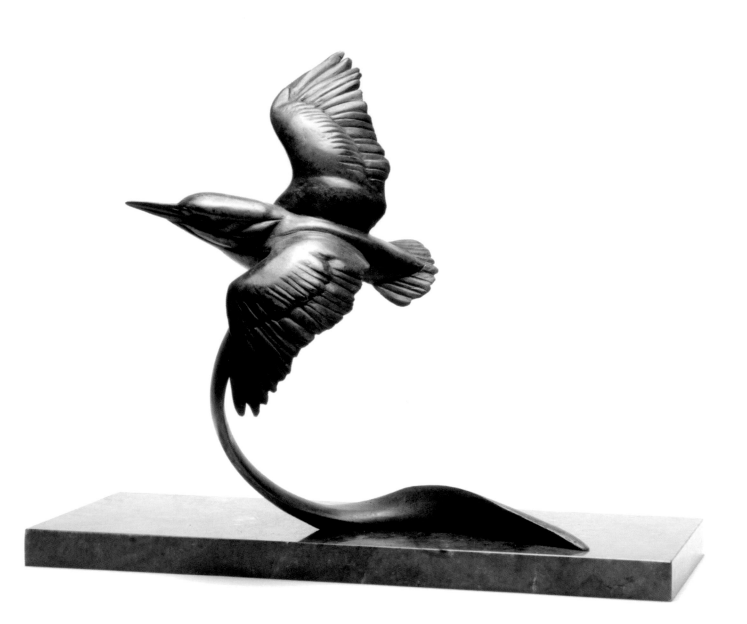

MARTIN HAYWARD-HARRIS

Flying Kingfisher
Bronze and Verde K Marble
110" x 138" x 55"

"It was from conception to sculpt the kingfisher in full flight, using natural patina both in the bronze and the marble to draw colour from natural sources, the bird skimming the water surface with the least suggestion of support and its reed base echoing the curve in the wings."

JANET HEATON

The Arrival
Acrylic on canvas
28" x 20"

"In Florida, we are always on the lookout for the new crop of baby Sandhill Cranes. Some years bring us happiness and other years we keep looking and hoping. The parents of the youngsters are as proud as we are to have them here."

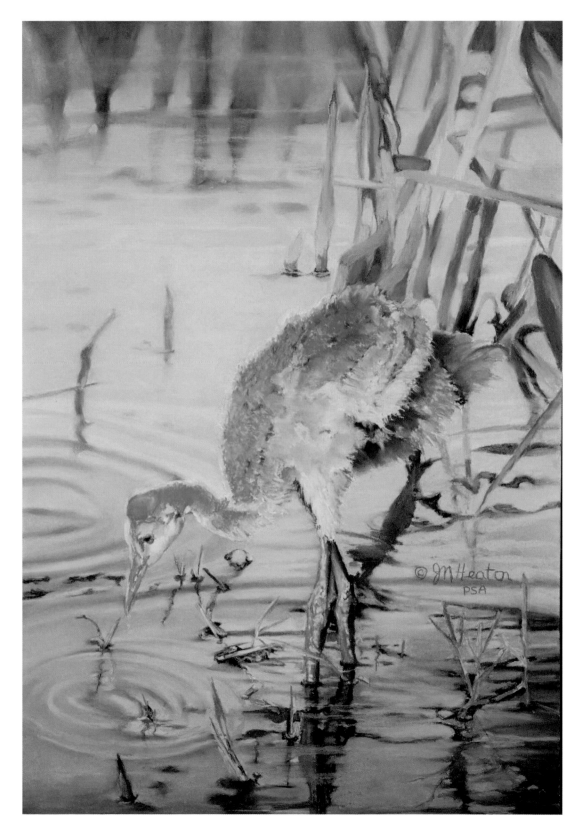

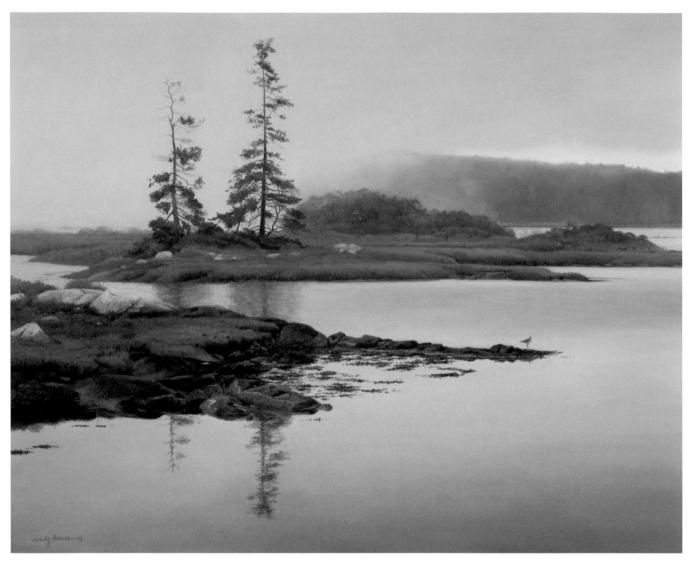

CINDY HOUSE

Fog Rolling In
Pastel
17" x 21"

"During fall migration, this Greater Yellowlegs was seen feeding and roosting in a salt marsh conserved by the Vinalhaven Land Trust in Vinalhaven, Maine. Land trusts such as this one, although small, can have an enormous impact on the preservation of local, yet globally important, habitats."

MIKE HUGHES

In the Shade of an Olive
Pencil
22" x 12"

"A pencil study of two Hoopoe in the shade of an ancient olive tree in Andalucia, Spain."

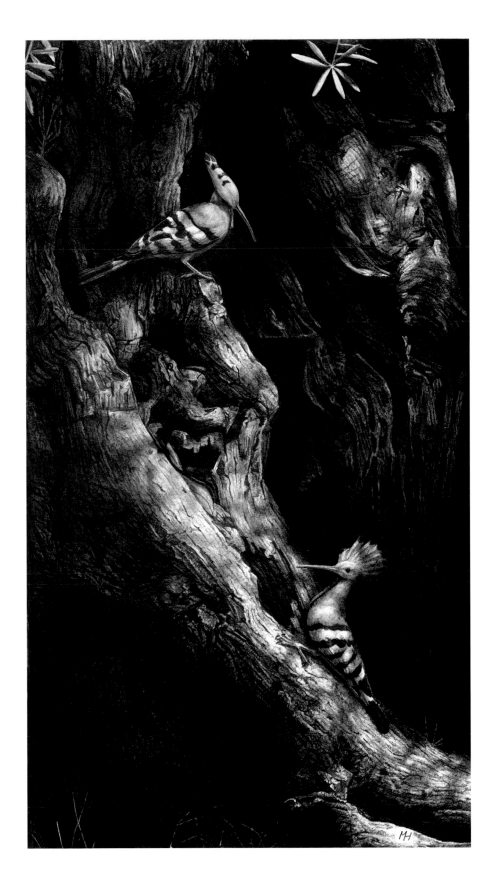

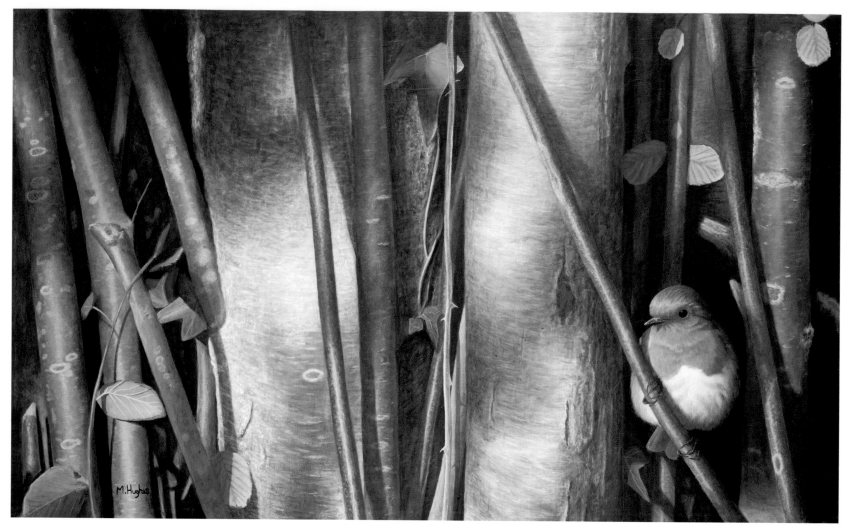

MIKE HUGHES

European Robin in Hazel
Acrylic
34" x 42"

"An acrylic painting of a European Robin perched in a hazel bush. It is an autumn afternoon and the sun is low in the sky, bathing the bird in light."

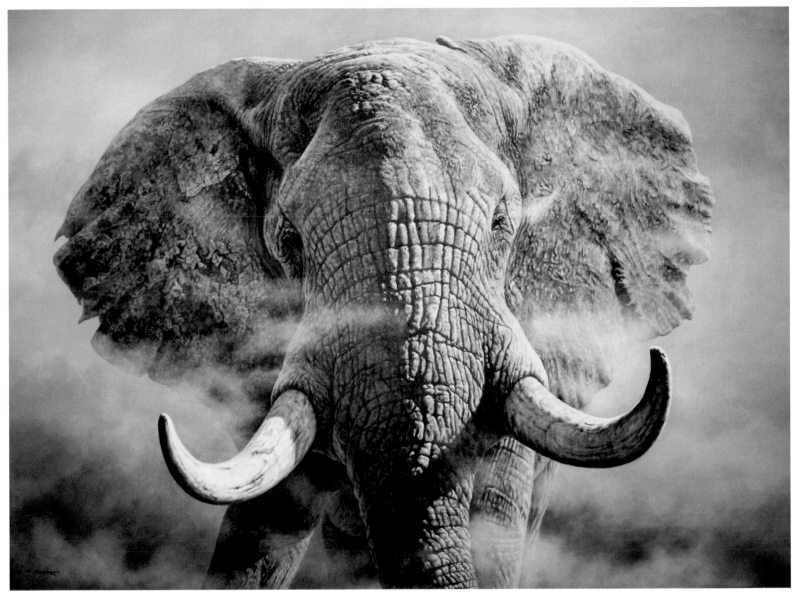

ALAN M. HUNT

Back Off - The Bull
Acrylic on masonite
34" x 42"

"Alan M. Hunt was born in England, studying zoology at Leeds College and Bristol University. His artist training came from Middlesborough Art College. This background of scientific and artistic skills causes Alan to call himself the zoologist who paints wildlife."

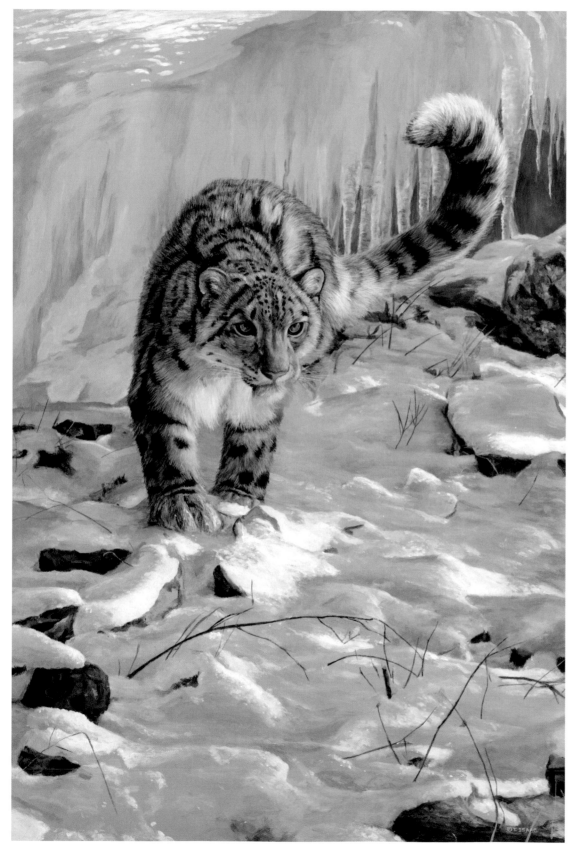

"Snow Leopards are both beautiful and endangered. Designed for mountainous terrain, these cats maneuver with ease and agility. They have an extra long tail which helps with balance when jumping from rock to rock and large paws for grip on the snow-covered surface. Like all cats the Snow Leopard is a predator. This one is on pursuit in its icy domain.

I enjoy painting anything from humming birds to whales but I get great satisfaction when painting an endangered animal. I feel blessed to have been able to see an animal that may become extinct and honoured to be able to capture it in paint."

TERRY ISAAC

Icy Intent
Acrylic on masonite
36" x 24"

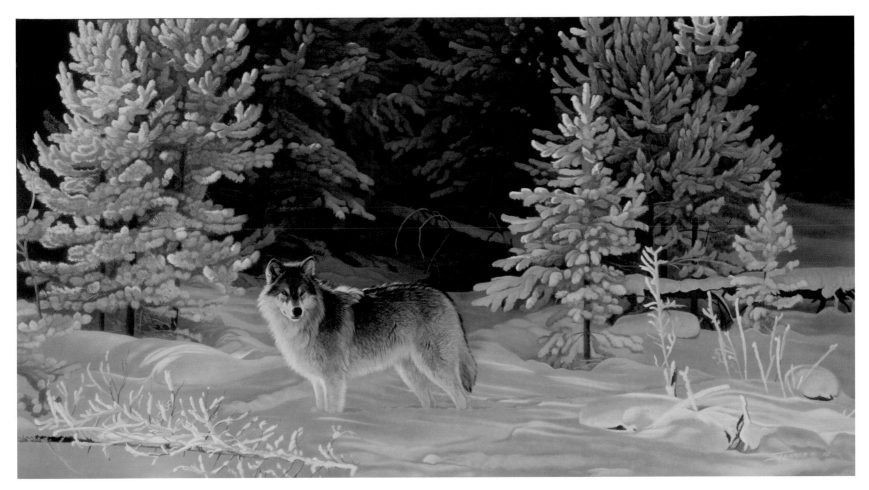

CLINT JAMMER

Montana Morning
Acrylic on masonite
17.5" x 31.5"

"I captured this scene on an early morning excursion along the Yellowstone River. The dramatic contrast, the beautiful shadows, and the fact that it was close to 40 degrees below zero, instantly inspired me to paint the scene. There is something almost magical about a Lodgepole Pine covered in morning frost and fresh snow. They have to be the most perfect tree to paint, bursting with flawless character."

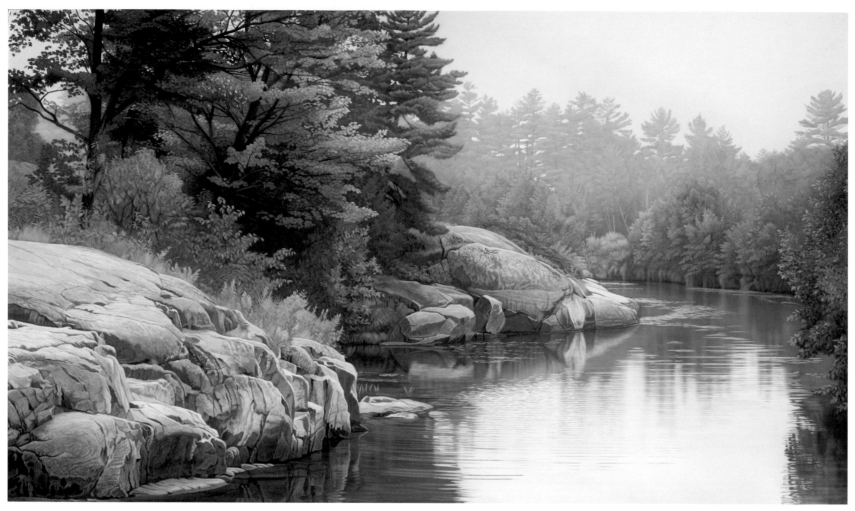

CLINT JAMMER

The River's Edge
Acrylic on masonite
28.25" x 48"

"I was drawn to this setting in Northern Ontario's Killarney Provincial Park because it displayed so many interesting elements — the two pink granite outcrops, the contrast of the large maple against the white pine above the rocks, and the mass of white pines in the distance. Ultimately, it all came together with the reflections in the water... a perfect early summer harmony."

STEPHEN JESIC

5 O'Clock Itch
Acrylic on board
14" x 11"

"Of all the members of the African mongoose family, meerkats have evolved the most advanced level of sociality. Day active, the meerkats form colonies of up to 30 individuals. They are found throughout southern Africa's deserts wherever the land is dry, open and often strewn with sparse bushes and trees. Meerkats live in many burrows which are enlarged from the former occupants, ground squirrels. During the cool early morning they emerge to sit up and sunbathe. If really cold the group will huddle together.

While most pack members forage for small prey, some members act as lookout sentries standing on vantage points such as mounds and in bushes especially looking out for hawks and other aerial predators.

Colouration is pale brown on the underside of the face, silver-brown on the upper parts, with 8 darker bands on the rear back, darker eye-rings, and a dark tip to the slender tail. After gestation of 11 weeks, the 2-5 young are born in a grass-lined burrow."

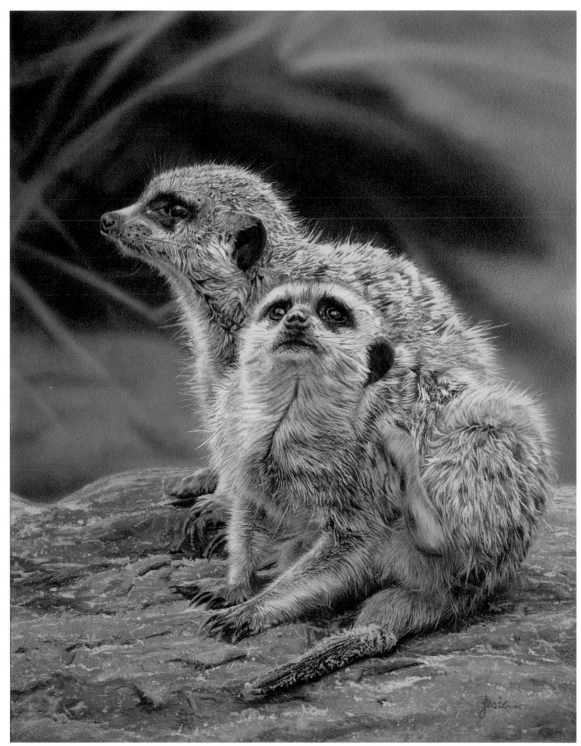

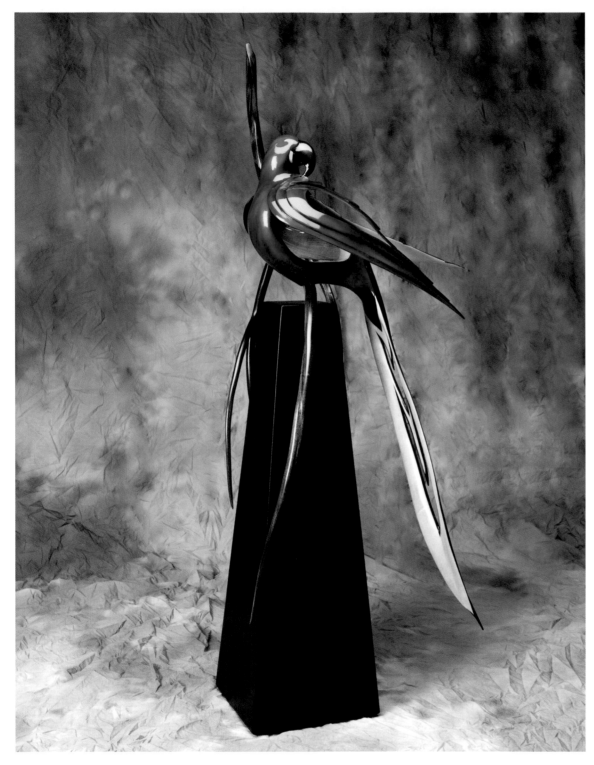

"Largest of all macaws, the Hyacinth is known for its large beak, huge feathers and spectacular blue color. This one-of-a-kind carving combines the vibrant color of the bird blended with the richness of the natural color of maple wood. The open airy feeling of the negative space design shows the puffiness of the feathers. The preservation of this species is of importance for future generations to be able to see."

RICHARD JONES

Hyacinth Macaw
Urethane on maple
46" x 20" x 19"

"Red-winged Blackbirds in the northeast are often the first signs of spring. They cling to the tops of the cattails and reeds in the swamps often looking like they can barely hold on in the March and April winds. They puff up their bright red shoulders showing them off. The main reed and bird of this sculpture were carved from one piece of wood. The base shows the trail of water in the marsh as it is blown by the wind . The rich maple color of the wood on the bird blends with the natural color of the reeds. The curves of the reeds, the open cavities of the bird and its open wings show the movement of the strong gusty winds."

RICHARD JONES

Gust in the Marsh
Urethane on maple
54" x 24" x 16"

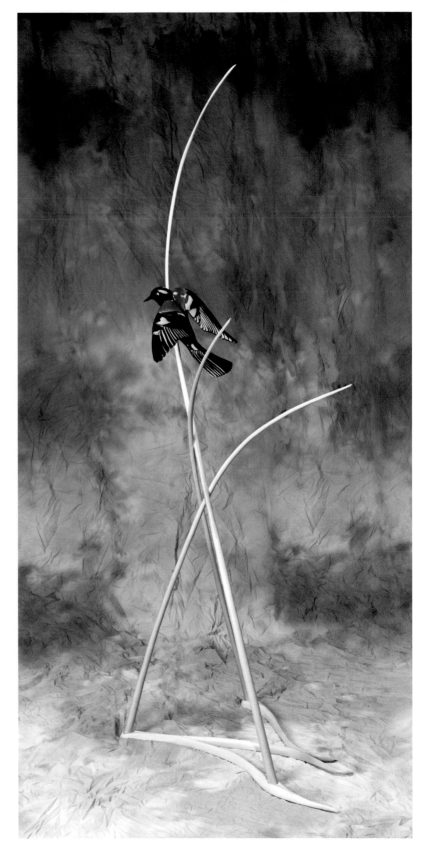

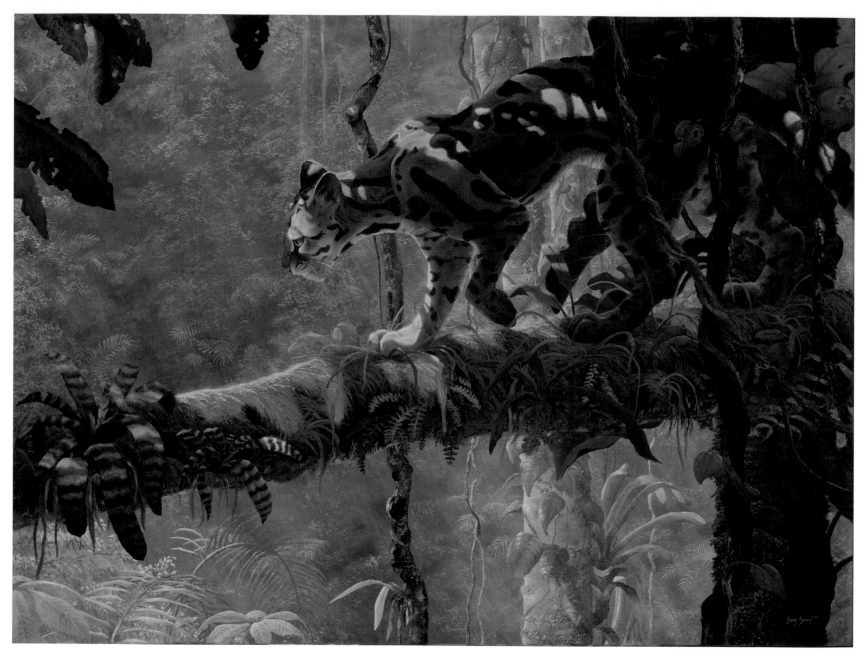

JASON KAMIN

Shadows of Panama
Oil
36" x 48"

"This piece is of the elusive Margay Cat, whose habitat can be found in jungles of Central and South America. A primarily arboreal felid about the size of a large house cat, this Margay is depicted traversing a precarious crossing through the Panamanian rainforest."

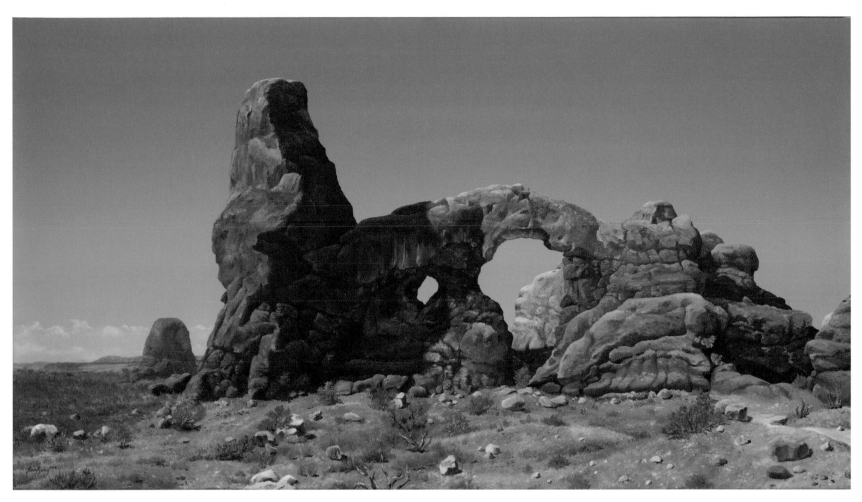

JASON KAMIN

Turret Arch
Oil
20" x 36"

"This work is of Turret Arch, situated in Arches National Park, Utah, USA. The unforgettable rock arches this park is so famous for are spectacular, and are undoubtedly recreated by many an artist. I couldn't resist adding myself to the list!"

HANS KAPPEL

Rising Storm - Tropicbirds
Oil on hardboard
24" x 31"

DAVID KITLER

Harpy Eagle (Chick) Montage
Graphite & Acrylic on Baltic birch
30" x 41"

"I saw this Harpy Eagle chick for the first time in its nest during my Flag Expedition to Panama, and that was an incredible moment. Since then, it has been my desire to share that experience through a painting, and now I have had the opportunity to do so. During my time sitting under the nest, I saw so many different aspects of this chick's life, that I was having a hard time deciding which one to portray. My solution was to include a collection of those moments. At the same time, I wanted to experiment and incorporate a mix of media along with graphic design elements, in order to venture away from the more 'traditional' wildlife painting."

DAVID KITLER

Madagascar - Creatures of the Night I
Acrylic on Baltic birch
6" x 20"

"Frogs are the only amphibians found in Madagascar, and ninety-nine percent of its frog species are believed to be endemic. Recently, hundreds more have been discovered, even in well studied areas, leading scientists to believe that many more are still unknown. Studies suggest that the total biodiversity in Madagascar could be much higher in other species as well. Where biodiversity is concerned, Madagascar remains one of the most critically threatened areas in the world, with estimates that only about eight percent of its original forest cover is still intact. I felt privileged to have had the opportunity to observe some of these creatures, which are found nowhere else on earth. This is the first of what I hope will become a series of paintings depicting my observations during a number of night walks."

JOHN KOBALD

Specks
Bronze
16" x 26" x 11"

"While fishing the gulf coast of Louisiana, I witnessed a group of marauding Speckled Trout. The fish were twisting and churning up the water as they feasted on the school of mullet.

I was immediately inspired to capture the movement and excitement in a sculpture. Currently the health of their habitat along the gulf coast is a concern."

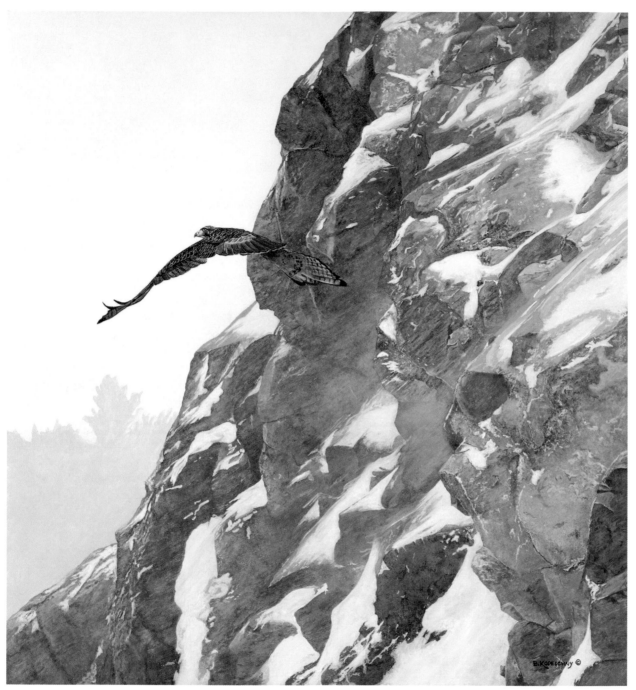

"This painting isn't about a blistery rock cliff, but about urging the viewer to feel the excitement in sighting a Red-tailed Hawk soaring past, rising up through a familiar corridor. I like to think it might be anticipating an early spring and seeking a companion in heading towards the treed horizon."

BARBARA KOPESCHNY

Hunter's Flight - Red Tail
Acrylic on masonite
31" x 28"

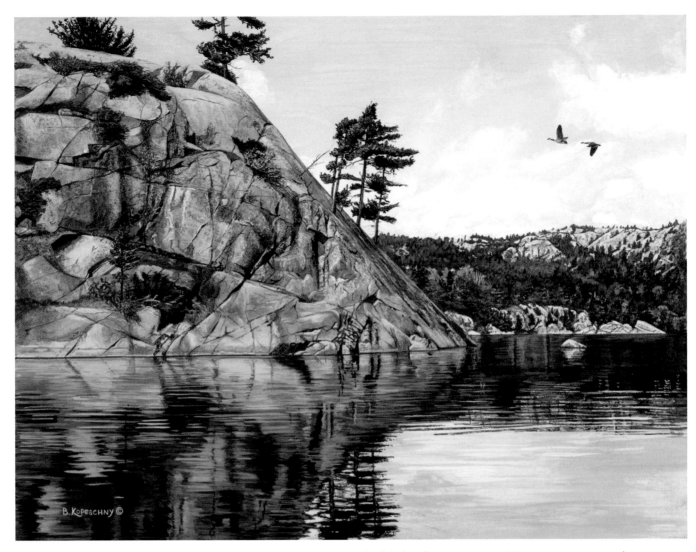

BARBARA KOPESCHNY

Granite Passage
Acrylic on canvas
16" x 21"

"I can't think of a more exciting way to spend an un-usually warm October day than canoeing on George Lake. Pink granite cliffs, earthy scents and the sound of the water on my paddle, set a peaceful canvas of tranquility. A kaleidoscope of colours in this autumn landscape painting is the ideal setting for a pair of Canada Geese on their long journey south!"

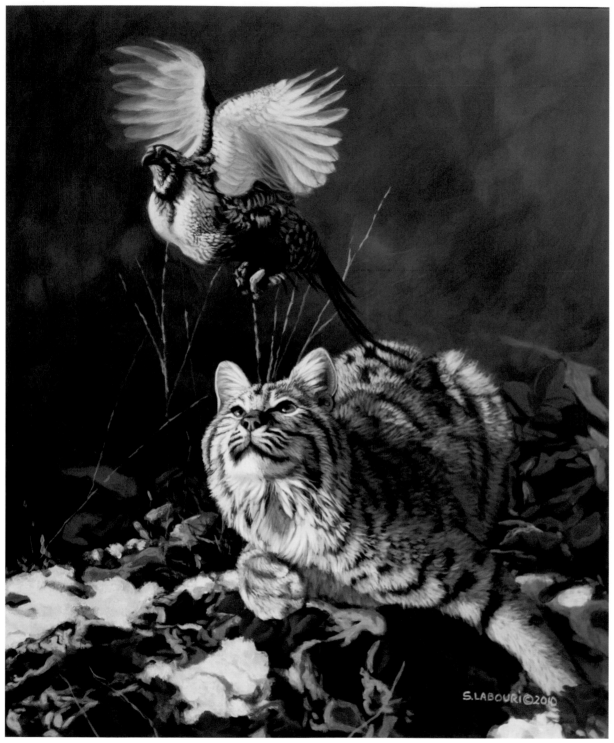

"This is a story that is played out every day in nature - the strong against the weak, the fast against the slow and even the airborne against the ground bound. It's a story that could have any ending but in this case the airborne is just a little faster."

SUSAN LABOURI

Narrow Escape
Acrylic on clayboard
22" x 18"

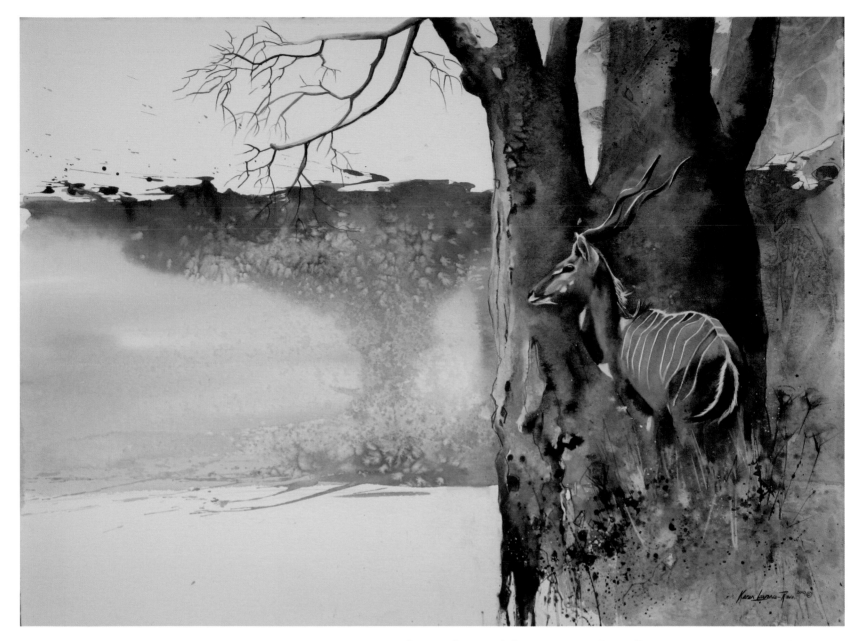

KAREN LAURENCE-ROWE

Under the Baobab
Watercolour
23" x 30"

"A clear sighting of the Lesser Kudu Bulls in Tsavo is a rare and wonderful thing. I was sketching a Baobab tree on the banks of the river and was blessed with this short sighting of a wonderful bull - he suddenly saw me and was gone in a flash of white tail!"

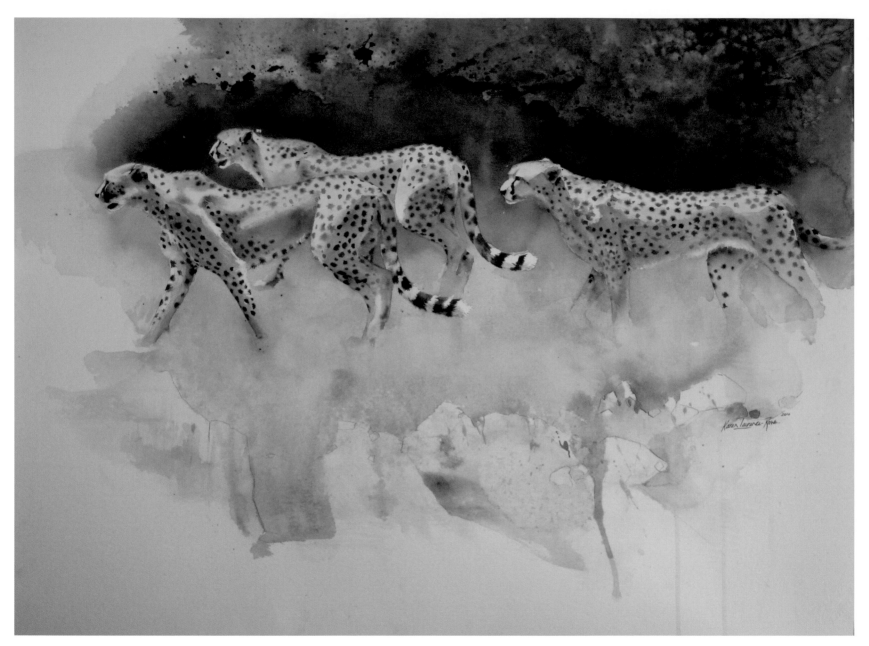

KAREN LAURENCE-ROWE

Noon Hunt
Watercolour
23" x 30"

"A Cheetah family begins their hunt - lithe, intent, and beautiful. They failed to get their prey this time, but the spectacle was breathtaking all the same."

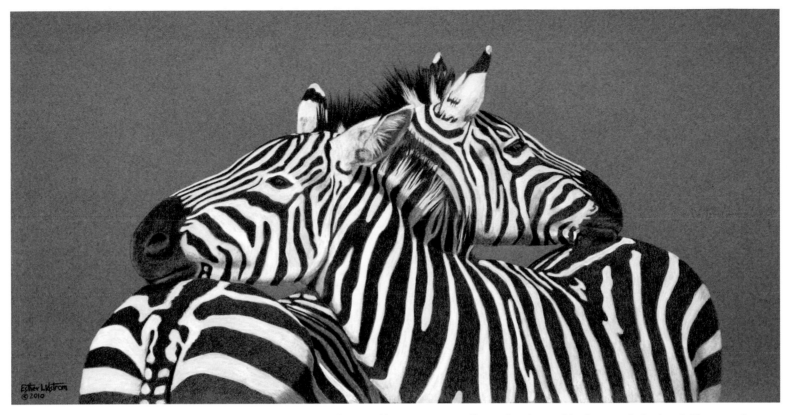

ESTHER LIDSTROM

Opposing Views
Mixed Media
7.5" x 14.5"

"Zebras offer me an endless display of lights and darks. I like to observe how their stripes interplay with the highlights and shadows on their individual forms. Each animal has unique markings and while moving about, the herd creates larger, collective patterns. Often they interact directly with one another, thereby making the scene a visual chatterbox."

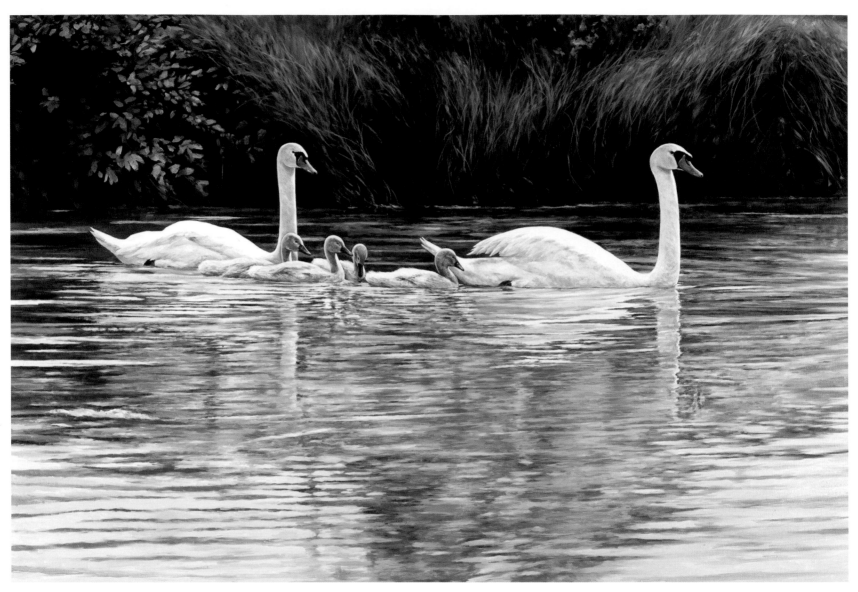

BO LUNDWALL

Mute Swan Family
Oil on canvas
44" x 56"

"Every province in Sweden has a bird, mammal, insect or flower as a symbol. The Mute Swan is the symbol for Östergötland."

HARRO MAASS

Woodpecker's Visit
Acrylic
31" x 27"

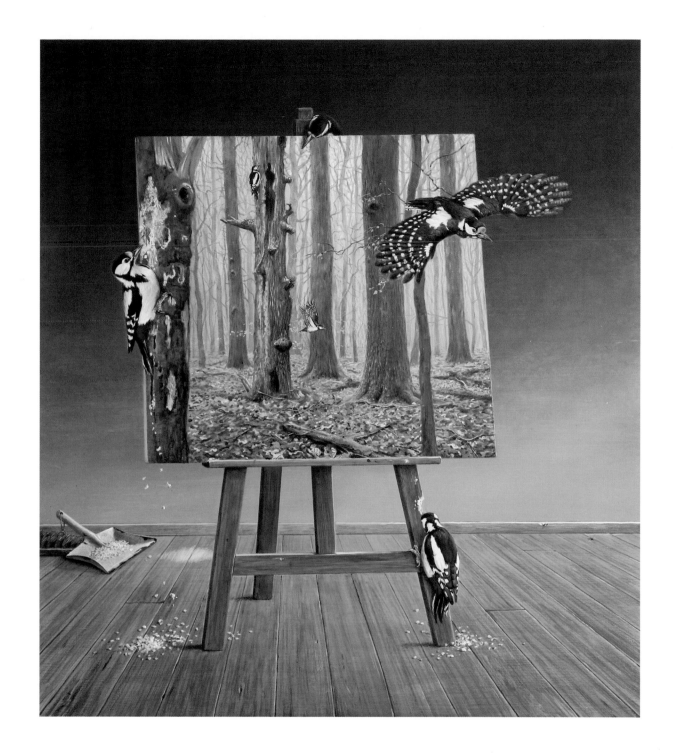

HARRO MAASS

Inside-Outside
Acrylic
23" x 31"

"In September, 2002 I visited the Baraboo Crane Foundation. The enclosure, which the White-naped Cranes occupied, had a narrow gap in the fence. One of the birds was inquisitively sticking its head through this gap as if to ask, "What's going on out there?" Several years later, while on a trip to Mongolia, I was able to see this species in the wild. This scene came immediately to mind and that is how 'Inside-Outside' came about."

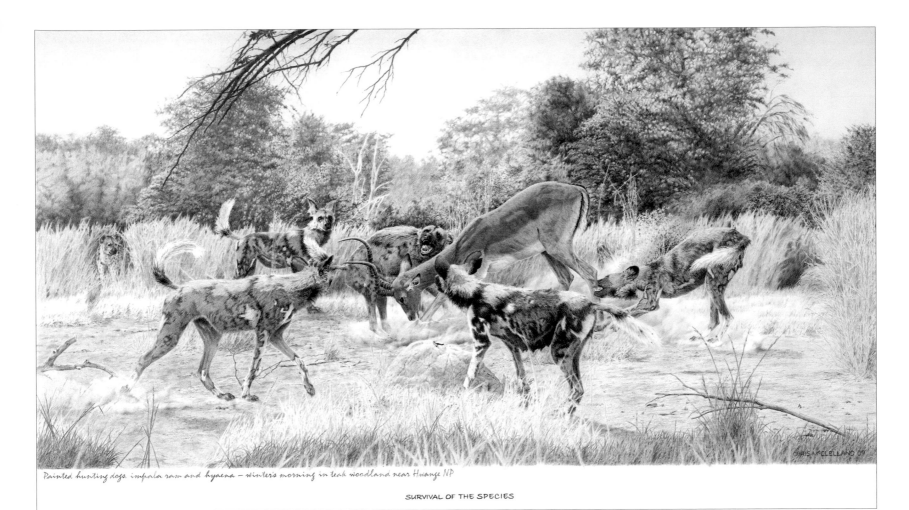

Painted hunting dogs, impala ram and hyaena — winter's morning in teak woodland near Hwange NP

SURVIVAL OF THE SPECIES

CHRIS MCCLELLAND

Survival of the Species
Coloured pencils
14.5" x 26.5"

"Burnished by the harsh touch of early winter, teak woodland near Hwange NP is bathed in the soft forgiving light of early morning. A pack of Painted Hunting Dogs has chased an Impala ram to exhaustion. As the members of the pack arrive on the scene they will combine to quickly dispatch their prey and bring home and disgorge meat for the young pups back at the den some distance away.

For the moment the whelping alpha female looks on with caution as the alpha male is dangerously swept aside by the Impala's horns after boldly going for an immobilising nose hold. The dog nipping the hind leg provides some timely distraction before the inevitable rear attack and disembowelment of the weakened animal.

While I was in the final stages of constructing this drawing a lone hyena, an opportunist, suddenly appeared on the page to add another dimension to this African play."

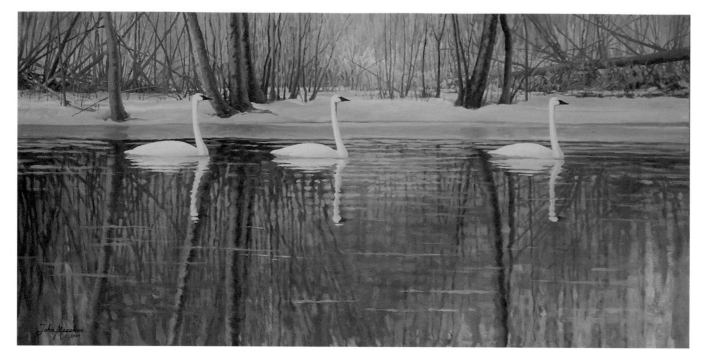

JOHN MEGAHAN

Huron River Swans
Oil
24" x 48"

"On a cold January morning I went hiking along Ann Arbor Michigan's Huron River. The air temperature hovered around ten degrees Fahrenheit as I crunched along the trail. At a bend in the river I settled down to watch the comings and goings of a surprising number of birds. An assortment of song birds including cardinals, chickadees, sparrows, bluejays and others flitted through the trees above. Buoyed by the icy water, ducks, geese and swans swam here and there. Then these three Trumpeter Swans glided by. Warm light filtered through the background trees and reflected off the water. The white of the snow and swans reflected the cool colors of the sky. The strong contrast of cold and warm color provided the inspiration for this scene."

BILLY-JACK MILLIGAN

Maternal Pride
Acrylic
48" x 36"

"The glare of a lioness can be intimidating yet extremely beautiful. In this painting the sunlight has managed to penetrate the branches and find a home on the newborn cub almost welcoming it into the world. Where there is calm there is also tension. In this scene the mother is forced to find cover in the tangled branches of a thorny Acacia. Nearby lies a threat to her newborn cub, perhaps a Cape Buffalo which will kill a cub on sight."

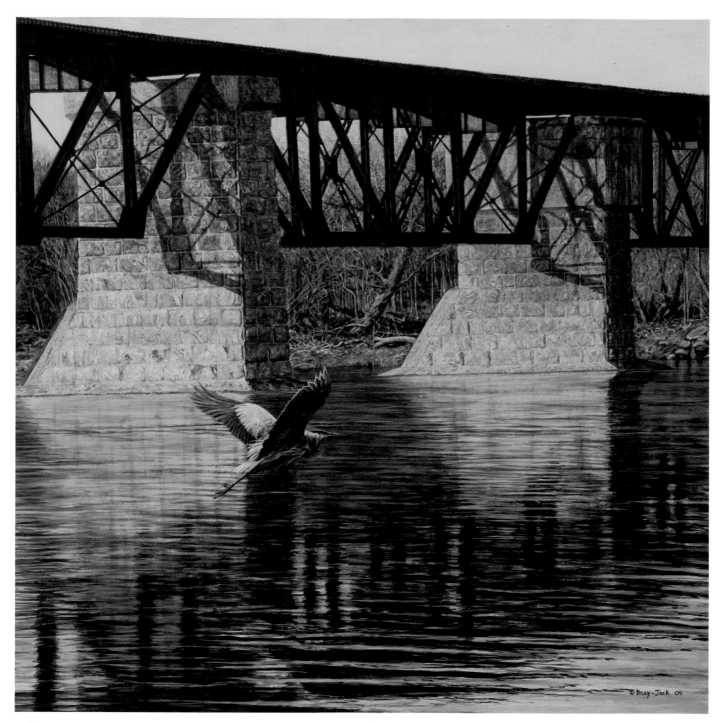

BILLY-JACK MILLIGAN

Cayuga Train Bridge
Acrylic
24" x 24"

"In my home town of Cayuga, Ontario, Canada, this bridge is a landmark. The light bouncing in amongst the trusses creates a reflective calmness. In honour of my town's 150th anniversary, I painted the bridge and heron for the Town Hall. I wanted to capture the everyday tranquility that exists here. The Blue Heron is as much a part of the background as the bridge is part of the foreground."

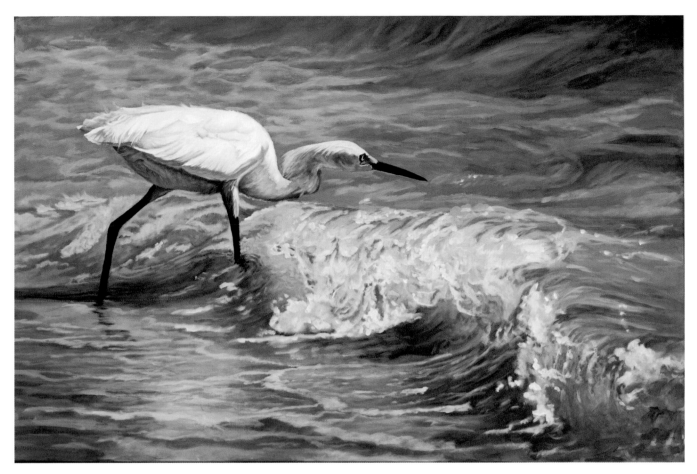

DIANNE MUNKITTRICK

Working the Waves
Acrylic
24″ x 36″

"The importance of our shorelines is underscored when we observe the beautiful creatures that rely on them for sustenance. This Snowy Egret was intent on his catch of the day. He completely ignored me as I snapped photos of him along a beautiful stretch of beach. I tried to capture the movement of the water and all the color variations in the waves as well as the colors reflected up into the underside of the bird."

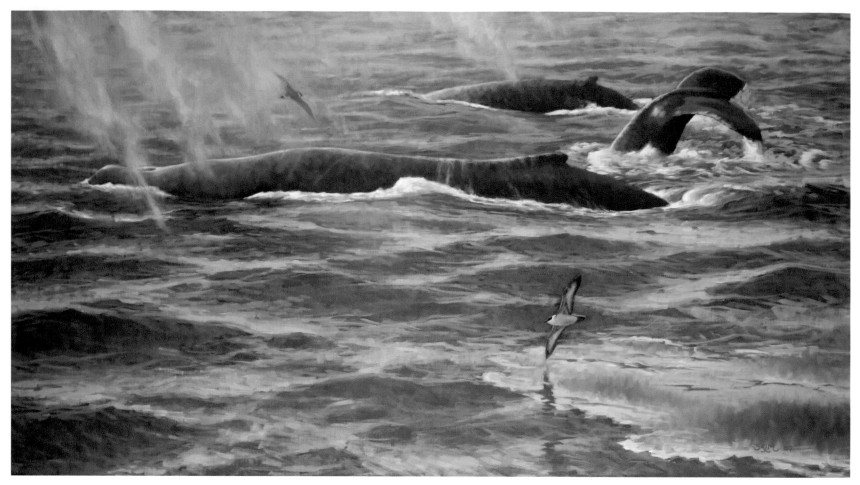

SEAN MURTHA

Great and Greater
Oil
20" x 36"

"During a recent whale watch cruise out of Provincetown, Massachusetts, I was intrigued by the relationship between whales and birds. The appearance of Shearwaters almost always presaged the whales, and vice versa; the disparity of scale, the mist, and the variety of textures made an exciting challenge. My approach began as a fairly abstract composition, balancing large and small, transparent and opaque, linear and circular movement."

"This painting resulted from my first trip to the Edwin B. Forsythe National Wildlife Refuge in Brigantine, NJ last October. Delayed by the quantity and quality of birds, we found ourselves still out on the dikes at sunset, the full moon rising as flocks of Brant and shorebirds settled down. I did a quick, small study immediately afterward to capture the scene, and later developed it into a larger canvas."

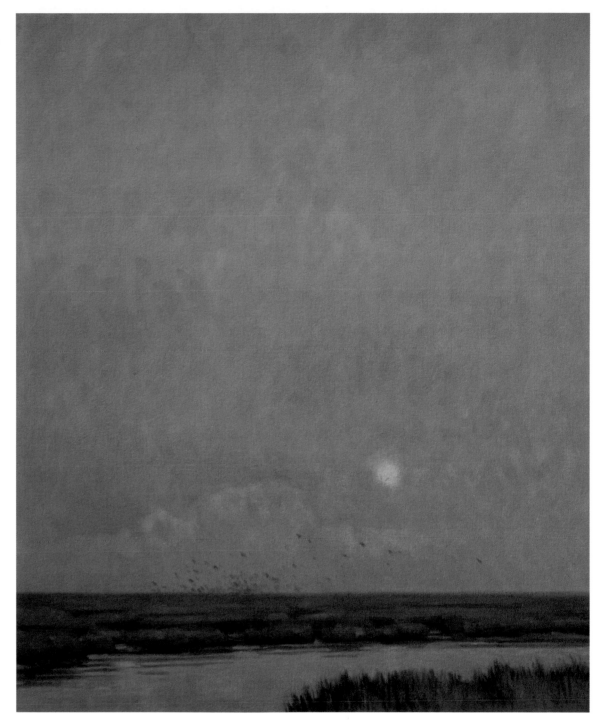

SEAN MURTHA

Moonrise over Brigantine
Oil
24" x 20"

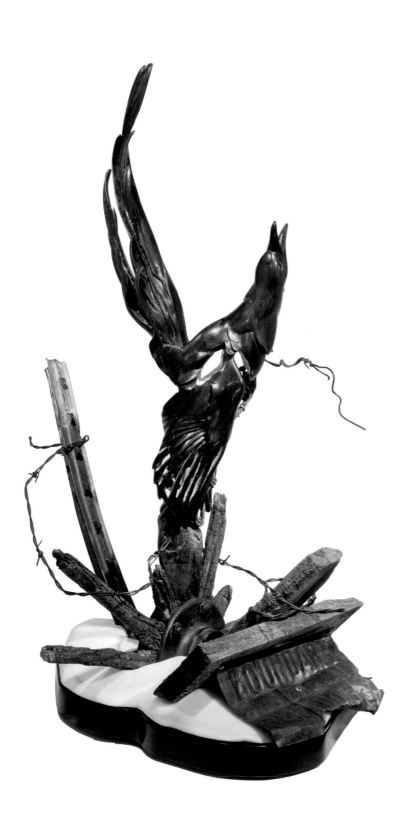

KEN NEWMAN

Defying the Wind - URI Boundaries
Oak with mixed media (carerra marble, wheel hub,
barbed wire, steel and wood sign posts and sign)
19" x 28" x 22"

"'Defying the Wind-URI Boundaries' poses the magpie
strategically perched on one foot while holding barbed
wire in the other, its tail blown up and cast off balance
by a gust of wind. In society, the winds of change are
determined or swayed by knowledge, technology,
research or profit. The magpie once had a bounty,
considered a nuisance bird by people. Now protected,
the winds change, the bird's purpose in nature is better
understood by society. Just like the wind, our attitudes
change depending on the wind's direction. The white in
the magpie is removed throughout the wood sculpture,
representing the unique patterning of the magpie as it is
seen especially in the snow when the white of the bird
disappears."

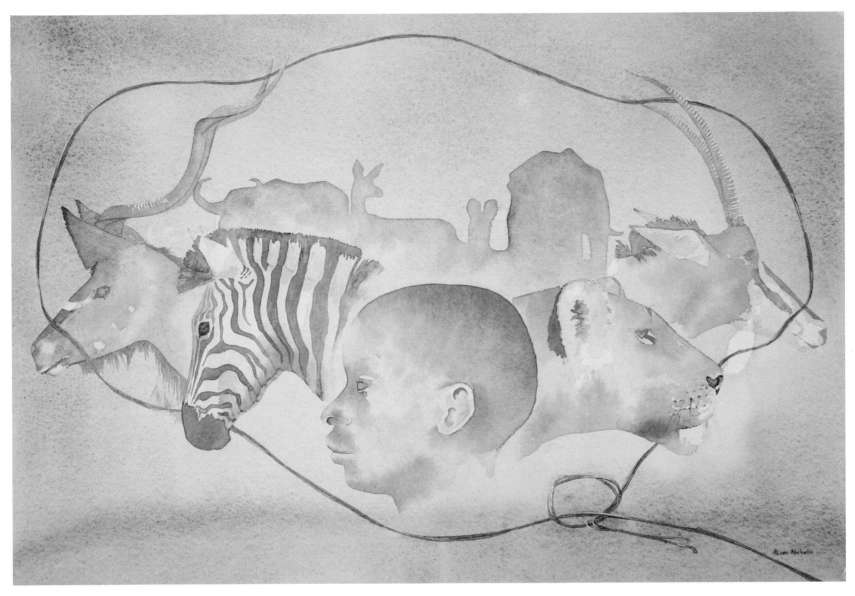

ALISON NICHOLLS

Ensnared
Watercolor
20" x 30"

"In many African countries villagers set simple but deadly wire snares to catch 'bushmeat' for sale or for their own consumption. The snares are indiscriminate and any animal, including endangered species, may be caught and suffer a long, lingering and painful death. However animals are not the only victims. Often the villagers are also 'ensnared' in a vicious cycle of poverty and hunger, with bushmeat being their only source of income or food.

This is one of the biggest challenges facing conservation in Africa – allowing local people the opportunity to make a living by protecting their local habitats and wildlife. When the preservation of wildlife brings sufficient local jobs, poachers will become game rangers, protecting the source of their income. By doing so they are conserving and protecting their own futures too, breaking the vicious cycle of poverty and creating a new cycle of sustainable interdependence."

CAROLE NICLASSE

Lady in Red
Watercolor & Colored Pencil
19.5" x 27.5"

"The beautiful Eclectus Parrots are the most obviously sexually dimorphic of all parrot species. The male is a brilliant green with bright orange beak, whereas the female is crimson and deep purple with a black beak. The first explorers to discover these birds thought they were two separate species until they were seen nesting together.

I was lucky to have seen such a flock while on a birding expedition on Cape York in northern Australia."

CAROLE NICLASSE

Three Loves
Watercolor & Colored Pencil
27.5" x 19.75"

"One of the lesser known Central African parrots, the Jardine's Parrot belongs to the Poicephalus genus. Pictured here are two males and one female (top)."

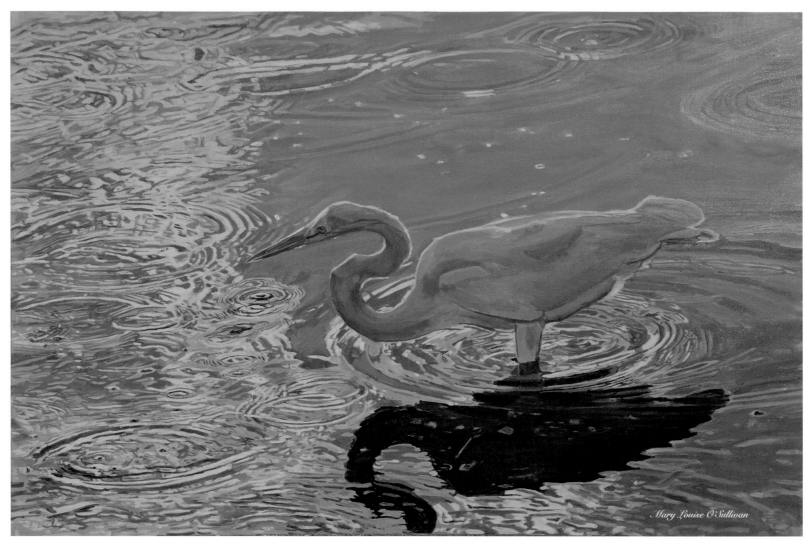

MARY LOUISE O'SULLIVAN

Circles of Light
Oil on linen canvas
28" x 42"

"The water in this pond was very very still. I believe a jumping fish created the intriguing reflections. I think a little movement makes a much more dynamic statement than a plain mirror-like reflection."

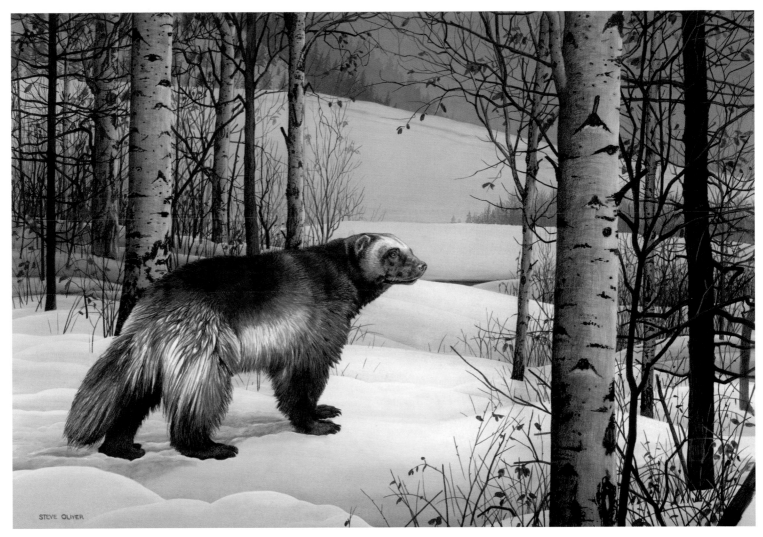

STEVE OLIVER

Sovereign & Solitary
Acrylics & Colored Pencils
18" x 24"

"For me, there has always been something very intriguing about this animal. Since very young, I've had a certain fascination with this elusive and secret animal, with my curiosity peaked by the folklore and the wolverine's reputation for ferocity, tenacity and general miserable disposition. I couldn't help but wonder how many of these stories were fact and how many were fiction. As I've gotten older, I've found, as it is with most really good stories, there are some truths and some, shall we say, embellishments. For me though, the more I learn about wolverines, the more interesting they become."

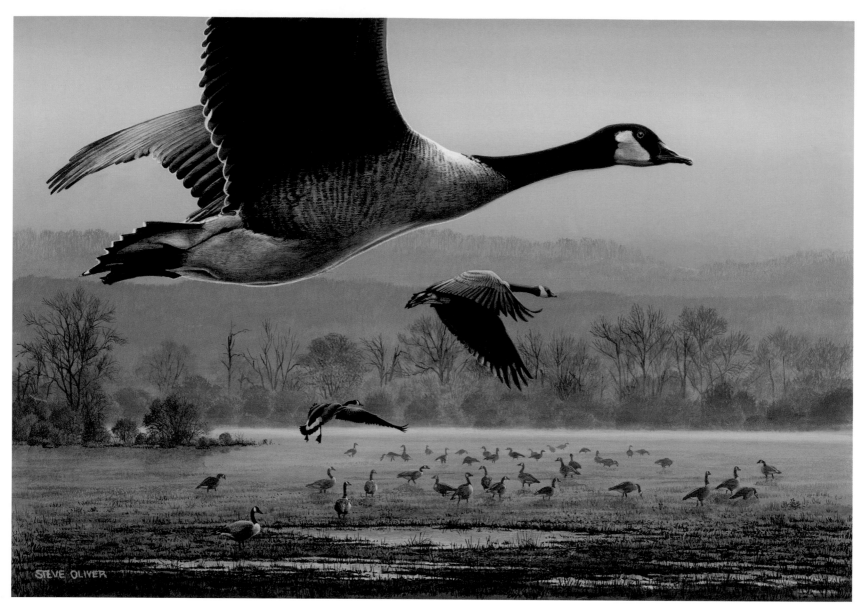

STEVE OLIVER

Setting In
Acrylic
13" x 18"

"It seems so unfortunate that I'll never understand what it feels like to fly like a bird. This painting depicts or characterizes one of those many daydreams and thoughts of being able to fly over the tree tops, set my wings to glide and parachute down into a field. Canada Geese seem to be in abudance almost everywhere in the east and can often be seen moving into fields in the morning to feed. I wanted to paint these from a bird's eye view, as it would be if I were flying along side of them, as the group drops in and joins the rest of the flock."

RON ORLANDO

Possession is 9/10
Acrylic
14" x 22"

"This is something that I have seen numerous times, a Red-tailed Hawk mantling over prey. I chose to portray that drama taking place on a rock outcropping not far from my house in Pennsylvania. We have many chipmunks living in these rocks and it seemed like a perfect match. However I couldn't bring myself to include the chipmunk."

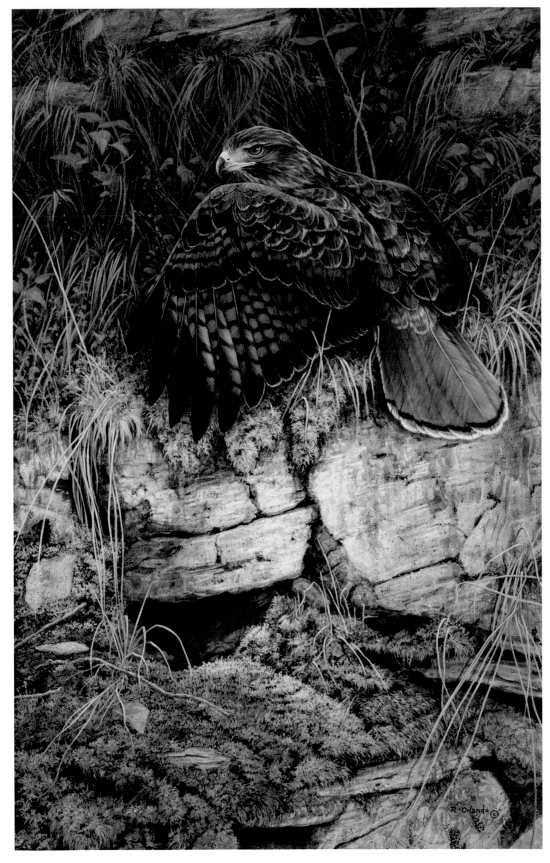

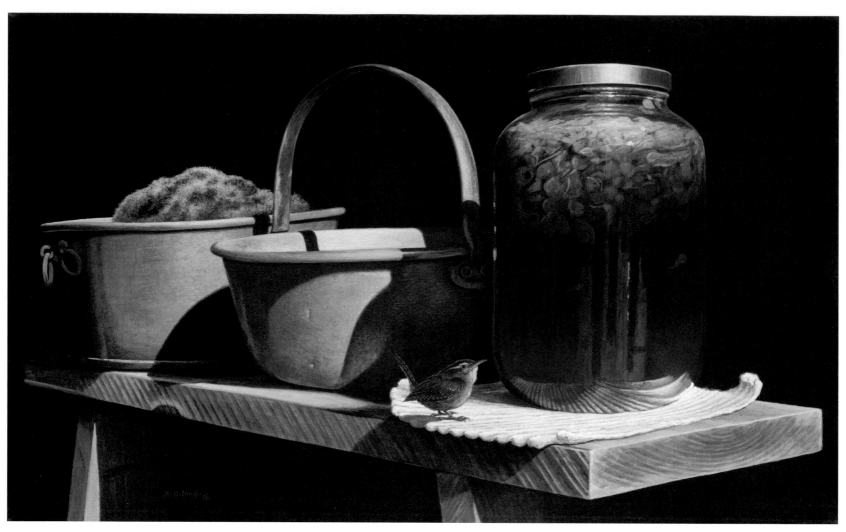

RON ORLANDO

The Dye Maker
Acrylic
11″ x18″

"I have always enjoyed portraying birds as part of a still life. They are part of our daily lives and it only seems natural to me."

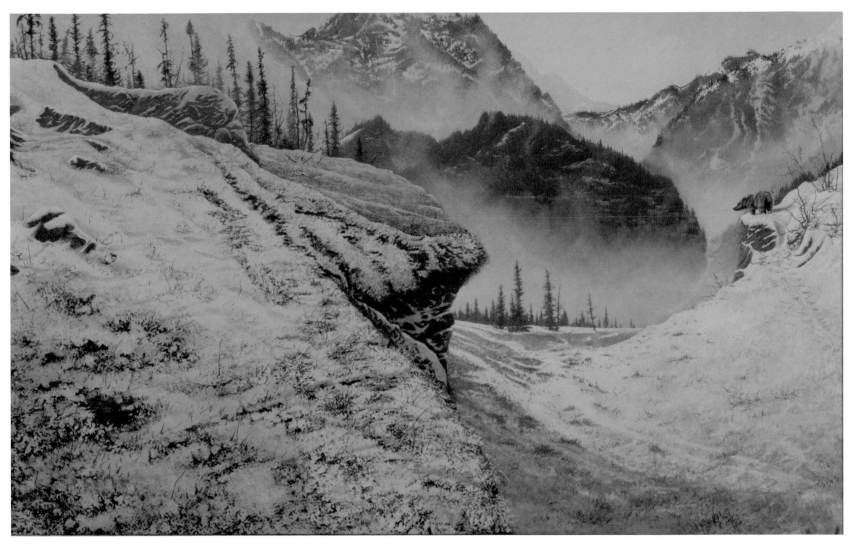

ROBERT PARKIN

Almost Time
Mixed media
30" x 48"

"This is an image I brought home from Canada when I was last over working in the 'bush', when the thaw and spring were 'almost' about to break. A landscape that to a human can seem so open and wild is just home to the wildlife who know it so well. It's a painting about what we should leave alone and learn to live with, nature and wilderness."

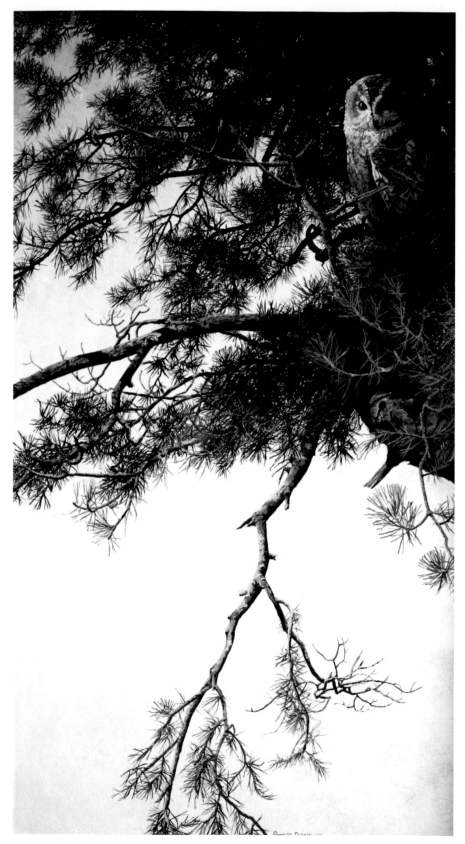

ROBERT PARKIN

I See You
Acrylic
39" x 24"

"A stone's throw from my studio, this old pine stands and survives all the elements that the North Sea can throw at it. A huge tree, the painting is inspired by its determination to survive. The Tawny Owl can be found there on most days, hidden in the tangle of overhanging branches. To survive the extremes she will shelter on the leeward side of the tree to escape the worst of the weather. She will see you long before you see her and will by and large remain unmoved by the presence of people."

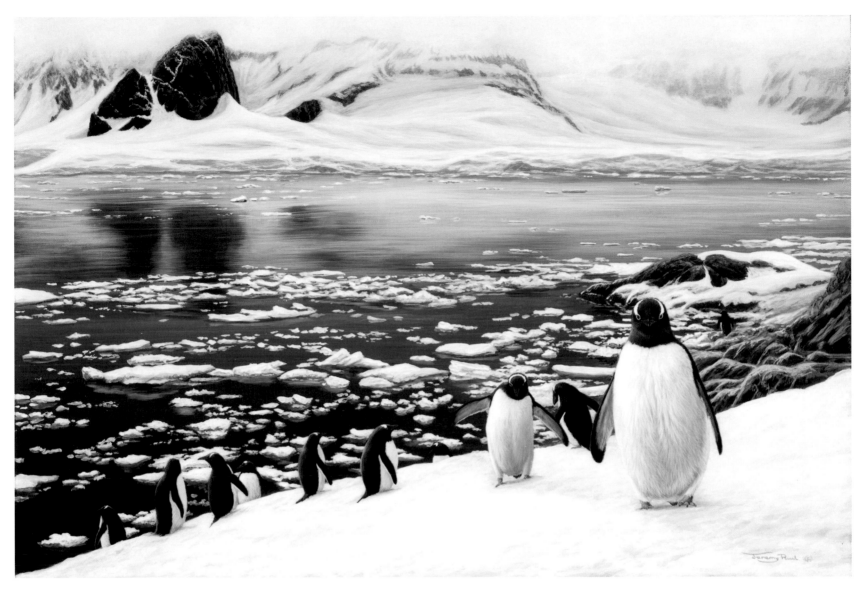

DR. JEREMY PAUL

Gentoo Penguins - Antarctic Peninsula
Acrylic
22" x 15"

"The beauty of the Antarctic Peninsula is almost overwhelming. This Gentoo Penguin colony was on Cuverville Island and I wanted to show the penguins moving up and down to their nesting sites - set against the background of mountains and glaciers. The penguins create their own 'highways' through the snow - with main routes and branching roads to different parts of the colony."

CRISTINA PENESCU

Predatory Intent
Acrylic
24" x 18"

"I find big cats to be fascinating animals. With 'Predatory Intent' I aim to bring the viewer an up close, intimate look at the tiger. The tight crop and dramatic lighting draws emphasis to the cat's eyes which are intensely focused, as if engaged in a stare down. I greatly enjoyed painting the subtle details, such as the texture of the iris or the way the tips of the whiskers catch the light. It is these tiny details that, I feel, bring life to a painting."

PATRICIA PEPIN

Leopard
Acrylic on linen
24″ x 20″

"The leopard's spots help it to hide in trees and grasses and keep its prey ignorant of imminent transformation into a meal until it's too late. On the other hand the spots have made the big cat a victim of hunting and the fashion industry.

But its greatest peril lies in the loss of its natural habitat."

DAG PETERSON

Mother and Daughter
Oil on panel
20" x 16"

"As long as I can remember I have been involved with nature protection through my art and in practice. I have been and still am especially concerned about birds of prey.

During the last 10 to 15 years, the White-tailed Sea-eagle has made a tremendous recovery in Europe.

My painting 'Mother and Daughter' is my way to celebrate this positive event."

POLLYANNA PICKERING

The Eye of the Storm
Gouache on canvas
40" x 34"

"I spend a great deal of time in the beautiful Highlands of Scotland sketching and painting. The Highlands remain a stronghold for the magnificent Golden Eagle, which has recently been proposed to represent Scotland as their national bird. No matter how many times you have seen one, the experience of witnessing this majestic species is always remarkable. I was inspired to paint this canvas by the dark, brooding, stormy skies over the mountains – the drama of the lightning flashes seemed a suitable background for our largest raptor."

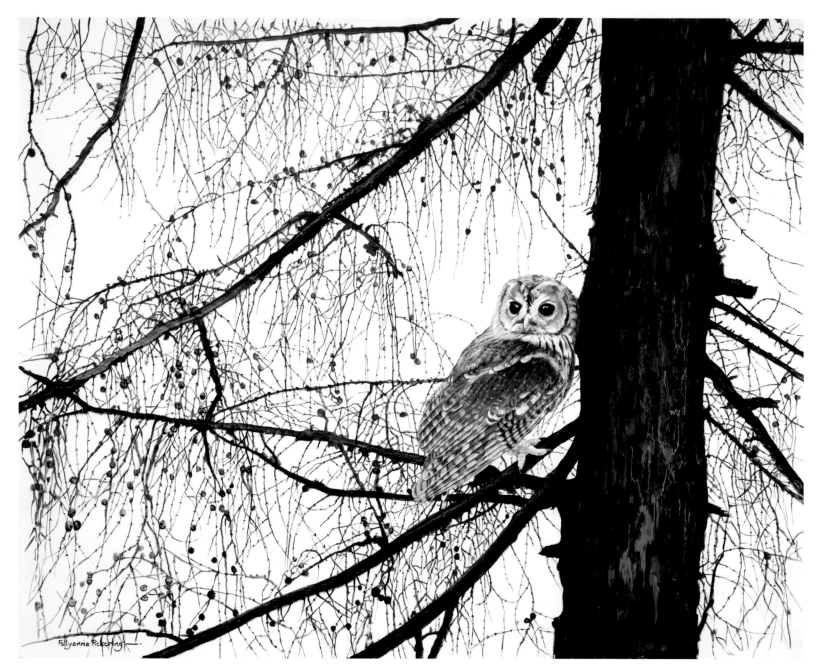

POLLYANNA PICKERING

Wildwood
Gouache
42" x 37"

"For fifteen years I ran a licensed registered sanctuary to care for and rehabilitate birds of prey. This gave me an unparalleled opportunity to sketch and study our native owls, hawks and falcons, and they remain among my favourite subjects. This Tawny Owl 'Daisy' was a special favourite among my patients – incredibly she was hatched from a cracked egg! A felled tree turned out to contain a Tawny Owl nest and the woodcutter brought two damaged eggs to me, which I sealed and placed in an incubator. Ten days later they hatched, and I then hand-reared the two young owls. Both were subsequently released into the wild. Daisy nested in an owl box in my garden where she paired up with a wild male, and continued to rear her own young for many years."

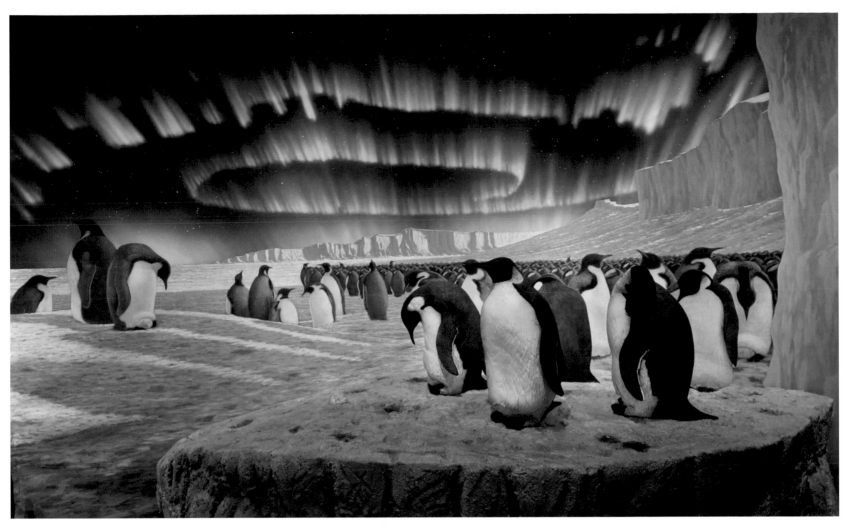

STEPHEN QUINN

True Love Waits
Acrylic
10′ x 16′

"This diorama is part of the exhibition 'Race to the End of the Earth' at the American Museum of Natural History in New York. The scene is based on the references made by Edward Wilson who accompanied Robert Falcon Scott on his ill-fated expedition to reach the South Pole in 1911. The stars and aurora are accurately plotted for what Wilson would have seen during his visit. Orion and the Southern Cross are both visible in the Polar night sky."

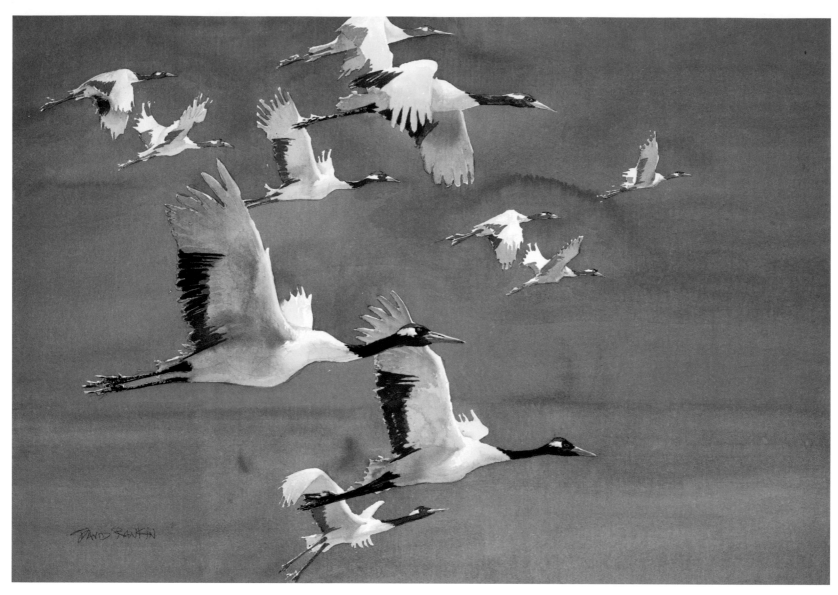

DAVID RANKIN

Above the Clouds

Transparent Watercolor on Arches Rough 300lb
25" x 36"

"There are 15 distinct species of cranes in the world, and Red-crowned Cranes are one of the most endangered species of all, with only 1500 remaining. I began painting this species of crane years ago while working on a series of projects for the International Crane Foundation, in Baraboo, Wisconsin. In fact, the International Crane Foundation used one of my watercolors of this species to design and refine their new corporate logo a couple of years ago."

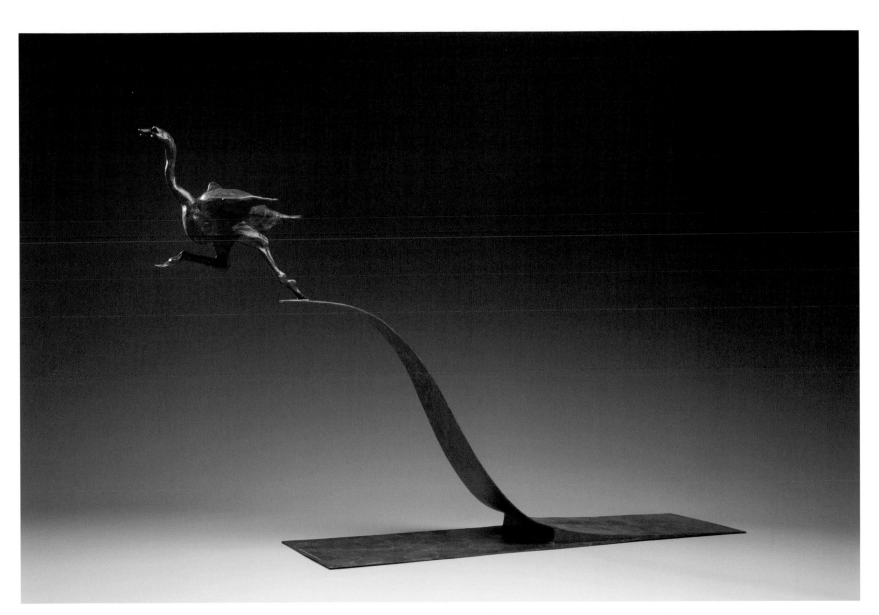

DIANA REUTER-TWINING

Flight
Bronze on Stainless Steel Base
36" x 38" x 8"

"Here an ostrich defies gravity and propels itself on one foot up and away. These birds are actually very large and top-heavy so when they finally get their momentum started they do seem to have a different kind of grace and balance."

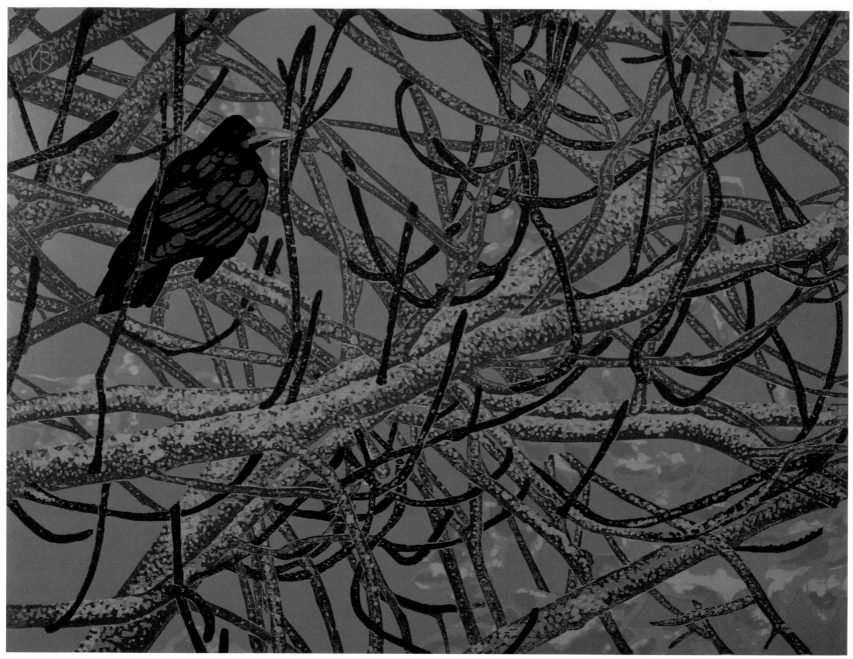

ANDREA RICH

Rook
Woodcut
12" x 16"

"A striking bird, I viewed this one on a trip to Scotland."

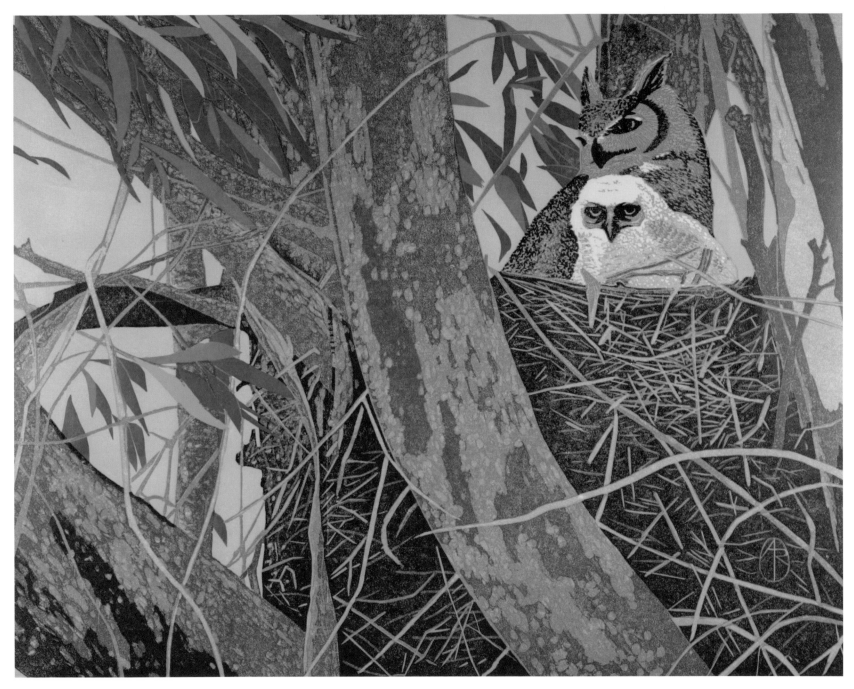

ANDREA RICH

Great Horned Owls

Woodcut

16" x 20"

"I often find owls nesting in this particular tree, one of only a few that grow to any height on the Carrizzo Plain in central California."

"Ground Hornbills live on the property where I stay when I am in Mfuwe, just outside S. Luangwa National Park, Zambia. These largest of hornbills are severely threatened all over southern and central Africa. Conservation and breeding efforts are underway in RSA to help save this prehistoric-looking bird from a rapid extinction due to loss of habitat, killing by humans, and the unfortunate fact that these birds will produce only 2 eggs every 9 years, with the stronger of the 2 chicks devouring the weaker. The mating pair's crepuscular calls to each other sound like drums, hence the chinyanja (one of Zambia's most commonly spoken languages) word for drum also being the vernacular name for this bird."

KATERINA RING

Ground Hornbills - Dry Season
Oil
24" x 16"

ROSETTA

Cheetahs on the Run
Bronze
3.3' x 32' x 6'

"This installation includes three over-life-sized Cheetahs in three stages of the Cheetah's famed running style. Legendary for its incredible speed, capable of reaching 70 miles per hour in the heat of the chase, the Cheetah's non-retractable claws grip the ground as its legs gather beneath the arched back and then, with amazing speed and strength, the spine stretches out to full length, propelling the cat forward to then gather its legs again and repeat the rhythmic stride. With its head held perfectly level as if connected to its prey with an invisible thread, this amazing cat can execute lightning fast sharp turns, using its long tail for balance. This magnificent cat is extremely endangered due to a combination of factors: habitat loss, predation by lions, hyenas and man, and a very narrow gene pool."

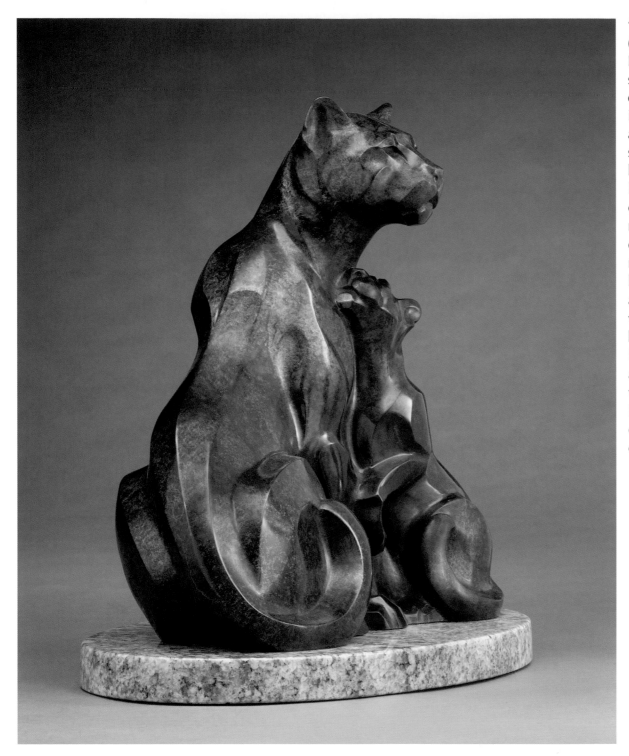

"Although it is just the melanistic (dark) variety of the Spotted Leopard, the Black Panther's shadowy presence carries an aura of mystery, stealth and power all its own. This tender rendition of a mother Panther and her cub shows another side of the mighty hunter: the maternalistic care she lavishes on her young, and the cub's obvious bonding with his mother, upon whom he will be dependent until adolescence. The mother's face projects not only her concern for the protection and nurturing of her offspring, to which she is totally committed, but also shows her obvious pride in the cub that she has produced and is successfully raising. A very capable hunter, the leopard is nonetheless one of the large cats of Africa that is highly endangered."

ROSETTA

Panther's Pride

Bronze

11" x 11" x 7"

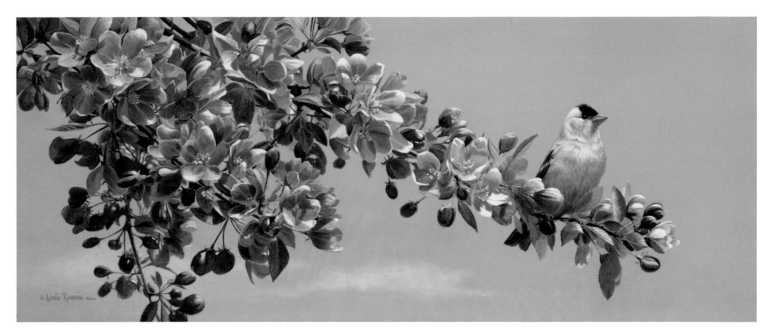

LINDA ROSSIN

Apple Blossom Time
Acrylic on composition board
7" x 17"

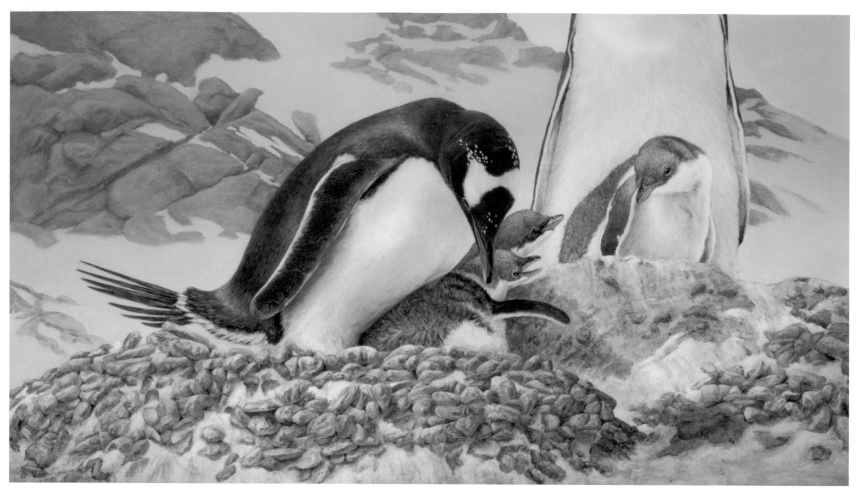

SHARON K. SCHAFER

Gentoo Penguins: Port Lockroy, Antarctica
Acrylic on clayboard
18" x 30.5"

"I watched this family of Gentoo Penguins in their rocky nest at Port Lockroy, Antarctica.

The nests, usually made from a roughly circular pile of stones, can be quite large, as much as 20 cm high and 25 cm in diameter. Competition for sparse nesting materials can be fierce and the stones are zealously guarded. The stones' ownership is often the subject of noisy aggressive fights between the penguins.

Two eggs are laid and hatch in just over a month. The parents then take turns tending the chicks and going out to catch krill, squid and fish.

The chicks remain in the nests for about 30 days before forming groups of chicks known as crèches where they will continue to be cared for by both parents. The chicks molt into sub-adult plumage and go out to sea in about 80 to 100 days."

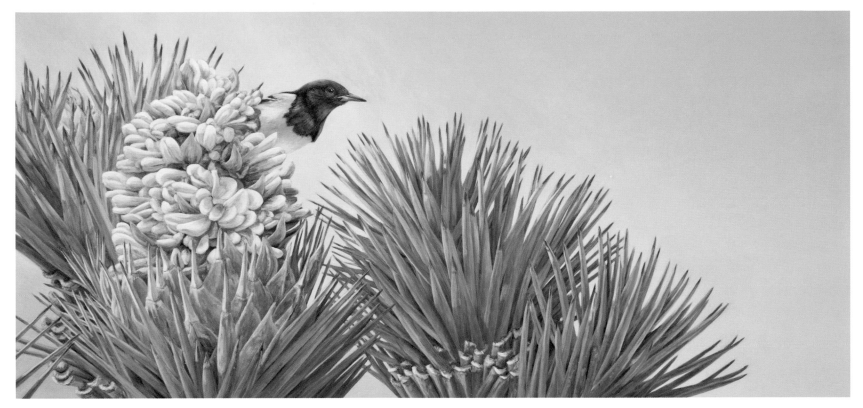

SHARON K. SCHAFER

Spring Bloom: Scott's Oriole in Joshua Tree
Acrylic on clayboard
15" x 30.5"

"These colorful orioles are found in desert, grassland prairies and mountain canyons, particularly if yuccas are present. They are often seen gleaning and probing in yucca leaves and flowers for insects and nectar, or collecting fibers for their nests.

In many parts of the southwest desert the Scott's Oriole can be found nesting in Joshua tree woodlands where they hang their nests from rugged twisted branches near the tree's crown. The nest is a carefully constructed hanging basket of woven plant fibers stripped from dead leaves then carefully lined with soft grasses and other plant fibers.

The Scott's Oriole breeds in southern California, southern Nevada, Utah, Arizona, New Mexico, and western Texas and spends winters mainly south of the U.S.-Mexico border."

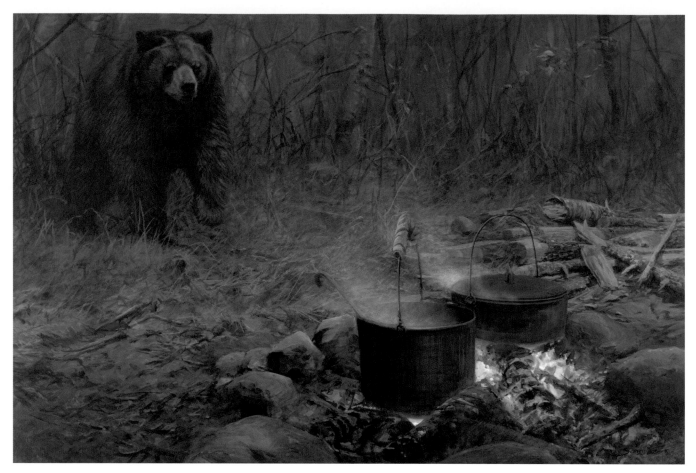

JOHN SEEREY-LESTER

Blackout
Acrylic
24" x 36"

"I love painting the elements of a campfire, and you never know who will be visiting."

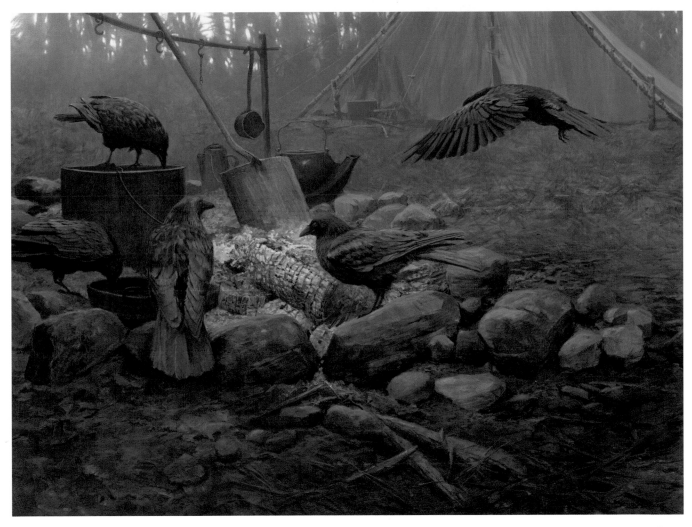

JOHN SEEREY-LESTER

Murder in the Morning
Acrylic
24" x 36"

"The collective name for a group of crows is a murder. I love the dark crows, with the dead campfire, looking for whatever they may find. Mysterious. Who left the campfire and what happened to them?"

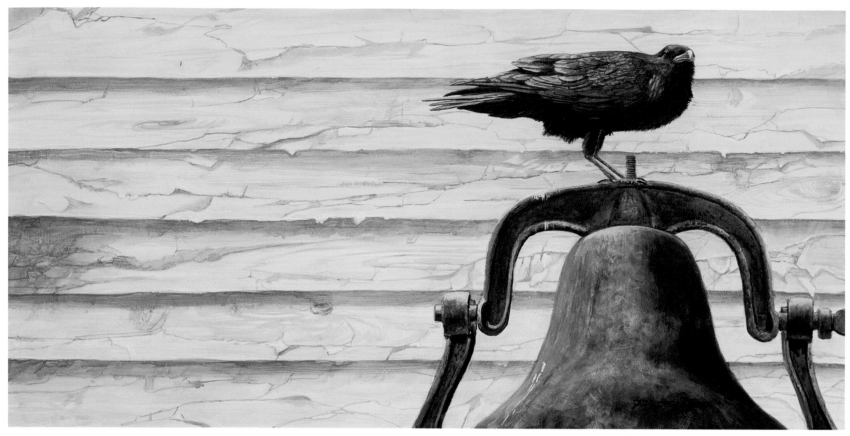

SUZIE SEEREY-LESTER

School Belle
Acrylic on panel
12" x 24"

"I love to have dark against light in a painting to create interest. We have this old school bell in our yard, the wall in the painting is from an old building three miles away and the raven is from Montana."

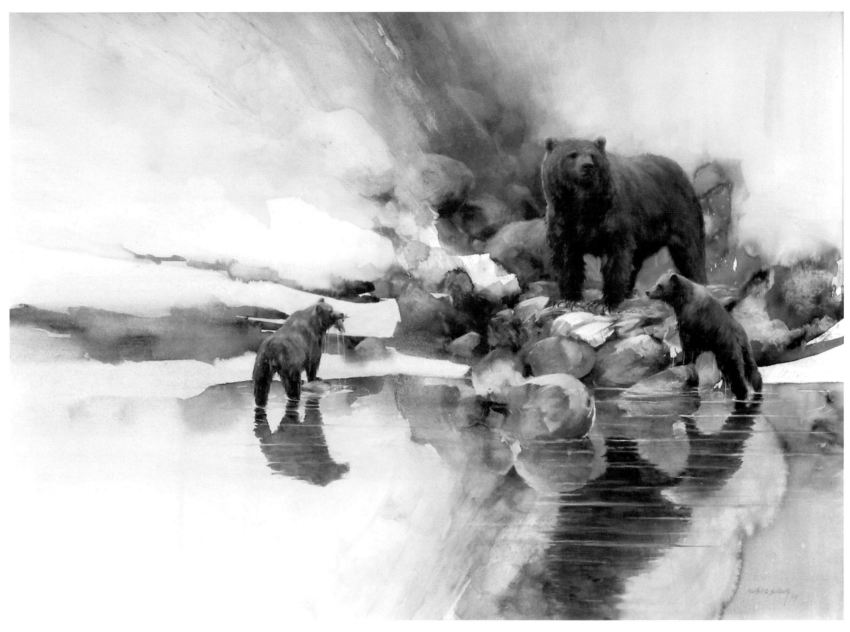

MORTEN SOLBERG

Where's Mine?
Waterbase media
22" x 30"

"The bear family have all caught a fish except for one."

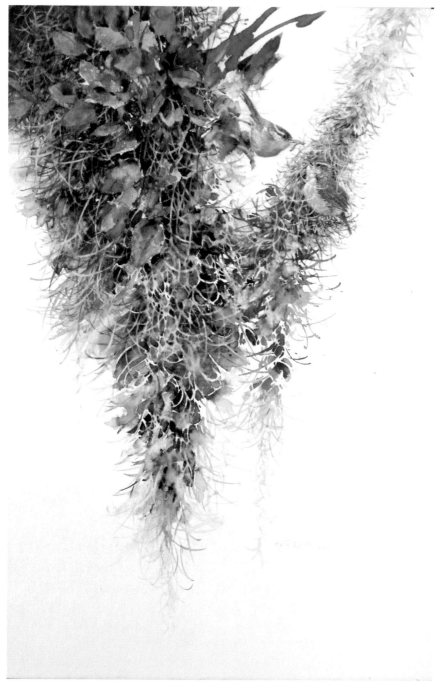

MORTEN SOLBERG

Carolina Wrens
Watercolor
22" x 14"

"Birds in Spanish Moss."

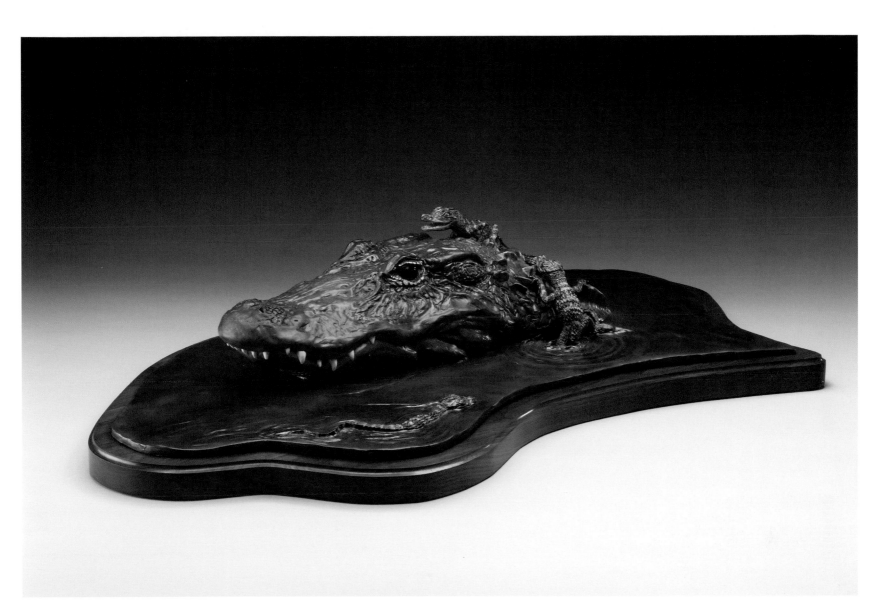

EVA STANLEY

The Swimming Lesson
Bronze
9" x 37" x 22.5"

"A silent armored presence, I find alligators to be fascinating creatures. Though destined to be top predators of the swamp, young alligators are food for the very creatures that later become their prey- raccoons, osprey, fish, snakes, herons and egrets, otters, even bigger alligators! With unparalleled behavior for the reptile world, their momma will protect them for 1-2 years! I had to capture this tender time in sculpture! Alligators lucky enough to reach 4' (growing 6" - 12" a year), will have only one predator - man.

Only two alligator species exist in the world- the American Alligator found only in the southeastern United States, and the rare Chinese Alligator of the Yangtse River. Alligators and their 21 relatives are the last living reptiles closely related to dinosaurs.

Appearing 245 million years ago during the Triassic period, the group - alligators, crocodiles, gharials, and caiman - have changed little in 65 million years."

143

EVA STANLEY

Space Invasion
Bronze
3.5" x 6" x 10"

"Commissioned work frequently gives me the opportunity to study creatures often much maligned. This piece began as a request from The Wildlife Experience Museum in Parker, Colorado!

Rattlesnakes fill a 3.5 million-year-old niche in nature, keeping rodent populations in check. They, in turn, are food for hawks, eagles, ravens, roadrunners, kingsnakes, bullsnakes, badgers, coyotes, bobcats, alligators and bullfrogs! But humans are their greatest threat.

Mostly nocturnal creatures, they are reluctant to be active below 40°F or above 94°, during windy periods or full moonlight. On days when temperatures reach over 70°, you may see them sunning on rocks in the mid-afternoon. They live most of their secretive lives in cool dark rodent burrows and deep rock crevices."

MARY TAYLOR

Flying Squirrel
Welded stainless steel rods, painted
15" x 12" x 11"

"We must understand our interconnectedness and responsibility to the earth. We are together in a vast web with other innumerable and necessary species. I pray we teach ourselves and our children to be both knowledgeable and vigilant stewards of our natural home.

In an age of extinction, I believe this is a poignant, crucial time - a time to reflect on the basic philosophical questions surrounding life and death, as well as beauty and harmony, not only of our endangered species, but also of our own fragile selves."

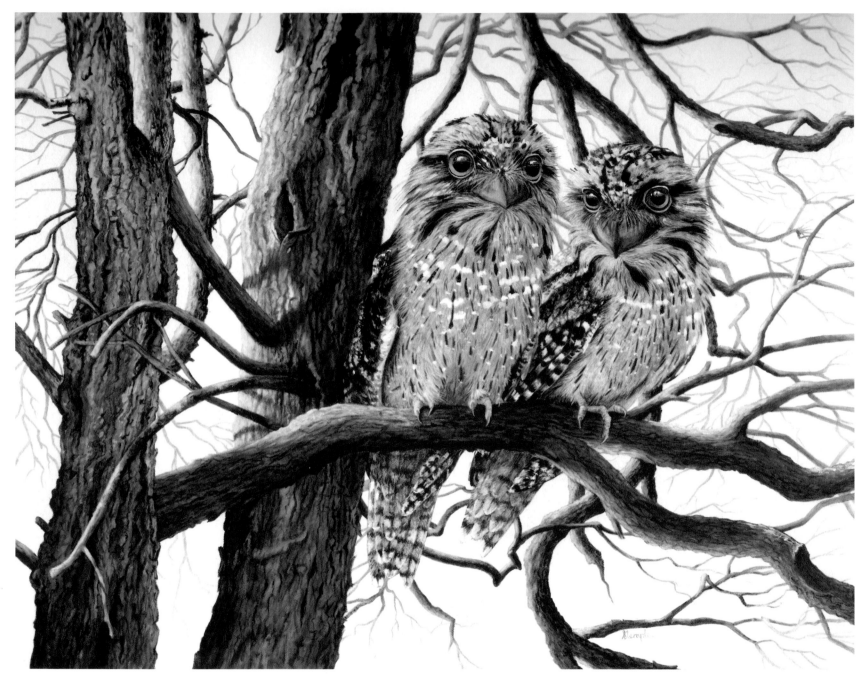

SANDRA TEMPLE

Just Us Trees
Oil
23" x 30"

"These beautiful nocturnal birds (Tawny Frogmouths) unfortunately have a high mortality rate on our roads at night. During the day they sit perfectly still, their attractive plumage allowing them to become invisible against a tree trunk.

Their nest building leaves a lot to be desired, consisting as it does of a few sticks forming a flimsy platform across a fork in a tree branch. Despite this, I have watched year after year as a new brood is hatched in the same tree with no 'accidents'.

A dream to paint, they stay still for me like no other birds do and I love hearing their soft but penetrating 'oom-oom' calls at night."

146

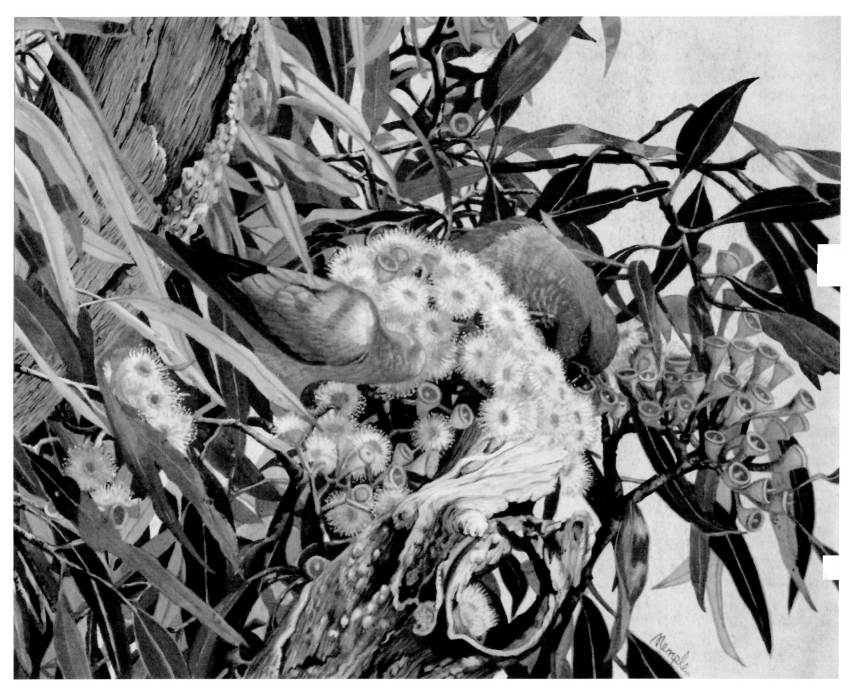

SANDRA TEMPLE

The Feast
Gouache and watercolour
14" x 16"

"When the gum trees are in flower, large noisy flocks of lorikeets decend for the feast. Over the past six years there has been no sign of the Scaly-breasted Lorikeet among them and we heard that they were disappearing everywhere.

Slowly in the last three years we have seen a few pairs arriving to enjoy the floral bounty and are a little more hopeful this year as the number increased to ten birds. Still a long way to go but hopefully this attractive little lorikeet is on the way back."

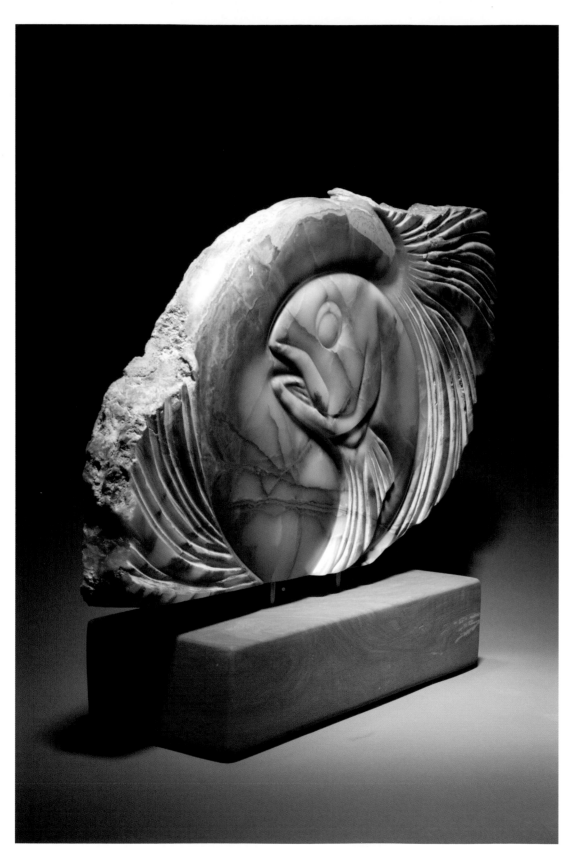

DAHRL THOMSON

Air-Time
Seven Springs Onyx on sandstone base
17" x 23" x 5.5"

"'Air-Time' is representative of freshwater fish, jumping above water in pursuit of flying prey. Fish are one of the early indicators of the health (or unhealthiness) of our rivers and streams. Man-made pollution, whether in the form of chemicals or trash detritis (plastic bags, fishing line, gear, etc.) greatly affects this precious commodity. With this carving, I wanted to exhibit the beauty of fish through the use of beautiful stone and as always, original design."

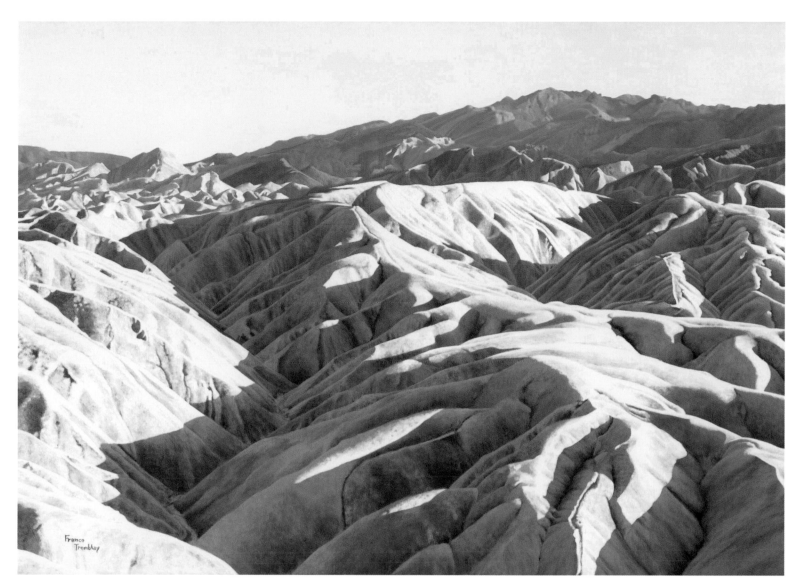

FRANCE TREMBLAY

Southeast View from Zabriskie Point
Acrylic on canvas
20" x 28"

"Death Valley National Park is a land of unique beauty. It offers colorful canyons, snow-capped mountains, ever-shifting sand dunes sculpted by the winds, a stream of salty water and even a black crater where time stands still. This extremely harsh desert is home to unique plants and animals. I have depicted a spectacular viewpoint surrounded by beautifully eroded and colorful badlands. The scenery varies greatly depending on the direction of observation. I have carefully picked an angle and an elevation to maximize the sense of vastness and depth. The interplay between light and shadow creates an ultimate drama."

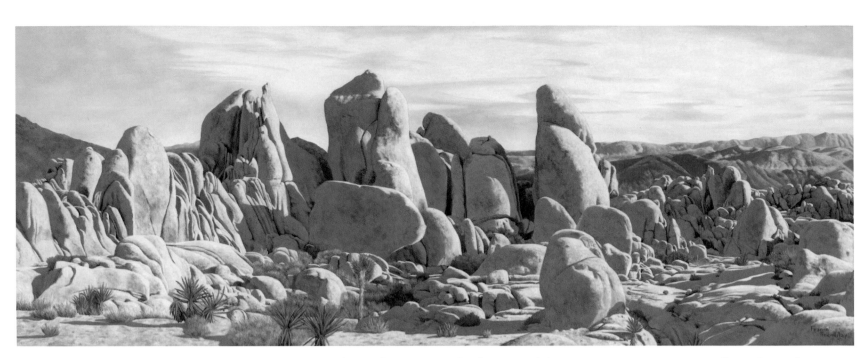

FRANCE TREMBLAY

Jumbo Rocks
Acrylic on canvas
14" x 36"

"The Joshua tree is the largest of the yuccas. It grows naturally only in the Mojave desert and nowhere else in the world. Joshua Tree National Park is a privileged place where one can admire extensive natural stands of this unique plant. Moreover, this park has an extraordinary geology. Jumbo Rocks depicts a spectacular sculpturing of granite rocks. Here and there, yuccas and other plants grow, adding life and color to the scene. The long and narrow format of the painting helps to convey the beauty of the extensive rock formation and helps to strengthen the composition. In the early morning light, the scene is dazzlingly beautiful."

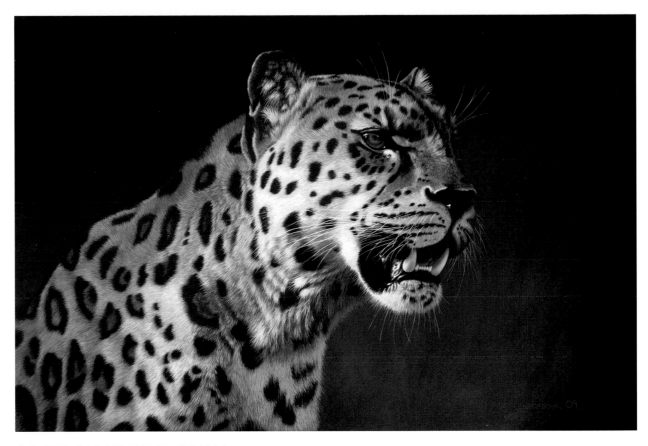

ALEX UNDERDOWN

Amur Leopard
Oil
19″ x 26″

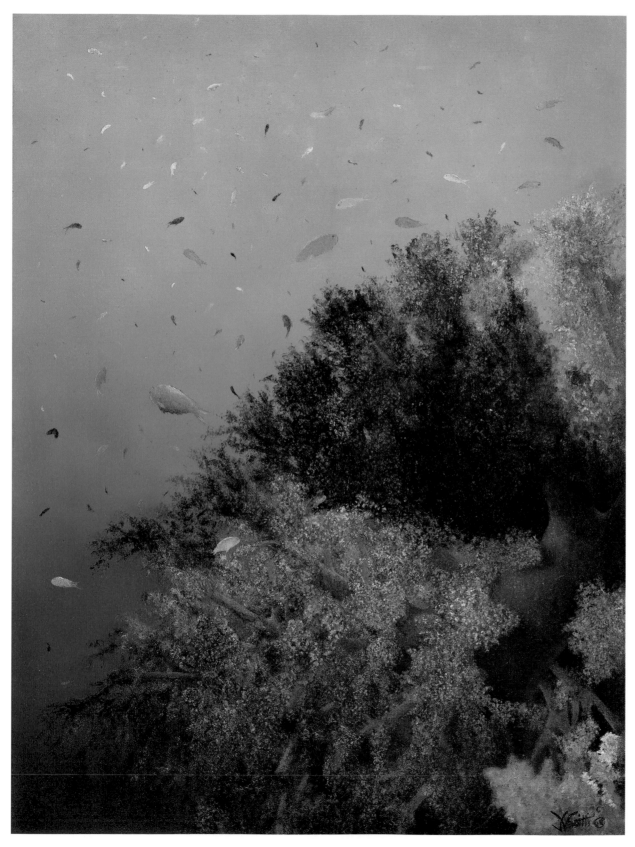

JERRY VENDITTI

Soft Coral
Oil on Belgium linen
24" x 18"

"Never a grander milieu of iridescence has the artist's eye beheld than that of our world's underwater coral reef gardens. Here even the darkness sparkles. With reverie and honor Venditti shares with us his tribute to our world's waters."

JERRY VENDITTI

DiscoSoma
Oil on Belgium linen
20" x 16"

"Never a grander milieu of iridescence has the artist's eye beheld than that of our world's underwater coral reef gardens. Here even the darkness sparkles. With reverie and honor Venditti shares with us his tribute to our world's waters."

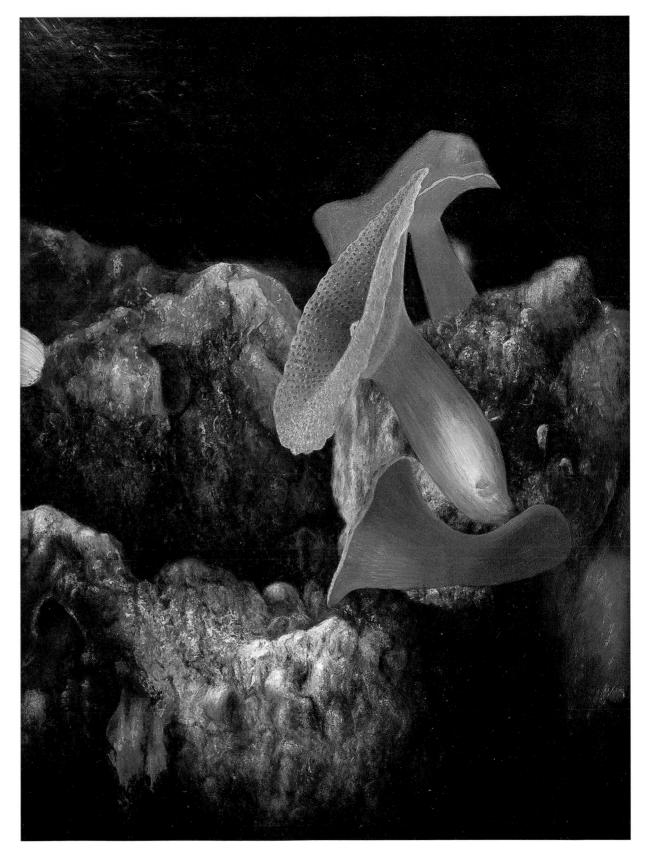

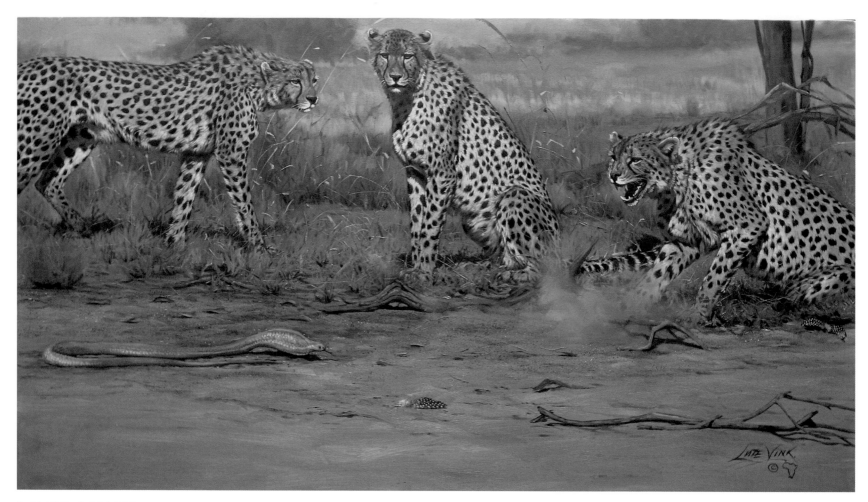

LUTE VINK

Dangerous Affair

Oil on canvas
800" x 1400"

"Cheetahs are facing so many dangers that their survival is always of great concern. A lot of us know this but so many people still need education.

In the wild, not only lions take their well-earned meal but leopards and hyenas steal their food and sometimes kill their cubs. Humans pose a threat by shooting them on cattle farms.

In this painting another possible threat is presenting itself in the shape of a Cape Cobra. These sub-adults came across a cobra that, in fact, wants nothing to do with them. The Cheetahs were probably taught to steer clear of all dangers, but being youngsters they are ever so curious!!

The cobra should be left well alone. Perhaps they know this, perhaps they don't.

It is up to the viewer to unfold the outcome of this scenario!!"

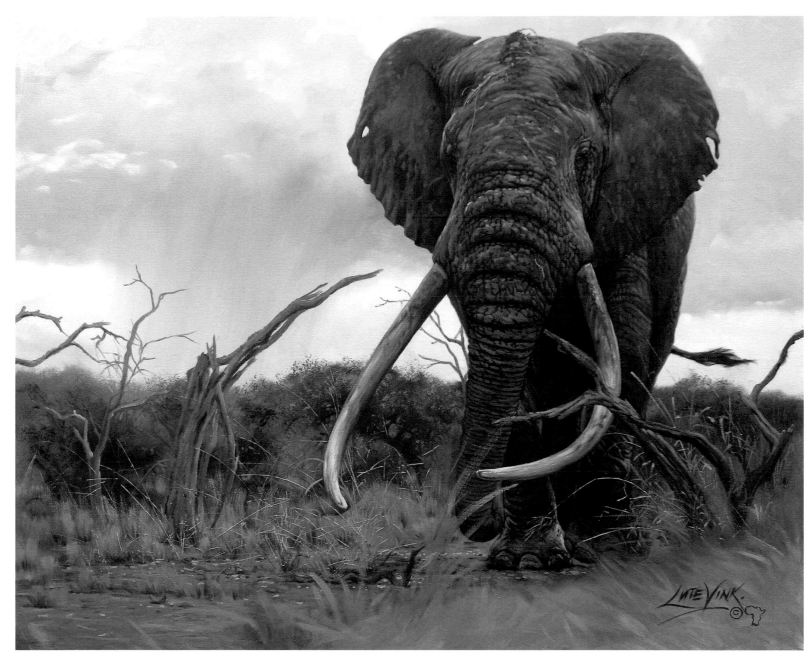

LUTE VINK

Madalla (Wise Old Man)
Oil on canvas
1000" x 800"

Earlier ivory and trophy hunters made a mess of things, diminishing their numbers as a species. Thankfully that was stopped but elephants still have to be protected from poachers. There are only a few parks/reserves that have elephant bulls with large heavy tusks.

This painting shows a large bull with beautiful tusks slowly wandering from feeding place to drinking place. Perhaps he's at the age where he wanders all by himself and competing for mating rights is not that important anymore. Perhaps he could still win the attention of a receptive cow by only showing off his huge profile.

For now he's just strolling along a well-known path after having had a drink. Where is he going to? It doesn't matter. While he is still walking, we can only stand in awe!!"

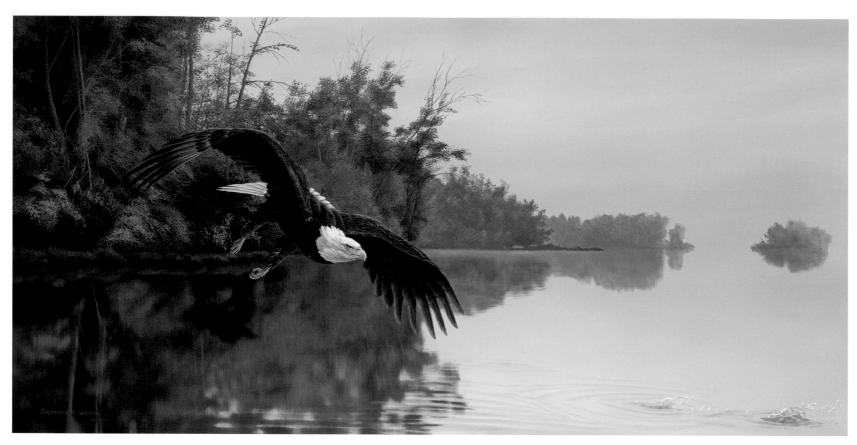

CHRISTOPHER WALDEN

Lake Patrol
Acrylic
33" x 57"

"The Bald Eagle has a precarious foothold on its existence at Lake St. Mary's in Ohio due to pollution from farm run-off. This is one of the two known nesting pairs which was hunting coots in the early morning mist."

CHRISTOPHER WALDEN

Balance of Nature
Acrylic
34" x 45"

"The wildlife and waterfowl on Lake St. Mary's in Ohio co-exist with algae bloom caused by the run-off from local farms. This Mallard, balanced on one leg at the edge of the lake after a long migratory flight, will not stay long. Most diving species of waterfowl eventually move on due to the lack of food."

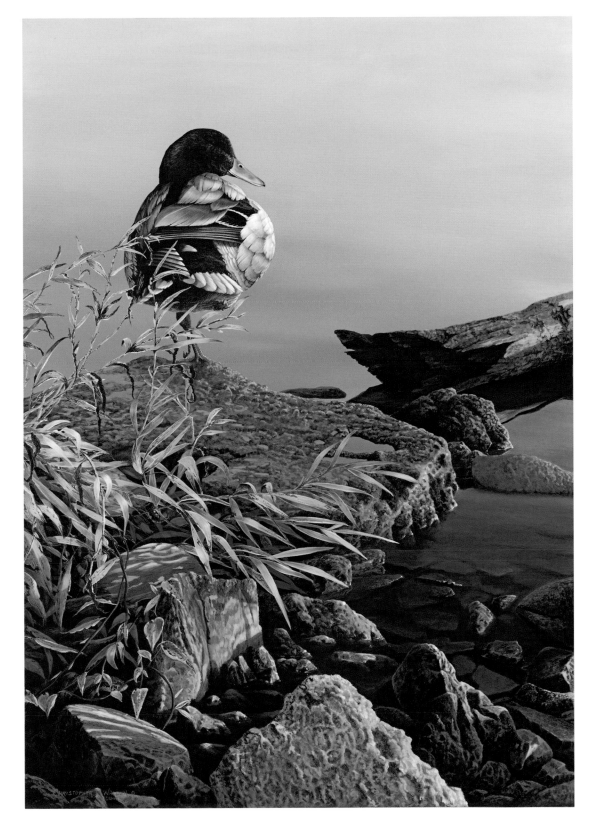

VAL WARNER

Grateful Griz
Oil on linen
40" x 50"

"This is Adam. He belongs to a friend of mine who has raised him to raise awareness of the nature of the Grizzly Bear. I think having Adam available for me and fellow photographers to enjoy and photograph is priceless. After a morning of just enjoying the waterfall, playing with the falls and tossing logs about while I watched, he stopped and looked right into my eyes. The look was pure gratitude. I was lucky enough to capture it with my camera and finally render it in oil paint for your enjoyment. I'm so grateful to Adam and the people that care for him."

VAL WARNER

Devotion
Oil on linen
32" x 28"

"While in Africa I visited an elephant orphanage. We got to feed them 2 times a day. I saw the devotion of their caretakers. This is Abde. He was totally devoted to his babies. Wendy, a favorite of his, is a teenager and full of mischief. Without Abde, she would give up and die as she had already been through trauma with her mother dying in the drought of '09. I couldn't wait to paint this and I do hope the emotion and connection is obvious and as strong as it is in real life."

TAYLOR WHITE

Nature's Spotlight
Oil on canvas
11″ x 14″

"I never had much desire to paint flowers until I saw the afternoon light bathe my garden with what I consider the essence of a painting - light. These lillies stand two feet over my head. I'm sure they feel for the light the way I do. I have been working for years trying to get the sun to shine in my paintings."

ELLEN WOODBURY

A Matter of Opinion
Cottonwood Limestone on Granite
22″ x 20″ x 16″

"I celebrate the animals we live with through my stylized stone sculpture. My 20-year career as a Disney Animator has helped me create these animals with expressive movement. These zebras approach their topic of conversation from different perspectives, much the way we differ in our views on ecology. The discussion is key to finding common goals."

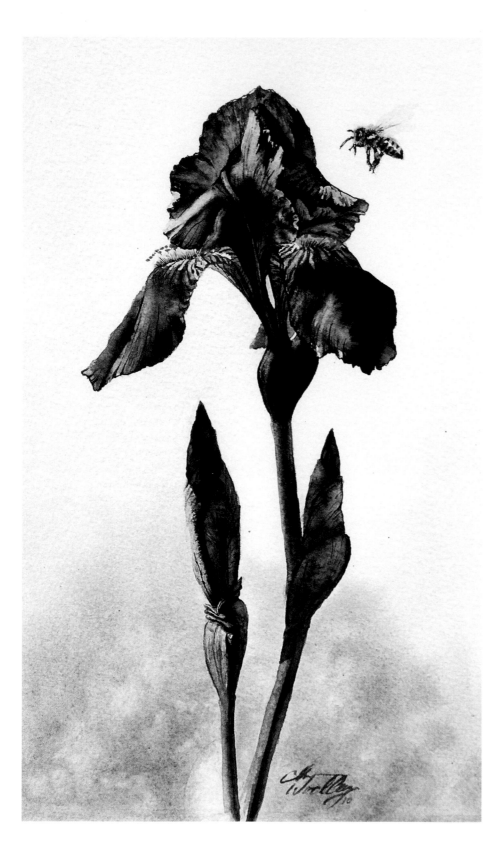

CHRIS WOOLLEY

The Honey Bee
Watercolor
10" x 6.5"

"I have grown to love our industrious Honey Bees. Their constant comings and goings keep our gardens alive. Recently, however, they have begun to disappear. What will happen if we lose our little friends?"

STEVE WORTHINGTON

Sumo Toads

Bronze

24″ x 38″ x 25″

"Amphibians are in a struggle for survival as habitat shrinks and becomes polluted.

This sculpture is a quirky but graphic depiction of the amphibian struggle."

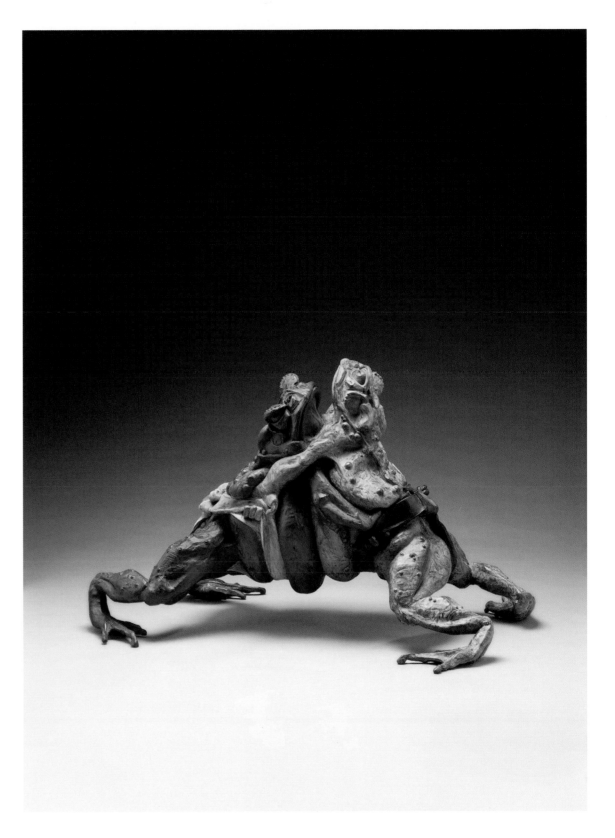

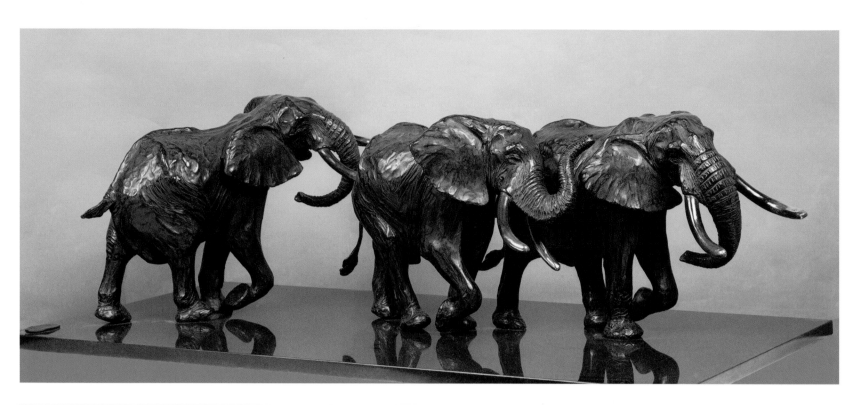

Above: Oil Painting "Ghosts Among the Trees" by Sue Stolberger.

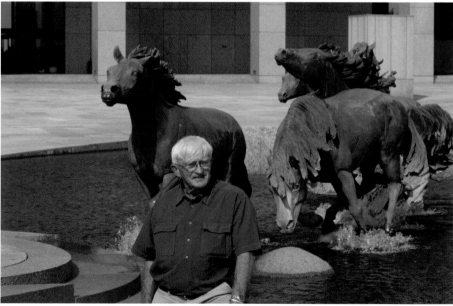

Top: "Three Old Bull Elephants" bronze sculpture by Rob Glen.
Immediately above: Rob Glen standing in front of landmark sculpture at Las Collinas in Dallas, Texas

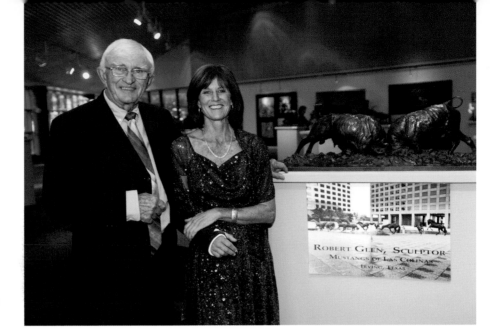

The Simon Combes
Conservation Award

2010 Co-Recipients: Robert Glen & Sue Stolberger

AFC's Simon Combes Conservation Award is the most prestigious award and highest honour AFC presents to a member artist who has shown artistic excellence and extraordinary contributions to the conservation cause, exemplifying the same qualities as the award's namesake. Past honourees include David Shepherd, Robert Bateman, and John Banovich.

A prominent member of AFC, Simon Combes was Project Director of the Kenya chapter of the Rhino Rescue Trust, an organization founded in 1985 to protect endangered species from being poached, and to help the communities surrounding Lake Nakuru National Park affected by wildlife conflicts. On December 12th, 2004, Simon was tragically killed by a charging Cape buffalo while hiking near his home in Kenya.

Simon was widely respected as a man of superb artistic talent, as a brilliant communicator, writer, instructor, world-traveler, painter, and as a steward of our planet. We were honoured to have had him as a member of Artists for Conservation.

The award's trophy design, the result of a competition among AFC members, was created by Peter Gray of South Africa. Depicting two Wildebeest emerging from a mass and fragmenting slightly to indicate the fragility of our efforts to sustain the wilderness areas and the disappearing herds, the trophy is sculpted in clay and founded bronze with personalized inscription.

Sue Stolberger and Robert Glen

Sue Stolberger and Robert Glen are internationally renowned artists living their dream as the only residents of Ruaha National Park in Tanzania. They specialize in depicting African wildlife, and are recognized as leading experts and advocates for the park and its inhabitants. Sue and Rob are committed conservationists and co-founders of the Ruaha Conservation Fund and the Idodi Environmental Center.

Artists for Conservation is extremely proud to present Sue and Glen with the Simon Combes Conservation Award this year, recognizing them for their hands-on dedication to conservation and environmental education through their extraordinary artistic talent.

As a painter with a distinctive style, Sue holds both solo and collaborative exhibitions around the world, including major city centres such as London, New

Above: Sue speaking near site of Idodi Environmental Center in Idodi, Tanzania.

"My motivation is to direct the viewer's attention to the fascinating design and beauty surrounding us in the natural world. The patterns and combinations of colours used in display and camouflage are all so perfect in their detail. I like to focus on a subject to highlight its design, which can be almost abstracted from its form and yet still be part of its environment."

"In addition to the more design-orientated paintings, I also like to capture fleeting moments, for that is all they ever are: the constantly changing light, the seasons, and the mood. Although the overall effect may be different, my interest in composition and design always remains paramount."

York, and Johannesburg to name a few. In 2003, she published The Ruaha Sketch Book, depicting in 200 watercolour studies and numerous pencil sketches the seasonal variations of her home, the Ruaha National Park, one of Africa's last remaining wildernesses.

Sue always works exclusively in the field, with her studio set up on the banks of the Great Ruaha River in Ruaha National Park. She finds the peace and solitude of the remote area not only conducive to painting but the best way to learn about the vast array of wildlife that surrounds her home.

Known for his dynamic and monument-sized bronze sculpture creations, Rob's work resides in many private collections including those of Her Majesty Queen Elizabeth II, His Highness the Aga Khan, and the actor James Stewart. He has held many solo shows in the USA, Canada, England, Monte Carlo, Spain and South Africa.

His public commissions include one of Texas' proudest monuments and one of the largest equestrian sculptures made in history - the Mustangs of Las Colinas. This impressive work (one and a half times life-size) depicts nine Mustang horses galloping through water, and celebrates the arrival in North America of the Andalusian horse. The monument was commissioned for the City of Las Colinas, Irving, Texas, and may be seen in Williams Square.

Above: Sue Stolberger and Rob Glen in their studio tents, in Ruaha National Park, Tanzania.

"My interest in art and natural history began in my childhood in Kenya where I was born in 1940. I was fascinated with birds and all living things and spent many hours at the Museum of Natural History in Nairobi. I established a life's friendship there with John Williams, the curator of ornithology at that time – my work was greatly influenced by him."

At merely sixteen years of age, Rob was accepted to serve an apprenticeship in taxidermy at the renowned studio of Coloman Jonas in Denver, Colorado. It was then that his particular interest in sculpture was born. Returning home after three years of training, he began a transition from taxidermy to sculpting animals in the European tradition of animaliers, and after working in various media, he cast his first bronze in 1970.

"I moved with Sue to Ruaha National Park in Tanzania in 1994. It is my true love of the African bush that has led me here. This is where I have sculpted and sketched for the past sixteen years, allowing me to be in close proximity to some of Africa's most engaging wildlife. Here, Sue and I have the peace and tranquility to inspire each other's work as well as fuel our passion for natural history, ecology, and conservation."

Rob and Sue have also contributed substantially to our understanding of African ecology and conservation of its habitats. Shortly after arriving in Ruaha, Sue discovered a new species of hornbill (*Tockus ruahae*). Since then, Sue and Rob have also discovered a new species of Chat, which is currently being described for publication in scientific journals. In his early years, Rob also discovered several new species of bats.

After serving for a decade on the Friends of Ruaha Society committee, Sue decided to branch off and lead her own conservation projects in the buffer zones surrounding the Ruaha park. As a child, Sue would visit the various game parks of Tanzania with her parents during the holidays. These trips into the wilderness were without doubt a great influence on Sue's desire to make a career from art and wildlife and fuelled her later passion for the conservation cause.

"I was born in Jamaica in 1995 - we moved to Dar es Salaam in Tanzania when I was four years old. I began painting seriously after leaving school. At eighteen, I held my first show in Nairobi. Four years later at 22, I was steadfast on making a career as a wildlife artist. I packed my bags and moved to Italy to study the great masters."

Sue funded everything by selling her paintings. After two years, she finally returned to East Africa where her adventures in the bush - paint brushes in hand – began.

Since Sue and Glen's arrival in the Ruaha National Park sixteen years ago, they have led efforts to protect and preserve the Ruaha River valley, and shared a dream of building an environmental center as a base for environmental education and support. Their dream became a reality with the opening of the Idodi Environmental Center in 2007. The solar-powered center has become an essential part of the Idodi community. Its library, film and lecture hall have become invaluable for the discovery process and growth of the 400 boarding-school children nearby.

"This is really quite an honour and we were surprised we were chosen to receive the award and very flattered. The nice thing about it is that Sue and I both knew Simon very well. He was not only a good artist but a fantastic person. We thank AFC for their work, highlighting the vital role art plays in the conservation arena."

Today, Sue and Glen still live and work out of their camp studios in Ruaha National Park. They are a remarkable story of two rare, dedicated and extremely talented individuals who inspire each other and those they meet through their work and their passion for nature and people.

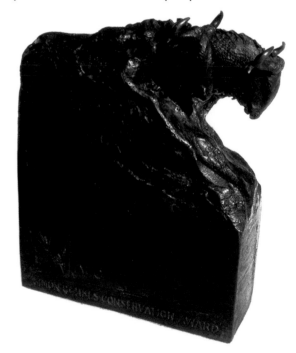

Photo of the Simon Combes Conservation Award trophy, designed by AFC artist Peter Gray of South Africa.

"The AFC Flag Expeditions program uniquely supports artists seeking to explore the world's remaining true wildernesses and to observe the rare or endangered species that live in those places. The program fosters a broader representation of the world's biodiversity in art by some of today's most talented artists."

— Jeffrey Whiting, President & Founder, Artists for Conservation Foundation

AFC Flag Expeditions
Exploration for Art & Conservation

www.artistsforconservation.org/flagexpeditions/

Launched in March 2005, this ground-breaking program was created to make possible the field study and artistic rendering of endangered species or habitats deserving of greater public attention. AFC Signature Members can apply for fellowship grants and the privilege of carrying the AFC flag on their journeys to remote and ecologically important areas of the planet.

Upon return from the expedition, participating artists are required to submit to the Foundation, a written journal and sketchbook of their journey, photos with the AFC flag in situ, a signed flag and video footage when possible. The AFC provides funding, as well as prominent exposure in a growing number of venues including on the AFC website, for each artist and each expedition. Each year at least two Fellowships are offered. The Program is open only to AFC Signature Members, who can apply to obtain financial support and the privilege of carrying the AFC flag on their journey.

The AFC's Flag Expeditions website documents these and other past expeditions and highlights new ones yet to be run. For more information about the program, please visit www.natureartists. com/flagexpeditions/.

Featured Flag Expeditions

- *"Not the Way of the Dodo - Endangered Species of Mauritius"*;
 Fellowship Recipient: Ria Winters

- *"The Argali Mountain Sheep of Mongolia - An Artist's Study of the Animal and the Desert-Steppe"*;
 Fellowship Recipient: Susan Fox

- *"Galapagos - Forty Days & Forty Nights - An Artists Sojourn"*;
 Fellowship Recipient: Kelly Dodge

AFC Flag Expedition #8:

Not the Way of the Dodo - Endangered Species of Mauritius

www.artistsforconservation.org/flagexpeditions/winters2009/

During May 2009, Ria Winters travelled to Mauritius to study, render and support conservation of its numerous endangered species, with special focus on its birds. The overall goal of her expedition was to bring particular attention to Mauritius and its wildlife, the geography of the island and the endemic species. The primary focus was on the Echo Parakeet, but also on highlighting the other endangered species, including the Pink Pigeon Mauritius Kestrel.

The project purpose remains aimed at drawing attention to the tragedy of extinction, the significance of the loss of species, and the fragility of ecosystems such as those found on Mauritius. At the time of writing, Ria continues her work to raise funds directly for wildlife conservation in Mauritius through the World Parrot Trust. In addition to lectures and fundraising activities, Ria plans a major exhibition at the Blue Penny Museum in Port Louis, Mauritius, featuring a series of 20 original paintings, a book and a special commemorative limited edition print.

Ria was inspired to travel to Mauritius due to the unique and fragile habitats it holds and the large number of endemic species that live there.

In natural history, the islands of the Republic of Mauritius are known for their endemic species and the tragic history

Opposite: AFC Flag in Mauritius with bronze sculpture of the extinct Dodo; Above (left): Female Echo Parakeet on endemic Ebony tree; Above-right (top): Original upland forest, Black River Gorges; Above-right (bottom): Madagascar Common Moorhen.

of some of them. That makes Mauritius unique and provides a unique subject for a conservation awareness project.

The Dodo (*Raphus cucullatus*) was a flightless member of the pigeon family, native only to the island of Mauritius. Full-grown, dodos weighed about 23 kg (50 pounds). After arriving in Mauritius, Europeans found the Dodo to be an easy source food and by the late 17th century, it had been driven to extinction by humans and human-introduced noxious species including feral dogs, pigs, rats, and monkeys.

The Dodo was not the only Mauritian bird driven to extinction in recent centuries. Only 21 of the 45 bird species originally found in Mauritius survive today. One bird species closely related to the Dodo became extinct in 1790: the Rodrigues Solitaire (*Raphus solitarius*).

The loss of the Dodo went largely unnoticed and was almost lost to history as a fictional oddity. Then, in the early 19th century, with the discovery of Dodo bones in the Mare aux Songes, reports written about them renewed interest in the species. The bird was brought to greater fame when it was featured in Lewis Carroll's "Alice's Adventures in Wonderland". With the popularity of the book, the Dodo became a

easily identifiable icon of extinction. The phrase "to go the way of the dodo" became a way of saying that something becomes extinct or obsolete, to fall out of common usage or practice, or to become a thing of the past.

On her journey, Ria successfully observed many threatened land and marine species, although her goal was to observe three particular species of interest, including the Echo Parakeet, the Pink Pigeon and the Mauritius Kestrel.

Once common on Mauritius, the Echo Parakeet (*Psittacula eques*) suffered a decline to 10 individuals in the wild. Today, through agressive conservation efforts, the population has rebounded to a few hundred individuals, though restricted to a small area of remnant native upland forest within the Black River Gorges National Par..

The Pink Pigeon (*Nesoenas mayeri*) was once found throughout Mauritius but is now limited to the wet upland forests in the south-west corner of the island. Suffering similar challenges faced by the Dodo, this very tame and vulnerable bird is threatened by habitat loss, cats, rats and monkeys. A captive breeding program started in the early 1980s, has increased population to more than 300 birds, from a low of

roughly 20 in 1985.

In the early 1970s, the endemic Kestrel population (*Falco punctatus*) fell to only 4 individuals, giving it the unenviable title of rarest bird in the world for a time. It has also recovered thorugh an active and successful intensive breeding program, though it remains the rarest falcon in the world.

Like the Echo Parakeet and Pink Pigeon, the Mauritius Falcon, is still recognized as an endangered species will require many more years of careful management to restore stable populations in the wild.

Ria Winters

Ria paints wildlife, landscapes, arctic and oceanic scenes, but most of all, she likes painting parrots. Parrots have always been an interest because of their colors and characters. Many people share their lives and homes with parrots, so parrots in art are loved by many people too.

"Another great thing about parrots is that there are so many species and they live on all continents. You never get bored with painting them because they are all so different.", says Ria. Study trips of observing parrots in the wild lie in the future. Next May is the first opportunity to study an endangered parrot species in the wild, which is the Echo Parakeet, endemic on Mauritius.

Ria has been drawing and painting frome early childhood. Animals and birds were always her main subjects. She is mainly self taught but after getting private training became more accomplished in her techniques. She collects reference material during her study trips. Besides being an artist she is also an advanced scuba diver and an accomplished

Above: Vista of Mauritius; Below (left to right): Madagascar Fody; Coral in the Indian Ocean; Female Echo parakeet

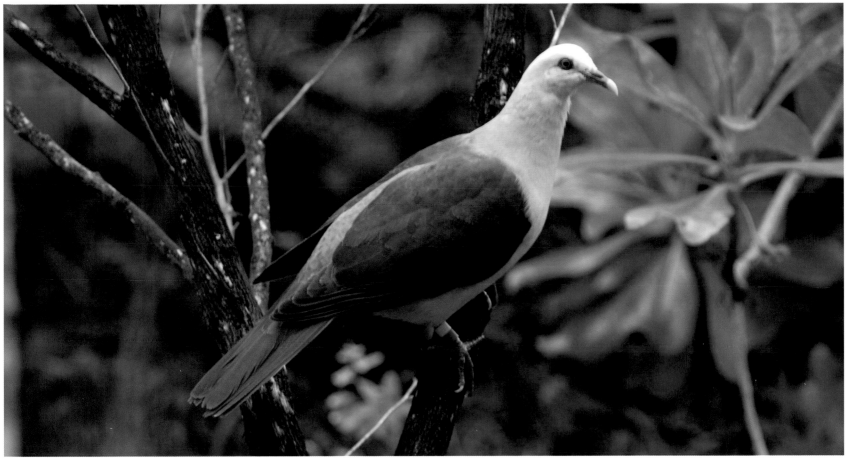

Above: The critically endangered Pink Pigeon of Mauritius. Below: Forest on Mauritus (left); Ria holding the flag in Port Louis (middle); Mauritius Kestrel (right).

photographer.

Ria supports the World Parrot Trust (WPT). Recently she's been invited to develop new products for the benefit of the WPT, saving parrots worldwide.

Nearly one-third of all parrot species are threatened in the wild and millions of pet parrots share people's lives and homes. The WPT is the leading parrot conservation organisation that works with parrot enthusiasts, researchers, local communities and government leaders to encourage effective solutions that protect parrots. Ria is happy to be one of them and to contribute through her art.

Comprehensive coverage of Ria's expedition, including photo, blog, as well as her flag journal can be found at www. artistsforconservation.org/flagexpeditions/winters2009.

 # The Mascarene Plateau

The Mascarene Plateau is an undersea plateau in the Indian Ocean. It extends approx. 2000 km from the Seychelles in the north to Réunion in the south. With depths ranging from 8 to 150 meters, plunging to 4000 m to the abyssal plain at its edges.

The southern part of the plateau includes the Mascarene islands (or Mascarene Archipelago) which are Mauritius, Réunion, Rodrigues, the Cargados Carajos Shoals and a few other small islands and banks (see map on previous page).

The Mascarene islands form a distinct ecoregion, known as the Mascarene forests.
The islands are home to many endemic plants and animals. They have never been connected to the mainland, so the flora and fauna arrived from over the sea.

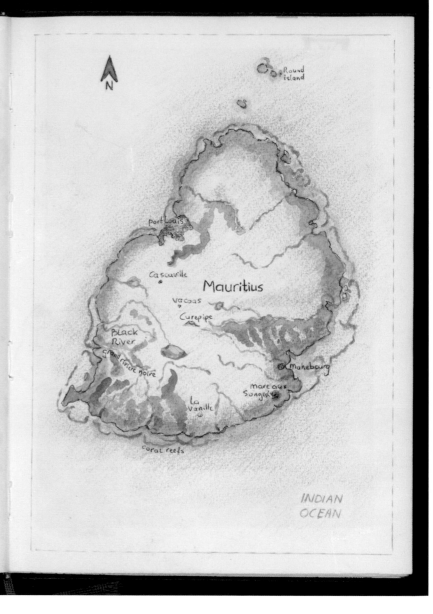

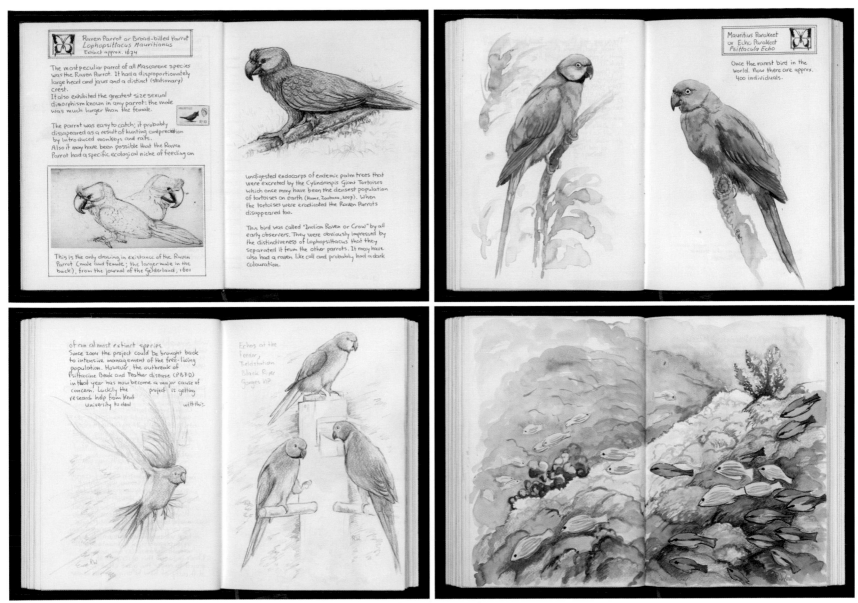

Above and opposite: Sample pages from the "Flag Journal" Ria completed during her Expedition to Mauritius.

References
- BirdLife International (2004). Raphus cucullatus. 2006. IUCN Red List of Threatened Species. IUCN 2006. www.iucnredlist.org. Retrieved on 2006-12-07. Database entry includes justification for why this species is listed as extinct.
- "DNA yields dodo family secrets". BBC News. London. 2002-02-28. http://news.bbc.co.uk/2/hi/science/nature/1847431.stm. Retrieved 2006-09-07.
- Dodo. (2010, August 6). In Wikipedia, The Free Encyclopedia. Retrieved 18:58, August 7, 2010, from http://en.wikipedia.org/w/index.php?title=Dodo&oldid=377461918
- "Scientists find 'mass dodo grave'". BBC News. London. 2005-12-24. http://news.bbc.co.uk/2/hi/science/nature/4556928.stm. Retrieved 2006-09-07.
- Lewis Carroll's Alice's Adventures in Wonderland was published in 1865.
- Dodo Bird FAQs - WikiFAQ - Answers to Frequently Asked Questions (FAQ)
- BirdLife International (2010) Species factsheet: Nesoenas mayeri. Downloaded from http://www.birdlife.org on 7/7/2010
- BirdLife International (2010) Species factsheet: Psittacula eques. Downloaded from http://www.birdlife.org on 7/7/2010
- BirdLife International (2010) Species factsheet: Falco cherrug. Downloaded from http://www.birdlife.org on 7/7/2010.
- BirdLife International (2010) Species factsheet: Falco punctatus. Downloaded from http://www.birdlife.org on 7/7/2010

AFC Flag Expedition #9:
The Argali Mountain Sheep of Mongolia:
An Artist's Study of the Animal and the Desert-Steppe
www.artistsforconservation.org/flagexpeditions/fox2009/

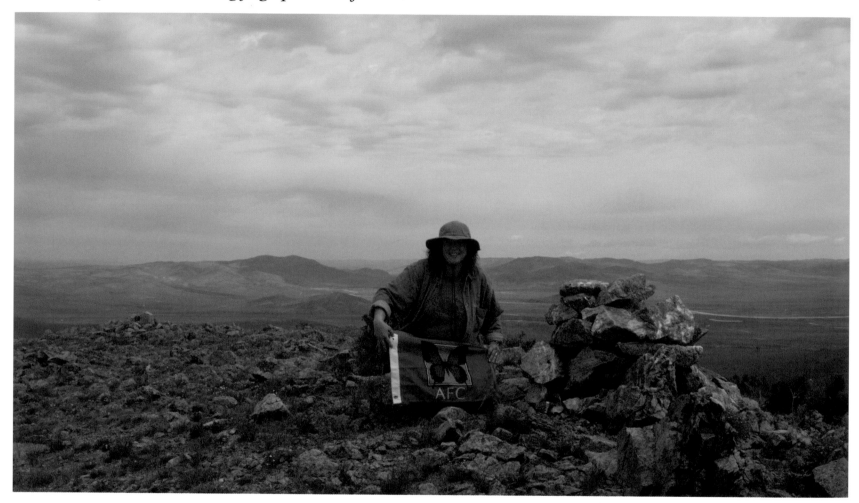

In July, 2009, Susan Fox travelled to the Ikh Nartiin Chuluu Nature Reserve in Mongolia to study, sketch and photograph endangered argali, the world's largest mountain sheep.

Ongoing research on argali is being carried on by Dr. Richard Reading of the Denver Zoological Foundation, who consulted closely with Susan on her expedition. In particular, in working with Dr. Reading, Susan learned about strategies being used with local people to "try to induce changes in livestock husbandry practices that will benefit argali." Upon her return home, she decided to look for ways to use the arts to support conservation. When the opportunity came along through the

Denver Zoo to help a group of local herder women set up a crafts cooperative, she gladly took this on as her first effort. The cooperative provides the women with the opportunity to realize a revenue stream from the existence of the reserve, its visitors who come to stay at an eco-ger camp, and the ongoing presence of Earthwatch Institute volunteers – who are based at the research camp in the reserve.

Since then, the director of the cooperative, which the women have named "Ihk Nart Is Our Future", has visited almost every Earthwatch team, bringing a variety of felt items for purchase. Susan, through her non-profit association, Art

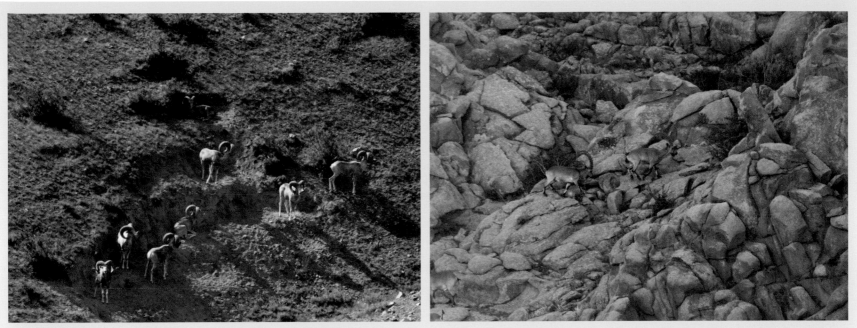

Opposite: Susan posing with the AFC Flag on Baits Uul (Mt. Baits) at Gun-Galuut Nature Reserve, the first stop on her Flag Expedition (Photo by Khatnabaatar). Above (left): Argali rams, Gun-Galuut. Above (right): Siberian ibex, Baga Gazriin Chuluu Nature Reserve.

Partnerships for Mongolian Conservation, has loaned the co-operative funds for the purchase of a felt press. She has also supplied a grant to pay for ten days of training for the director and one other woman and to acquire some additional tools. Donations have come in for the outright purchase of a second press and also 21 high-quality sewing scissors. "It's a rare privilege to be involved personally with a project of this kind," says Susan, "I'm looking forward to working with Ikh Nart Is Our Future for many years. Art has once again proved to be an important bridge between cultures."

During the three-week expedition, Susan travelled to two additional locations, the Gun-Galuut Nature Reserve and the Baga Gazriin Chuluu Nature Reserve, where there are also populations of argali, to compare their status and conditions with those at Ikh Nartiin Chuluu. In the future, she wants to learn more about, and gather reference if possible (since many are nocturnal), of other species which share argali habitat, such as Siberian ibex and khulan (wild ass) and small carnivores like badger, Corsac fox and Pallas' cat. The Reserve is also home to one of the largest nesting concentrations of cinereous vultures, the world's largest.

Ikh Nartiin Chuluu is located in what is called a Desert Steppe or Gobi-Steppe Ecosystem, which covers 20% of Mongolia's land area. It lies between the true Steppe and true Desert. Many Central Asian endemic plants are found is this zone. The Ikh Nartiin Chuluu Nature reserve was created to conserve a large area of rocky outcroppings of about 43,000 ha. It has retained a relatively pristine ecology. Until Dr. Reading began his research project in 1994, little was known scientifically about the argali. However, the population is declining and the species is listed as threatened both internationally and in Mongolia. His goal is to "understand argali sheep ecology well enough to develop a long-term conservation management plan". An important part of Susan's expedition was learning what information has already been gleaned in this regard, so as to apply it to her artwork.

Argali are listed on Appendix II of the Convention on International Trade of Endangered Species (CITES). The US Endangered Species List includes them as threatened and they were listed as vulnerable on the 1996 IUCN Red List of Threatened Animals.

Besides the resident argali, endangered khulan or Asian ass visit the southern part of the reserve in the summer. One hundred and twenty-four species of birds have been observed at Ikh Nart, including the endangered Saker Falcon.

Permanent and ephemeral streams and springs provide water, both for the wildlife and the local herder families. The presence of water attracts a variety of migrating birds.

Local herders and their animals live in and around the Reserve. A recent study demonstrated a 95% grazing overlap between the argali and domestic livestock, which include

horses, goats, sheep, cattle and bactrian camels. Sustainable land use is an environmental issue in Ikh Nart, as it is throughout Mongolia and many parts of the world.

Susan's Flag Expedition was a success on all counts. She had multiple good sightings of argali at all three locations that she visited. One of the most significant happened on the very first day at Gun-Galuut when she took what turned out to be the first known photographs of an argali swimming across a river. She broadened her knowledge of the species by seeing them in different places, which will provide a larger context for her paintings.

Her meetings with the women at Ikh Nart exceeded everyone's expectations. The women had come well prepared and were very enthusiastic. Susan and her scientist/translator were kept very busy for three solid days, but she did find time to offer a drawing lesson to three interested young people. By the time Susan left, there was no doubt that the cooperative would grow and thrive. Efforts are underway to find USA outlets for their work.

For the future, Susan plans to return to Mongolia, and Ikh Nart every year as time and finances allow. There have already been queries from herders in other areas who have heard about what is happening at Ikh Nart and want to learn more. So perhaps her expedition was really only a beginning. "I want to thank AFC for making my journey possible through their Flag Expedition grant program, the Denver Zoo for finding a way for an artist to aid their conservation efforts and Nomadic Journeys for their usual professional and reliable travel support while I was in Mongolia.

Susan Fox

Susan Fox had the good fortune to grow up on the Redwood Coast of California, about five hours north of San Francisco. She started her

Above (top): Making felt, Ikh Nart- On Susan's first morning at Ikh Nartiin Chuluu, the women demonstrated how they make felt from wool which comes from their own sheep. Above (bottom): A felt purse - One of the felt craft items made by a member of the cooperative and which was given to Susan as a gift.

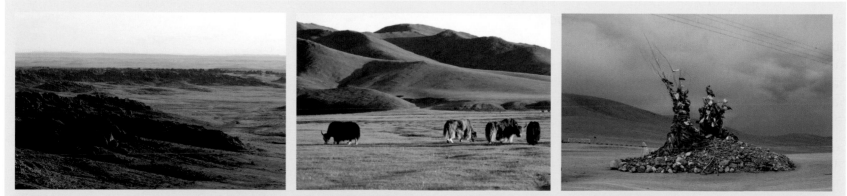

Above-left: Overview of rock formations and argali and ibex habitat at Baga Gazriin Chuluu Nature Reserve; Above-middle: Yaks, Gun-Galuut- A herd of domestic yaks graze near the base of Baits Uul (Mt. Baits) at Gun-Galuut Nature Reserve.; Above-right: Large ovoo, enroute from UB to Arburd Sands.

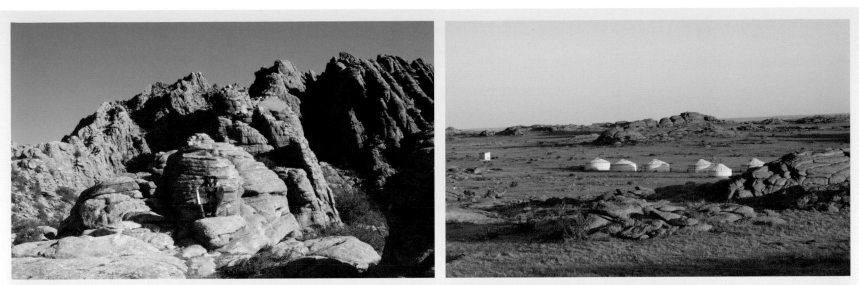

Above (left): Susan with AFC Flag, Ikh Nartiin Chuluu; Above (right): Red Rocks ger camp, Ikh Nartiin Chuluu.

career as a sign painter's apprentice in 1976 at age 22, also getting on-the-job training as a graphic designer.

For the next ten years, she freelanced as a graphic designer and sign painter for a wide variety of clients in northern California. She went back to school in 1987 at age 35 and received her BFA Illustration from the Academy of Art College (now University) in San Francisco, California in 1989.

Upon moving back home to Humboldt County, Susan studied traditional oil painting with a local instructor while she continued with her illustration and design business and, for an interesting year, ran her own art gallery. By the late 90's, she was painting in oil full-time and had decided that the natural world was her chosen subject.

She has studied with well-known artists such as John Seerey-Lester, Paco Young, John Banovich, Jim Wilcox and Scott Christensen. In October of 2004, Susan went on a 16-day artist's workshop/safari in Kenya with Simon Combes.

Susan counts Carl Rungius, Maurice Braun, Edgar Payne, Bob Kuhn and Scott Christensen among her major influences. She has always been more interested in developing a personal, painterly manner of interpreting her subjects than in a literal representation.

Susan loves to travel and she and her sketchbook have been to Mongolia, Kenya, Portugal, England, France, Germany, Canada, Japan, and many states in the US.

She has found during her fieldwork that when one takes the time to sit and observe animals in their native habitat, they in-

Below (top): Argali; Below (bottom): Susan posing with the AFC Flag in her new del (Mongolian garment) in front of a "maikhan" or Mongol summer tent at Ikh Nartiin Chuluu Nature Reserve. Photo by Gana Wingard.

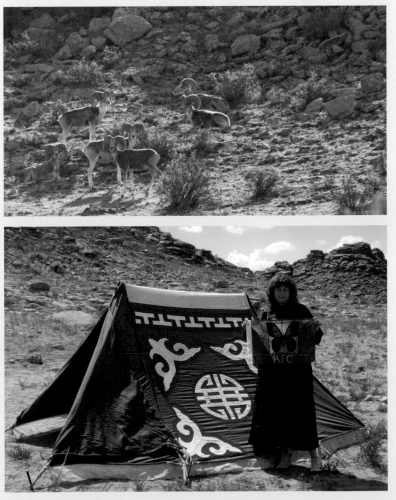

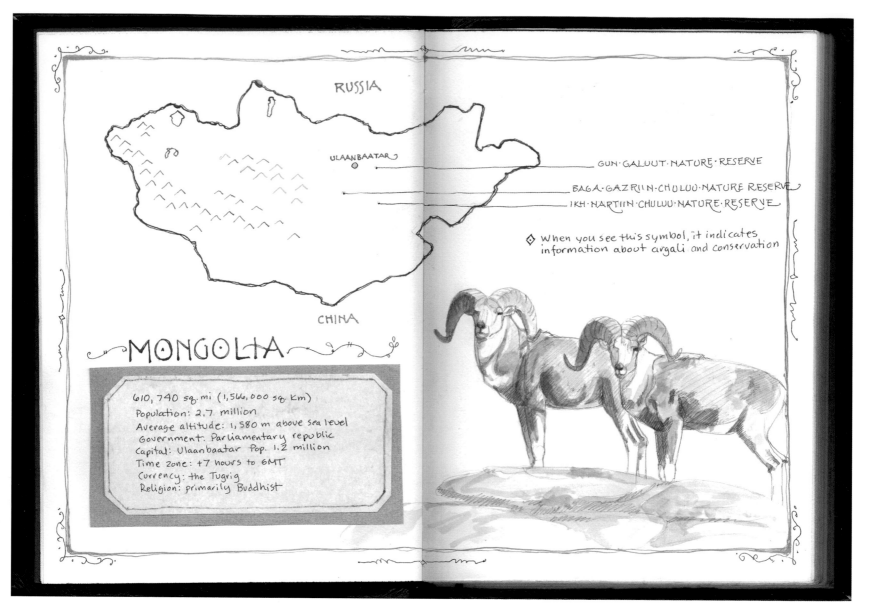

RUSSIA

ULAANBAATAR

GUN·GALUUT·NATURE·RESERVE

BAGA·GAZRIIN·CHULUU·NATURE·RESERVE

IKH·NARTIIN·CHULUU·NATURE·RESERVE

◇ When you see this symbol, it indicates information about argali and conservation

CHINA

MONGOLIA

610,740 sq. mi (1,566,000 sq. Km)
Population: 2.7 million
Average altitude: 1,580 m above sea level
Government: Parliamentary republic
Capital: Ulaanbaatar Pop. 1.2 million
Time zone: +7 hours to GMT
Currency: the Tugrig
Religion: primarily Buddhist

evitably reveal little insights into their lives which are totally separate from any relationship, or perceived value, to humans. The chance to record those moments on canvas is one of the things that gets Susan's creative juices flowing. She always tries to to depict a specific individual, not just a generic representation of the species.

Susan feels very strongly that "The planet belongs to all of us together. If there are no good places for the animals, then ultimately there will be no good places for us either. We are just barely beginning to comprehend how interconnected and mutually dependent our world is. One of my fondest hopes for the future is that we, as a species, will finally grow up and learn to share."

Susan and her husband currently reside on one acre near the Pacific Ocean in Dow's Prairie, McKinleyville, California, which they share with their tri-color rough collie, Niki, and three cats: Eowyn, Michiko and Alexander.

Comprehensive coverage of Susan's expedition, including photo gallery, blog, video clips, finished paintings, and her Flag Expedition journal can be found at: www.artistsforconservation.org/flagexpeditions/fox2009.

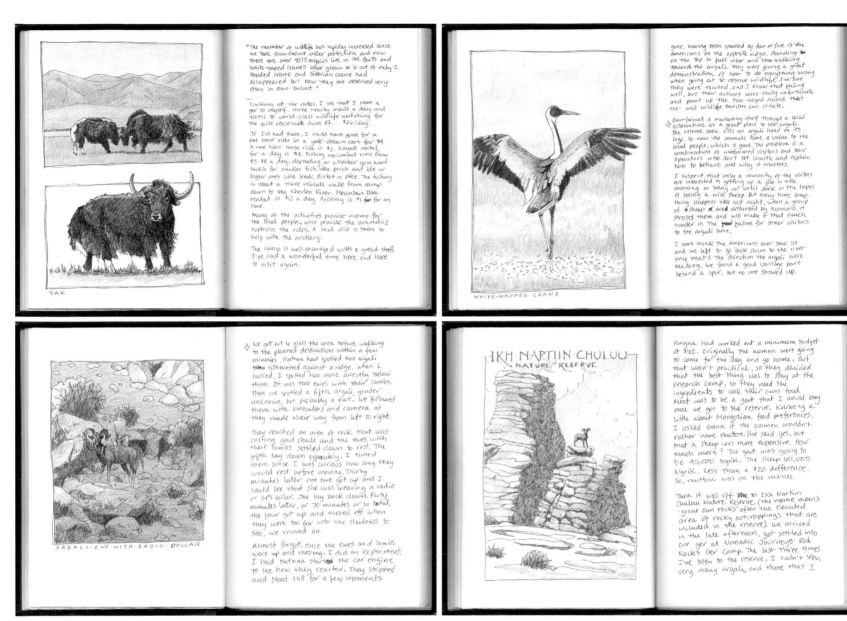

Sample pages from the "Flag Journal" Susan completed during her Expedition to Mongolia.

"The planet belongs to all of us together. If there are no good places for the animals, then ultimately there will be no good places for us either. We are just barely beginning to comprehend how interconnected and mutually dependent our world is. One of my fondest hopes for the future is that we, as a species, will finally grow up and learn to share."

— Susan Fox

References

- Gobi Desert. (2010, August 5). In Wikipedia, The Free Encyclopedia. Retrieved 18:54, July 7, 2010, from http://en.wikipedia.org/w/index.php?title=Gobi_Desert&oldid=377323559
- Alexander K. Fedosenko and David A. Blank: Mammalian Species, No. 773, Ovis ammon (Jul. 15, 2005), pp. 1-15. Published by: American Society of Mammalogists
- Argali. (2010, August 2). In Wikipedia, The Free Encyclopedia. Retrieved 19:03, August 7, 2010, from http://en.wikipedia.org/w/index.php?title=Argali&oldid=376741960

AFC Flag Expedition #10:
Galapagos - Forty Days & Forty Nights - An Artists Sojourn
www.artistsforconservation.org/flagexpeditions/dodge2009/

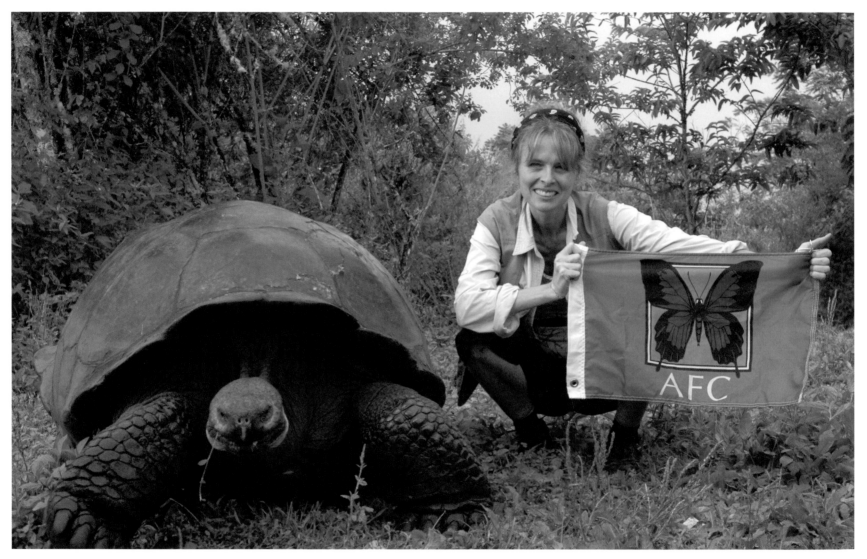

In late September, 2009, Kelly Dodge travelled to the Galapagos as recipient of the AFC's tenth Flag Expedition fellowship, to spend forty days studying, sketching and photographing the unique animals and plants of the Islands.

The purpose of her expedition was to study through sketching, notes, photography and collaboration with local scientific experts, the endemic and endangered flora and fauna of the Galapagos archipelago. During her expedition, Kelly successfully explored ten of the thirteen islands in the archipelago,

ranging from open sea and rock islets to the six distinct vegetation zones – each supporting specific communities of plants and animals.

Her objectives included partnering with local NGOs to support the preservation, restoration and enhancement of the Galapagos ecosystem with a goal of creating a major body of artwork featuring the diversity of endangered species living on the islands. Through her artwork, she placed a strong emphasis on environmental education, while highlighting

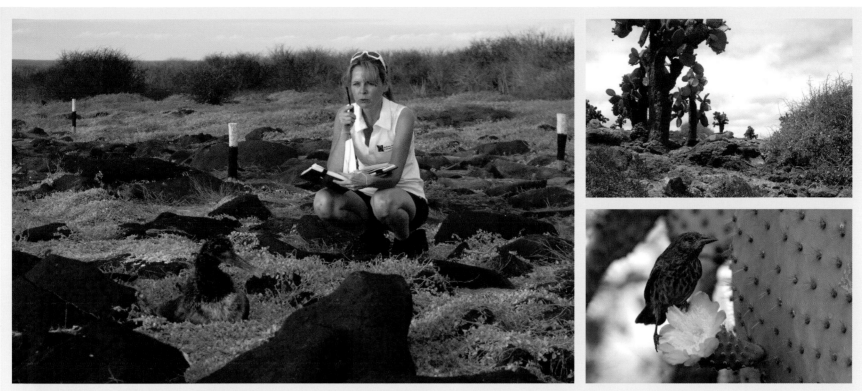

Opposite: Kelly posing with the AFC Flag and Galapagos Giant Tortoise; Above-left: Kelly sketching critically endangered Waved Albatross Chick; Above-right (top): South Plaza Island; Above-right (bottom): Cactus Finch.

the conservation challenges each species faces. Her studies, while in the field, encompassed endemic and resident birds, mammals and reptiles of the eight zones of the Galapagos archipelago.

"My goal is to observe, learn about and document as many of the endemic and resident wildlife species as possible as they relate specifically to the habitat zones that support and sustain them, and as they relate to each other both physiologically and behaviorally. No species exists on its own. We all exist as members of intimately related communities. The Galapagos is a unique community of species sharing the same unique environment in a social relationship so intimate that symbiosis between species is commonly observed."

At the time of writing, Kelly has already created a significant body of studio artwork inspired from her expedition, and is preparing for a major solo show focused entirely on the Galapagos. Both the expedition and her show were intended to coincide with the 200th anniversary of Charles Darwin's birth and 150th anniversary of the publishing of the "On the Origin of Species". In the years ahead, Kelly will be sharing her personal experience with the world in the hope of demonstrating the need for preservation and conservation of this area.

About the Galapagos

The islands are unique for many reasons including the isolated and diverse habitats, endangered species, and the sensitivity of the environment. The tropical sun, combined with the cool Humboldt and Cromwell currents, create a unique mix of tropical and temperate zones that in turn support a uniquely diverse ecology made up of a plethora of species that exist nowhere else on the planet. This convergence of currents results in a spectacular range of marine life which supports an array of seabirds, mammals and reptiles.

During his world voyage aboard the H.M.S Beagle in 1831-1836, Charles Darwin visited the islands. During his stay, Darwin was inspired by what he saw, and began work on his revolutionary book about evolution and natural selection. "The Origin of Species" was published in 1859, and was both controversial and popular. Darwin was a religious man himself and had even considered a career in the church. Nonetheless his theory of evolution attacked by those who viewed it contrary to interpretations of the Bible. Today Darwin's theories are nearly universally embraced by the scientific community, and have been heavily expanded upon.

Human activities since the 17th and 18th centuries have resulted in substantial alterations in Galapagos ecosystems. Nearly 60% of the 168 endemic plant species are close to extinction, threatened by goats and other introduced herbivores, competition from introduced plants and the destruction of their natural habitat. For example, one species of Opuntia Cactus found only on one island (Isabella) is critically endangered. These cacti are a vital food and nesting source for a variety of vulnerable and endangered wildlife.

Access to all the islands is strictly regulated. Although tourists visit the islands, there are restricted areas that few people will ever get the opportunity to experience firsthand. This expedition allowed Kelly the opportunity to study, document and catalogue various endangered species of plants and animals and to share these through her finished studio pastel paintings. Kelly will be continuing to share her personal experience with the world in the hope of demonstrating the need for preservation and conservation of this area.

Kelly Dodge

2010 marks a career milestone for Kelly as she celebrates her 10th anniversary as an artist. A highlight of her career has been the prestigious AFC Flag Expediton fellowship enabling her to travel to the Galapagos Islands.

Having had the privilege of meeting firsthand the creatures who become the subjects of her artwork, Kelly's desire is to share this experience with others who may never be able to encounter firsthand a wild creature in their natural environment. Kelly explains: "I want to invite viewers into their world through my art as participants, while at the same time instilling a global awareness of the challenges that they face and that

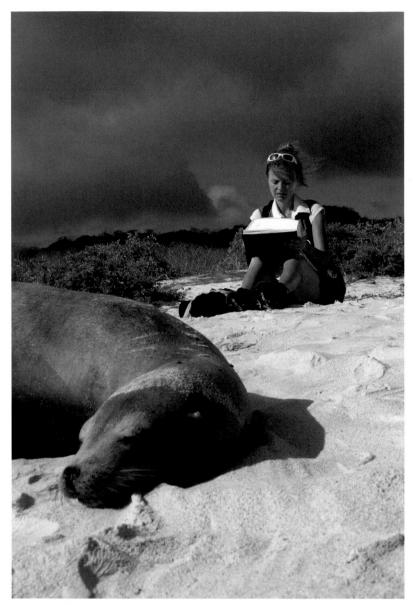

Above: Kelly sketching Galapagos Sea Lion.
Below: Images from Kelly's journey through the Galapagos Islands.

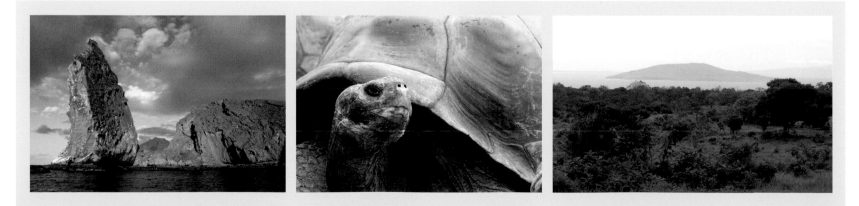

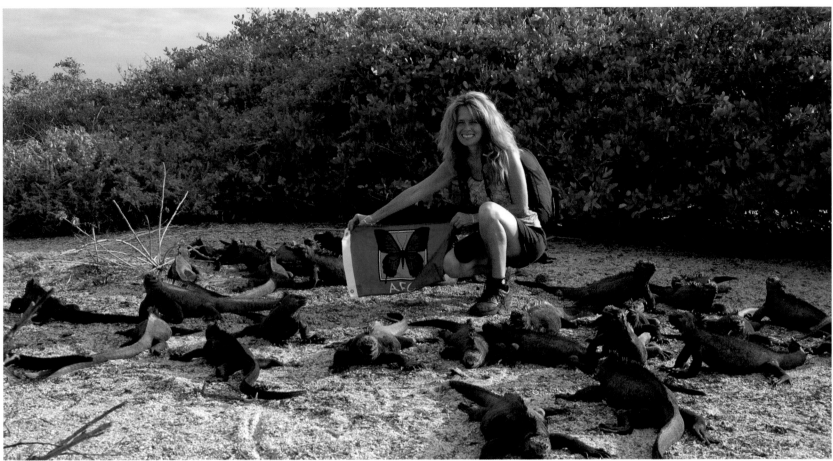

Above: Kelly holding AFC flag with Marine Iguanas. Below: Images from Kelly's journey through the Galapagos Islands.

we ultimately all face. I hope to share a message which will result in reflection of our own conservation behaviors with an understanding that we can make a difference."

Kelly has had the opportunity to explore the Southern Hemisphere flora, fauna and skies in Kenya in 2005, while in the summer of 2007, she was the accompanying artist on an AFC Flag Expedition to the Indian Himalayas. In 2008 she journeyed on a scouting mission with her husband to Ecuador to explore the Galapagos Islands – a precursor to receiving an AFC Flag Expedition fellowship to return once again.

Primarily painting in pastel, Kelly is perhaps best known for her ongoing focus on birds often combined inspirationally with traditional Christian hymns. She has also garnered much popularity with a second series, pastel paintings por-

Vermilion Flycatcher
assessed 2008
observed in Pampa / Fern Sedge
Zone on the ledge
of transitional zone

Adult ♂

Adult ♀

1st year ♂

traying breathtaking views of the constellations.

Kelly has been a member of the Pastel Society of America, N.Y and the Society of Animal Artists, N.Y. since 2003 and 2004. Her work has been published numerous times, most recently being featured in Wildscape Magazine, U.K. She is represented by Studio 737 and by Canada's leading wilderness and wildlife art gallery, The Algonquin Art Centre.

When summarizing her work, Kelly proclaims: "As stewards of Creation, we must remember our place in the natural world. My art is a celebration of the privileged place I hold in partnership with my fellow creatures and my Creator. A genuine appreciation of our place in the natural order is where true change begins — a truth driven home by my forty days and forty nights on the extraordinary islands of Galapagos."

Comprehensive coverage of Kelly's expedition, including photo, blog and flag journal can be found at www.artistsfor-conservation.org/flagexpeditions/dodge2009.

Sample pages from the "Flag Journal" Kelly completed during her Expedition to the Galapagos.

"I want to invite viewers into their world through my art as participants, while at the same time instilling a global awareness of the challenges that they face and that we ultimately all face. I hope to share a message which will result in reflection of our own conservation behaviors with an understanding that we can make a difference."

— Kelly Dodge

References

- Galápagos Islands. (2010, August 1). In Wikipedia, The Free Encyclopedia. Retrieved 19:05, August 7, 2010, from http://en.wikipedia.org/w/index.php?title=Gal%C3%A1pagos_Islands&oldid=376527307
- Charles Darwin. (2010, August 6). In Wikipedia, The Free Encyclopedia. Retrieved 19:06, August 7, 2010, from http://en.wikipedia.org/w/index.php?title=Charles_Darwin&oldid=377499498
- On the Origin of Species. (2010, August 4). In Wikipedia, The Free Encyclopedia. Retrieved 19:08, August 7, 2010, from http://en.wikipedia.org/w/index.php?title=On_the_Origin_of_Species&oldid=377157345

Artists for Conservation

Supporting Nature Through Art

The Artists for Conservation Foundation is the world's leading non-profit group dedicated to supporting the environment through art. Founded in 1997 in Vancouver, Canada, AFC's membership spans five continents and 27 countries and comprises the world's most gifted nature artists.

AFC has a mission to support wildlife and habitat conservation, biodiversity, sustainability, and environmental education through art that celebrates our natural heritage. The organization dedicates its resources to nurturing its world-class community of artists, and leveraging this unique pool of talent to support its mission through a variety of objectives and initiatives, including:

- Engaging and educating individuals through artistic expression to convey the importance and urgency of sustaining our natural heritage;

- Supporting art-science field research expeditions to study endangered species and threatened habitats;

- Facilitating member art sales to raise funds for conservation.

- Producing art exhibitions and publications in support of conservation;

- Maintaining the world's largest gallery of nature art, and

- Recognizing artists and other individuals and organizations for their support of conservation.

How We Do It - Key Programs

ArtistsForConservation.org Website

ArtistsForConservation.org features thousands original and limited edition nature inspired artwork with thousands of original paintings and sculptures for sale. It is the largest, most sophisticated and most visited site of its kind today, receiving over 300,000 visits per month. It is also the leading source for nature oriented news and events.

The Art of Conservation Exhibition

AFC's annual juried exhibit – The Art of Conservation – recognizes artists for their commitment to artistic excellence and conservation, raises awareness of environmental issues, and directly supports conservation organizations through the sale of artwork.

AFC Flag Expeditions Program

AFC's Flag Expedition program facilitates collaborative art and science field work to study and promote endangered species and their vanishing habitats. The program uniquely supports artists seeking to explore the world's remaining true wildernesses and to observe the rare or endangered species that live in those places. It fosters a broader representation of the world's biodiversity in art by some of today's most talented artists.

For more information about AFC, visit the AFC website at:

w w w . A r t i s t s F o r C o n s e r v a t i o n . o r g

Why Support AFC?

We live during an extraordinary period in history. Most who read this may well see over one-third of Earth's species vanish, along with dozens of human cultural lines and languages. The challenge of climate change, loss of biodiversity, desertification, overpopulation, and deforestation - each on its own - stands to adversely affect us all. Together, these challenges represent symptoms of a global pattern of impact by humans on the web of life that supports us. Many artists today are active participants in an important movement, channeling artistic talent toward addressing the challenge of achieving a sustainable future. At the forefront of this movement is AFC. With your generosity we can continue our movement and our programs to create lasting pillars of support for our environment.

Art for Conservation

AFC's Art for Conservation program provides an online venue for the sale of artwork with a portion of the proceeds voluntarily earmarked by the artist to support a conservation organization of their choice.

AFC Awards

AFC Awards exist to highlight excellence in conservation and art and to empower and reward passionate professional artists as effective ambassadors for the environment. We currently run two awards programs: the monthly Conservation Artist Award and the yearly Simon Combes Conservation award.

AFC Principals

Jeffrey Whiting, President & Founder

Educated with a degree in biology and geology, Jeff is an award-winning sculptor of natural subjects, a software engineer and an author and illustrator of several published art and nature books. As an artist, Jeff's sculptures and books aim to inform and inspire others to learn more about our natural heritage. He is a member of the Society of Animal Artists, and has exhibited his work in the Leigh Yawkey "Birds in Art" exhibition. At 16 years old, one of his sculptures was presented by the Prime Minister of Canada to Prince Philip, Duke of Edinburgh.

In 1997, Jeff combined his passions for nature and art with his management skills and his technology knowledge and resources to found Artists for Conservation. Today, Jeff is the key driving force and visionary behind the organization. Jeff is also co-founder and partner in a leading Internet technology consulting firm, ISCAPE Internet Consulting, based in Vancouver, Canada.

Jeff resides in North Vancouver, British Columbia with his wife Yasaman, and two children—Amanda and Anthony.

William Whiting, Managing Director

Bill has 30 years of industrial and trade policy experience with the Canadian Federal Government. A Professional Engineer with a Masters degree in Business Administration (MBA), he was a senior executive for a number of years with the Industry Department, where he managed a staff of senior professionals before his retirement. He has been involved with AFC from its inception as a volunteer and strategist.

As Director of the Automotive Branch of Industry Canada, Bill was exposed to many of the latest alternative fuel initiatives and became familiar with fuel cell technologies. Bill has had a life filled with creativity—from woodworking, architecture and wood sculpture to landscape design. He is an avid outdoorsman and amateur naturalist and operator of a small organic Christmas tree plantation. He currently works for AFC from his rural 1830s log home, just one hour's drive from Canada's capital.

When not corresponding with AFC members, digging holes with his tractor, or tending to his gardens, Bill is working on a long-term strategy to retire from his retirement.

For more information about AFC, visit the AFC website at:

www.ArtistsForConservation.org

AFC Membership (2010)

Patricia Ackor
Sue deLearie Adair
Jodie Adams
John Agnew
Al Agnew
Douglas Aja
Edward Aldrich
Charles Alexander
Phillip Allder
Charles Allmond
Tom Altenburg
Wayne Anderson
Carol Andre
Brenda Angelstad
Emil Antony
Paul Apps
Stuart Arnett
Malcolm Arnold
Stephen A Ascough
Julie G. Askew
Curtis Atwater
Del-Bourree Bach
Tucker Bailey
Sheila Ballantyne
Dawn Banning
John Banovich
Anne Barron
BAS
Sarah Draper Baselici
Robert Bateman
Cheryl Gervais Battistelli
Rita Bechtold
Joy Kroeger Beckner
Jennifer Belote
Renee Bemis
Julie Bender
Eric Berg
William Olaf Berge
Sally M. Berner
Robin Berry
Alejandro Bertolo
Linda Besse
Lucie Bilodeau
Adam Binder
Marianne Birkby
Thomas J. Bishop
Lauren Hayes Bissell
Peter Blackwell

Sandra Blair
Caroline Bochud
Ian Bodnaryk
Edwin Bogucki
Deanna Boling
Kirsten Bomblies
Derek Bond
Beatrice Bork
Barry Bowerman
Peta Boyce
Jeffrey Brailas
David Seth Brass
Burt Brent
Carel Brest van Kempen
Peggy Brierton
Thomas Brooks
Ray C. Brown Jr.
Hilde_Aga Brun
Renata Bruynzeel
Linda Budge
Sergio Budicin
Kathrin Burleson
Diane E Burns
Glenys Buzza
Sandy Byers
Michael A. Byrne
Lee Cable
Fuz Caforio
Robert L Caldwell
Clarence P. Cameron
Meredith E. Campbell
Ray Carbone
Brian S. Carney
Roy Carretta
Brenda Carter
Roger Casteleyn
Gloria Chadwick
Larry Chandler
Wendy Saville Chaney
 Chapel
Peggy D. Chapman
Alicia Charlton
Karen F Christopher
Wayne Chunat
Michele Clarkson
Daniel Cliburn
James Coe
Guy Coheleach

Simon Combes
Guy Combes
RoseMarie Condon
Bunny Connell
Carrie Cook
Brent Cooke
Judy Cooper
Reggie Correll
Deborah Crossman
Anni Crouter
Dennis Curry
Christian Dache
Dan DAmico
Nancy J Darling
Daniel Joseph Davis
Pierre de Ganay
Ilse de Villiers
Chris Dei
Leslie Delgyer
Richard Allen Dellalonga
Michael Demain
Andrew Denman
David Glade Derrick Jr.
Sue Dickinson
Michael A. DiGiorgio
Rachel Dillon
Kim R. Diment
Alice Ann Dobbin
Mel Dobson
Kelly Dodge
Pablo Dominguez
Tim Donovan
Ron Dotson
Doris Drabbe
Angela Drysdale
Shane Duerksen
Gordon Dufoe
Michael Dumas
Kathleen E. Dunn
Lori Dunn
Kathleen Dunphy
Linda DuPuis-Rosen
Ray Easton
Theresa Ruth Eichler
Richard Ellis
Lyn Ellison
Leslie Helena Evans
Melanie Fain

Oscar Famili
Larry Fanning
Linda M. Feltner
Kate Ferguson
V. M. Ferguson
Del Filardi
Jeanne Filler Scott
James Fiorentino
Cynthie Fisher
Tim Flanagan
Thea Flanagan
Mike Flanagan
Lindsey Foggett
Crista Forest
Andrew Paul Forkner
Nancy Fortunato
Dawie Jakobus Fourie
Susan Fox
Sunny Franson
Christine Friedrichsmeier
Julian Friers
Sid Frissell
Chris Frolking
Cindy Ann Gage
David C. Gallup
Tykie Ganz
Martin Thomas Gates
Paul Gauthier
Rick Geib
Deb Gengler-Copple
Teri Gillespie
Catherine Girard
Robert Glen
Ulco Glimmerveen
Patrick R. Godin
Paula M. Golightly
Sue Gombus
Susie Gordon
Shawn Gould
Bridget Eileen Grady
Peter Clinton Gray
Kindrie Grove
Gemma Gylling
Grant Hacking
Hap Hagood
Peter Hall
Mark Hallett
Setsuo Hamanaka

Lorna Hamilton
Alan H. Hamwi
Thomas F. Hardcastle
Julia Hargreaves
 Harlan
Nancy Harlin
John Nelson Harris
Judith Hartke
Daniela Hartl-Heisan
Guy Harvey
Kitty Harvill
Kathy M. Haycock
Karole Haycock Pittman
Martin Hayward-Harris
Janet Nichols Heaton
Marie F. Heerkens
Kenneth Helgren
Gabriel Hermida
Linda R. Herzog
LaVerne Hill
Andrew Hoag
Mark A Hobson
Edward Hobson
Mary Louise Holt
Ron Holyfield
Beth Hoselton
Cindy House
Jessa Huebing-Reitinger
Mike Hughes
Karen J Hultberg
Alan M Hunt
Alan William Hunt
Dorothea Hyde
Barry R.J. Ingham
Margaret Ingles
Debra Lynn Ireland
Tammy Kutsuma Irvine
Terry Allan Isaac
Patti Jacquemain
Graham Jahme
Clint Jammer
Jon Janosik
Mary Ellen Jantzi
Brian Jarvi
Stephen A Jesic
Mary Jane Jessen
David Bruce Johnson
Jay J. Johnson

190

Brenda D. Johnson
Joni Johnson-Godsy
Richard Rees Jones
Jason Kamin
Hans Christoph Kappel
Karryl
Aleta Karstad
Debby Kaspari
Mark A. Kelso
Doni Kendig
Judi Kent Pyrah
James Kiesow
Osamu Kimura
Leslie Kirchner
Andrew Kiss
David N. Kitler
Christine Knapp
John Kobald
Eriko Kobayashi
Jack Koonce
Barbara Kopeschny
Pawel Kot
Stephen Koury
Eric Kraft
Stephen J. Krasemann
Robert Clement Kray
Jeff Krete
Heidi Krueger
Marjolein Kruijt
Susan Labouri
Laney
Yvette Lantz
Judy Larson
Karen Latham
Rebecca Latham
Bonnie Latham
Karen Laurence-Rowe
C. Frederick Lawrenson
Luc LeClerc
Pierre Leduc
Linda Lemon
Esther Lidstrom
Patsy Lindamood
Janeice Linden
Steven Lingham
John Lofgreen
Craig Anthony Lomas
Emily Lozeron
Bo Lundwall
Sascha Lunyakov
Harro Maass

Dorcas MacClintock
Barry Kent MacKay
Linda Mackey
Craig Magill
Michelle Mara
Laura Mark-Finberg
Cindy L. Markowski
Pete Marshall
James Marsico
Diane D. Mason
Terry Owen Mathews
Peter Mathios
Denis Mayer Jr.
Keith McAllister
Chris David McClelland
Rebecca McClive
Michelle McCune
Pip McGarry
Gregory McHuron
Candy McManiman
Larry McQueen
John Megahan
Krystii Melaine
Stanley Meltzoff
Clive Meredith
Kim L Middleton
Rudy Miller
Billy-Jack Milligan
Marti Millington
Laurel Mines
Deian Moore
Jason Morgan
Steve Morvell
Zenaida Mott
Frans E Mulder
Dianne Munkittrick
Sean Murtha
Chris Navarro
Francoise Nesse
Ken Newman
Marilyn Newmark
Calvin Nicholls
Alison Nicholls
Tim Nicklin
Carole Niclasse
Kentaro Nishino
Arnold Nogy
Larry Norton
Mary Louise O'Sullivan
Michael Bata Oberhofer
Steve Oliver

Ron Orlando
Francesca Elisabetta Owens
Jennifer O'Cualain
Mac L. Pakula
Wendy Palmer
Michael Pape
Dino Paravano
Curt Parker
Robert Parkin
Linda J. Parkinson
Victoria Parsons
Kathy R. Partridge
Jeremy David Paul Dr.
Pat Pauley
Fabio Pellicano
Cristina Penescu
Patricia Pepin
Marcia Perry
Dag Peterson
Anne Peyton
Pollyanna Pickering
Sandra Place
Kay Polito
Christopher Brian Pope
Elizabeth (Betsy) Popp
Richard Prather
David L. Pratt
David L. Prescott
Ji Qiu
Stephen C. Quinn
Manuel Quiros
Ahsan Qureshi
Maya Ramaswamy
Don Rambadt
David James Rankin
Gamini Ratnavira
Linda S Raynolds
Parks Reece
Sonia Reid
Vicki L. Renn
Diana Reuter-Twining
Paul Rhymer
Andrea Rich
Rebecca Richman
Martin Ridley
Katerina Ring
Craig Roberts
Julia Rogers
Rosetta
Linda Rossin
Jonathan C. Roveto

Karla Runquist
Len Rusin
John Ruthven
Maria Ryan
Eleazar Saenz
Laurence Saunois
Patricia Savage
Mike Savlen
Sharon K. Schafer
Bill Scheidt
Robert Schlenker
Judy Scotchford
Martin James Scuffins
Suzie Seerey-Lester
John Seerey-Lester
John Serediuk
Steve Shachter
J. Sharkey Thomas
Nigel John Shaw
Kathleen Sheard
David Shepherd
George Shumate
Naomi Rita Siegmann
Wes Siegrist
Rachelle Siegrist
Herb Simeone
Geraldine Simmons
Kelly Singleton
Susie Slater
Alex D. Slingenberg
Richard Sloan (1935-2007)
Josephine Anne Smith
Karin Snoots
Morten E. Solberg
Cindy Sorley-Keichinger
Leslie Spano
Edward Spera
Gloria Spevacek
Melanie Springbett
Susanne Staaf
Anders Stahl
Pati Stajcar
Eva Stanley
Mark Stoddart
Dolfi Stoki
Sue Stolberger
Uta R. Strelive
Ken Stroud
Mark A. Susinno
Linda Darsow Sutton
Joseph D. Swaluk

Jan Sweeney
Ramona Swift
Richard Symonds
Frederick Szatkowski
Yutaka Tamura
Mary C. Taylor
Sandra Temple
Claude Thivierge
Dahrl Thomson
Daniel C. Toledo
Jon Tremaine
France Tremblay
Les D. Troyer
Jonathan Truss
Deborah Ann Uhl
Alex Underdown
Heidi E. Uotila
Eva Van Rijn
Jake Vandenbrink
Jerry Venditti
Joseph S. Venus
Diane Versteeg
Cleo Vilett
Lute Vink
Christopher B. Walden
Linda Walker
Robert Wand
Val Warner
Cliff Wassmann
Peggy Watkins
Pat Watson
Allen F Weidhaas
Dale Weiler
Gregory Paul Wellman
Dinah Wells
Rick Wheeler
Taylor White
Kitty Whitehouse
Jeffrey G. Whiting
Derek C. Wicks
Kay Williams
Patti Wilson
Victoria Wilson-Schultz
Ria Winters
Terry Woodall
Ellen Woodbury
Chris Woolley
Steve Worthington
Larry Zach
Pete Zaluzec
Sallie Ann Zydek

Wildscape
Wildlife Art & Conservation

Wildscape is proud to be a main sponsor for the Artists for Conservation Exhibition as part of its ongoing mission to support wildlife art and conservation worldwide.

Now in its tenth year of publication, Wildscape is unique, the only magazine currently available dedicated to wildlife art and conservation.

Wildscape has subscribers in over eighteen countries worldwide, and has gained an enviable reputation for its quality and high standard of presentation. As well as informative, high quality articles by leading artists, Wildscape provides information about activities and events that make this genre such a feast of beautiful images that appeals to so many people, artists and collectors alike.

Our aims are to highlight the whole spectrum of wildlife art, to bring its benefits and pleasures to as many people as possible, thereby serving the interests and futures of all those artists working within the genre.

What some of our readers say...

Thank you for the splendid work you do publishing such a high-quality wildlife art magazine. With the demise of 'Wildlife Art' magazine in the United States, your publication is the only one that solely represents wildlife artists. It's a pleasure to read about and see the wonderful work of British and European wildlife artists who, without your magazine, probably would not be known in the United States.
Randy Stevens – USA

I would like to thank you for providing Wildscape for all like minded artists, especially a true amateur like myself. The unique online competition and the very reasonable entry fees encourage artists to have a go with their art. Wildscape is such a wonderful place to learn and to have fun. Thank you!
Rita Chang – UK

Just a big 'Thank You' for providing us with a fantastic magazine, it is so inspiring. No one will get any sense out of me today until I have read it from cover to cover!
Sally Berner – USA

I just wanted to congratulate you on your magazine reaching its 10th year. This edition is just fantastic, and I have loved reading the articles by Bateman, Bond and Isaac, truly inspirational stuff. I was so sad when the American Wildlife art vanished, but feel Wildscape is now filling the gap with the new format, long may it continue.
Julie Stone - UK

Just got my latest copy of Wildscape and it is great! Congratulations on yet another wonderful edition.
Sandra Temple - Australia

What a mother lode of good stuff!
Marcia Theel - Leigh Yawkey Woodson Art Museum - USA

We look forward to welcoming you to our readership in the near future.

For more information please contact us at the following address...

Wildscape
Darwin Publishing
Greenways. Bridge Road, Lower Hardres, Canterbury, Kent CT4 7AG. UK
Telephone: +44 (0)1227 464739
e-mail: info@wildscapemag.co.uk www.wildscapemag.co.uk